Van Dyck

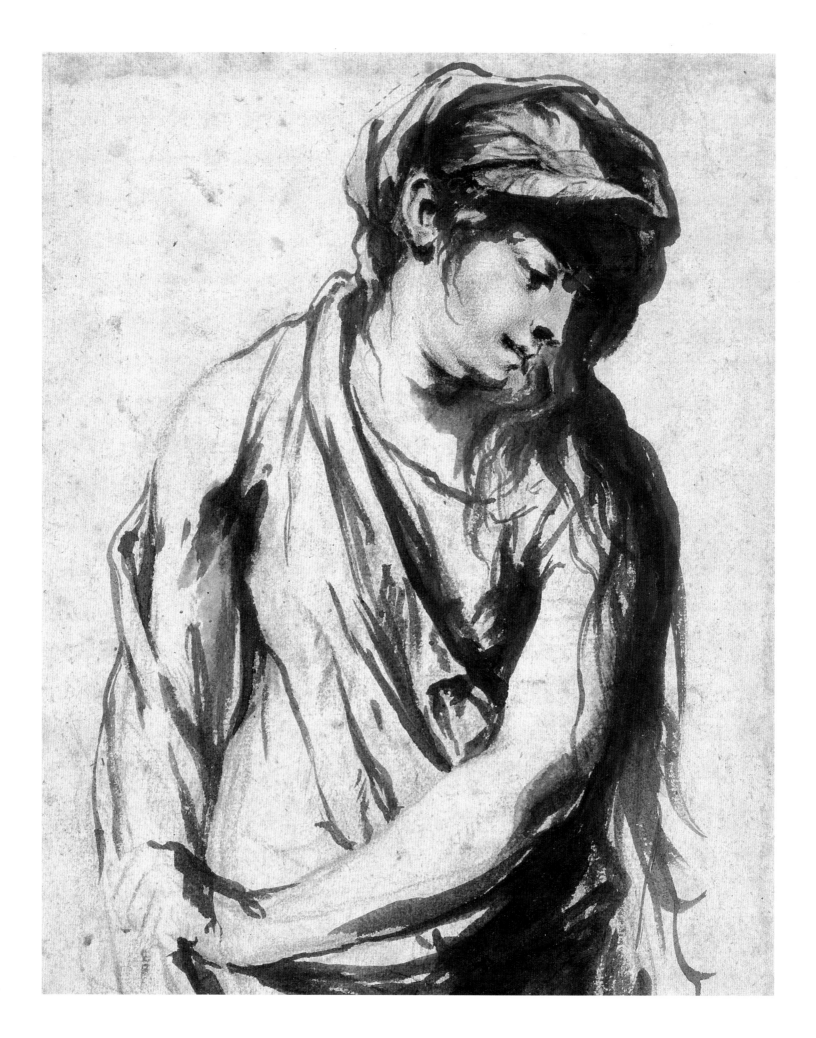

James Lawson

Van Dyck

Paintings and Drawings

Prestel

Munich · London · New York

© Copyright 1999 Prestel Verlag
Munich – London – New York

Front jacket: *Self-portrait* (detail), 1613–14 (see p. 118)
Back jacket: *Time Discovering Truth*, 1632 (see p. 24)
Frontispiece: *Study for Mary Magdalene* (detail), 1632 (see p. 27)

Library of Congress Catalog Card Number:
99–65113

Prestel Verlag
Mandlstraße 26
D–80802 Munich
Tel.: (89) 38 17 09–0
Fax: (89) 38 17 09–35

4 Bloomsbury Place
London
WC1A 2QA
Tel.: (171) 323 5004
Fax: (171) 636 8004

16 West 22 Street
New York
NY 10010
Tel.: (212) 627 8199
Fax: (212) 627 9866

Prestel books are available worldwide.
Please contact your nearest bookseller or any of the above addresses
for information concerning your local distributor.

Editorial Direction by Philippa Hurd
Biography and Context by Kate Ferry-Swainson

Designed and typeset by Heinz Ross, Munich

Colour separations by ReproLine, Munich
Printed by Aumüller Druck KG, Regensburg
Bound by Kunst- und Verlagsbuchbinderei, Baalsdorf

Printed in Germany

ISBN: 3–7913–2090–4

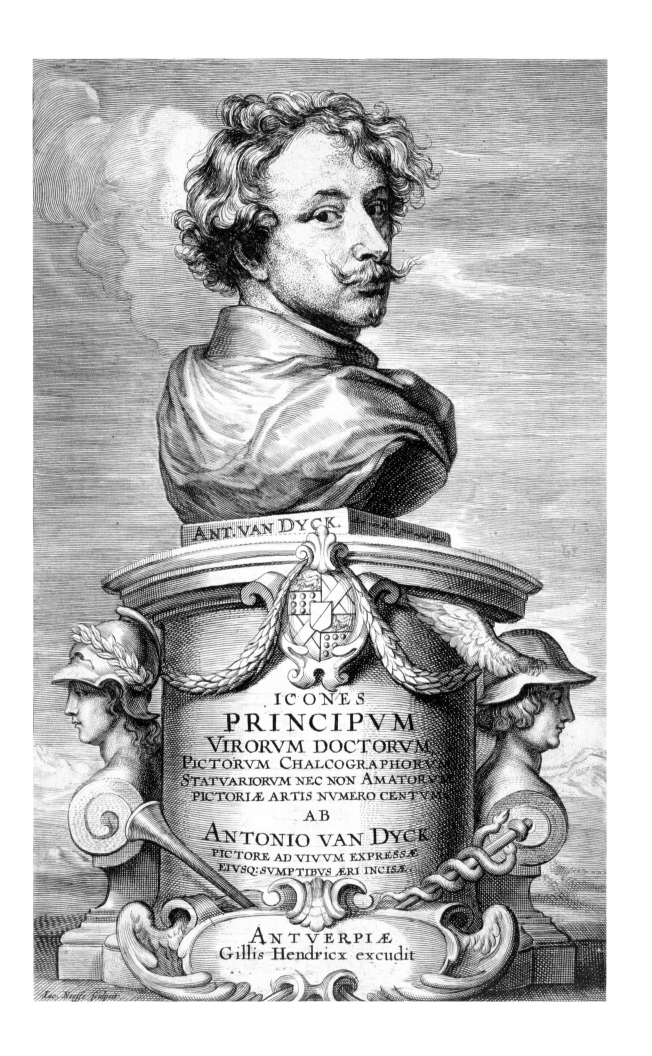

ANT. VAN DYCK.

ICONES
PRINCIPVM
VIRORVM DOCTORVM
PICTORVM CHALCOGRAPHOR
STATVARIORVM NEC NON AMATOR
PICTORIÆ ARTIS NVMERO CENTV
AB
ANTONIO VAN DYCK
PICTORE AD VIVVM EXPRESSÆ
EIVSQ: SVMPTIBVS ÆRI INCISÆ

ANTVERPIÆ
Gillis Hendricx excudit

Van Dyck in Hindsight

Introduction

In 1526 the painter, Hans Holbein the Younger (1497/8–1543), set off for England. His fellow citizen in Basel at the time, Erasmus of Rotterdam, wrote to a friend in Antwerp: 'Hic frigent artes; petit [Holbein] Angliam ut corradat aliquot angelatos' [Here, the arts are out in the cold. He [Holbein] is making for England in order to mint a few angels.].[1] It is a very elaborate pun. Holbein intended to make his way to England in order to make some money, for an 'angelatus' was a gold coin, and to paint some Englishmen, or Angles (or even angels). At the same time, the verb 'corradere' carries notions of coining, or forging or counterfeiting, and Erasmus jokes upon that perplexing fact of the portrait – that it invites us to treat it as a substitute for the real thing, the sitter. He hints at something paradoxically fraudulent in that. There could be no more veracious portraiture than Holbein's; it seems to be a perfect optical substitute for the sitter. The forgery could not be better.

The truth of the portrait was a less problematic issue for Oliver Cromwell, Lord Protector from 1653 to 1658. The story is told that he demanded, of the painter, Peter Lely (1618–80), that he, 'remark all these roughnesses, pimples, warts and everything, as you see me'.[2] Evidently, it would be false to gloss over blemishes.

But neither Holbein nor Lely have succeeded, in the view of posterity, in representing the Englishman in more than a particular sense. It is a painter who was active between the periods of these 'truth-tellers' whom posterity judges to have done that: Sir Anthony van Dyck. And Van Dyck did not tell an unvarnished truth about the ladies and gentlemen of England during the reign of Charles I. It is enough to contrast Holbein's treatment of Henry VIII and Van Dyck's of Charles I. There is no improving evasion of physical fact by Holbein; but Van Dyck is ready, as will be seen, to adopt a multitude of devices to raise the observer's thoughts above the regrettable fact of physical imperfection. At the same time, and perhaps most remarkably, his was a subtle art, for his improvements did not render his sitters unrecognisable. In either event though – truth-telling or improvement – Cromwell did not intend to look like a Caroline gentleman. Clearly, portraiture is a complicated business, and truth, which is what retains the curiosity and delight of posterity, is not just a matter of visual accuracy. In the context of portraiture, as everywhere else, truth is a slippery notion.

Perhaps a way to approach this somewhat uncomfortable fact is to acknowledge that the portrait, rather than being a thing in itself, is the product of a collaboration. Two of the parties are clear enough to identify in theory; they are the painter, and the sitter. But the third party complicates things considerably. Of particular importance in the case of the portraiture of Van Dyck is the role of this third party, namely of posterity. Posterity has continued to make of Van Dyck and his English sitters the stuff of imagining, or myth, or fiction. In other words, a historiography, with all its tendentiousness, intervenes between the work and its observers, and it demands to be acknowledged. For example, it is not too large a claim to say that, without the English portraiture of Van Dyck, one of the most well-known and popular pictures of Britain, *And when did you last see your Father?* by William Yeames (1835–1918), in the Walker Art Gallery, in Liverpool, would never have been created. A group of black- and dun-clad Cromwellians interrogate a young Royalist boy in blue silk. The picture is about history, politics and style.

Self-portrait, 1645–46
(reworked by Jacob Neeffs)
Engraving, 24.3 x 15.6 cm
The British Museum, London

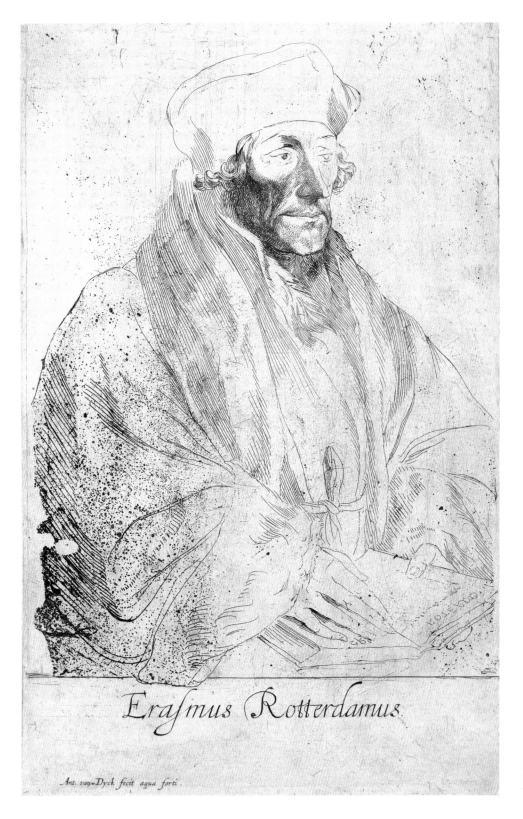

Erasmus, 1627–35
Engraving, 24.8 x 15.9 cm
The British Museum, London

Posterity in Antwerp, Genoa, Brussels and the other places where he worked has had less to make of Van Dyck than in England. He made two trips to England. The first, in 1620, was a brief four-month stay. The second, interrupted by short visits to the continent of Europe, lasted for nine years, till his death in 1641. During that second period, Van Dyck's output was prolific. But the English part of his career was, in no sense, his artistic and professional 'arrival'. He spent long periods in Italy and the Low Countries. And Van Dyck was not held in England by particular ties of duty, allegiance or affection, for he promptly returned to Antwerp in 1640, in the

Self-portrait, 1617–18. Oil on canvas, 82.5 x 70 cm. Alte Pinakothek, Munich

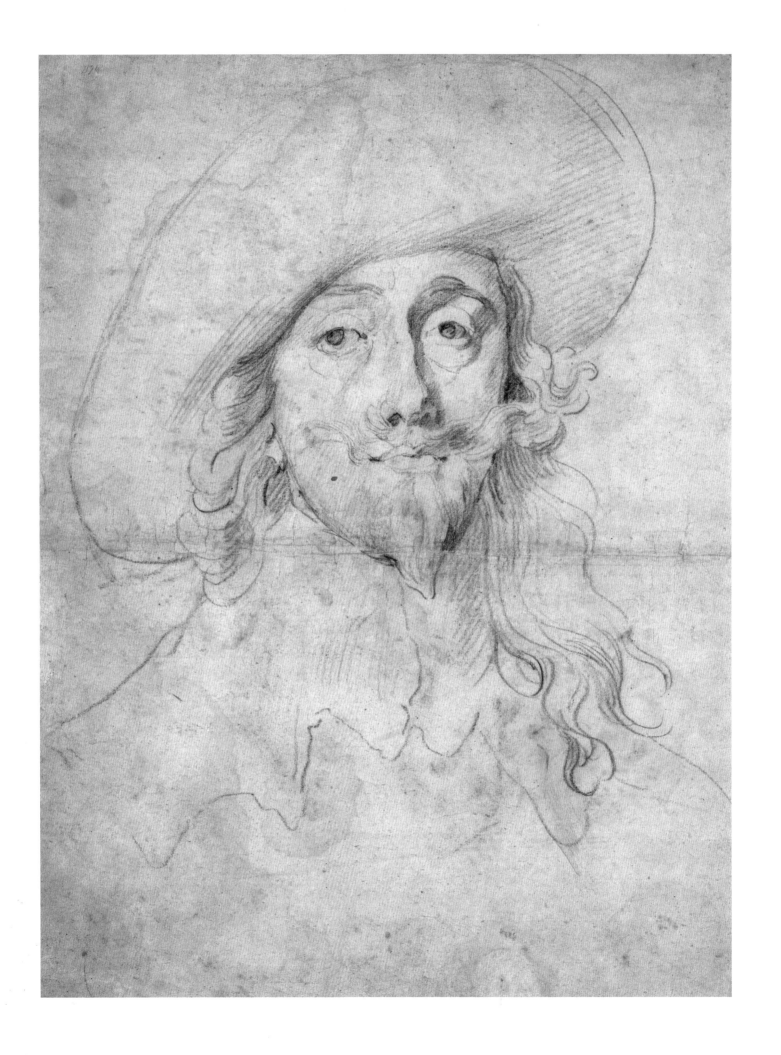

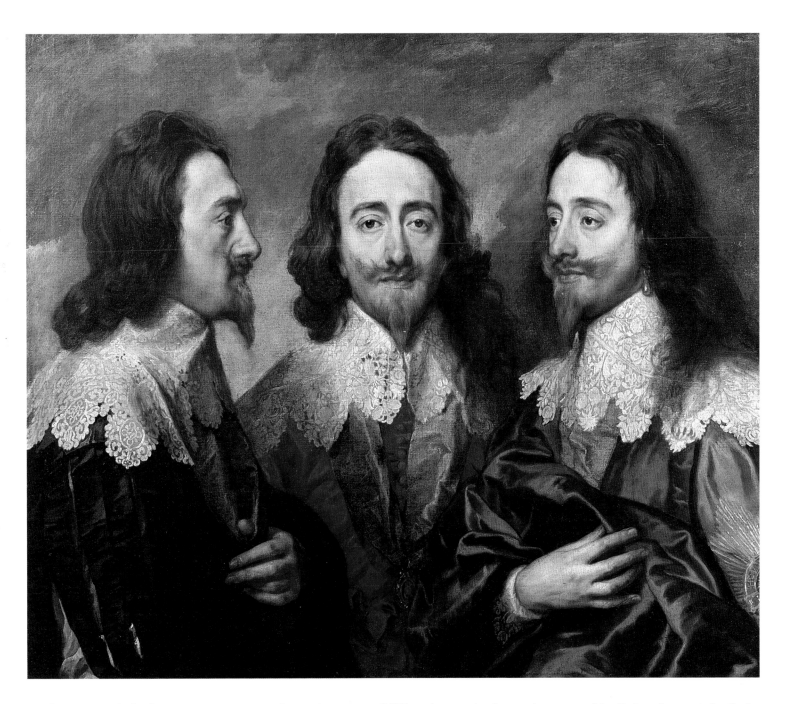

Triple Portrait of Charles I, 1635
Oil on canvas, 84.5 x 99.7 cm
Her Majesty Queen Elizabeth II

Portrait of Charles I, c. 1633
Black chalk, 47.9 x 36.5 cm
Rijksmuseum, Amsterdam,
Rijksprentenkabinet

hope, it seems, of filling the gap in the market created by Rubens' recent death. In that year, he also went to Paris, hoping to receive the commission to decorate the Louvre for Louis XIV. There can be no doubt that, had he been successful, he would have removed from England.

Van Dyck has been expropriated to English art history because of the fate of the monarch to whom he became 'principalle Paynter in ordinary' in 1632 and the fate of the aristocracy that was decimated by civil war.[3] The cataclysmic nature of the events that unfolded around these people has engaged the imagination of posterity to such an extent that the visual record – Van Dyck's portraiture – has been conned in search of clues as to why they happened. Indeed, hindsight infects vision so much that the destiny of Van Dyck's sitters is commonly seen to be foretold in their features and demeanour. At the same time, hindsight lends emotional colour to relics. But Van Dyck's portraiture gives a certain amount of encouragement to these acts of 'reading in'. If Caroline England had been painted by Holbein, the romantic historian would have had to look for documentation elsewhere.

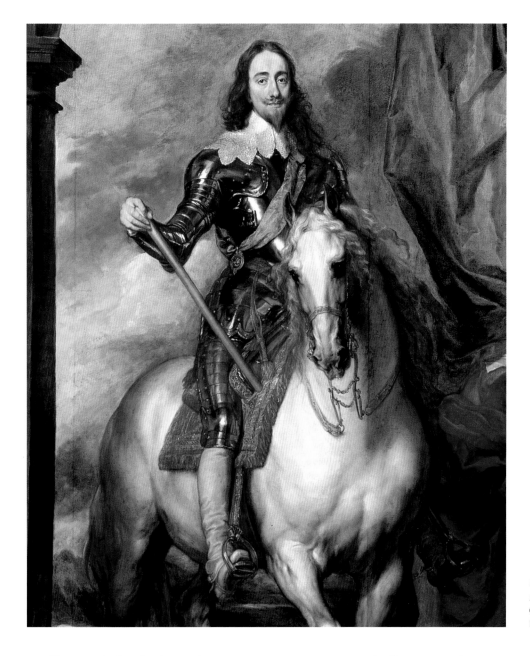

Charles I on Horseback with Monsieur de St Antoine (detail), 1633
Oil on canvas, 368.4 x 269.9 cm
Her Majesty Queen Elizabeth II

The search for destiny – that attempt to map causes and effects onto the consciousness of those who lived through them – prompted John Evelyn, the diarist, to give prominence to a tale about the sculptor Gianlorenzo Bernini's prescience in regard to Charles I. In his *Numismata*, of 1697, he reported Bernini's response on receiving Van Dyck's *Triple Portrait* of the king from which he was to make the marble bust: there was, 'something of the funest and unhappy which the Countenance of that Excellent Prince foreboded.'[4] Whether and when Bernini said this must remain uncertain. But the intriguing question is whether the tale gains plausibility from the actual painting. Hindsight is implicated, should there be any diffidence in our answer.

A good example of acquiescence in the idea that Charles I's destiny was signified in his appearance is an oil painting at Petworth, connected with the portrait of *Charles I on Horseback with Monsieur de St Antoine*, at Buckingham Palace. It is clear that the King's head in the painting at Petworth is not the work of Van Dyck. A painter with hindsight upon events has inserted it, omitting a subtle and significant tilt backwards of the head. A hint of swagger, appropriate to generalship, is replaced by a slight nervousness, more appropriate to sensibility, and therefore

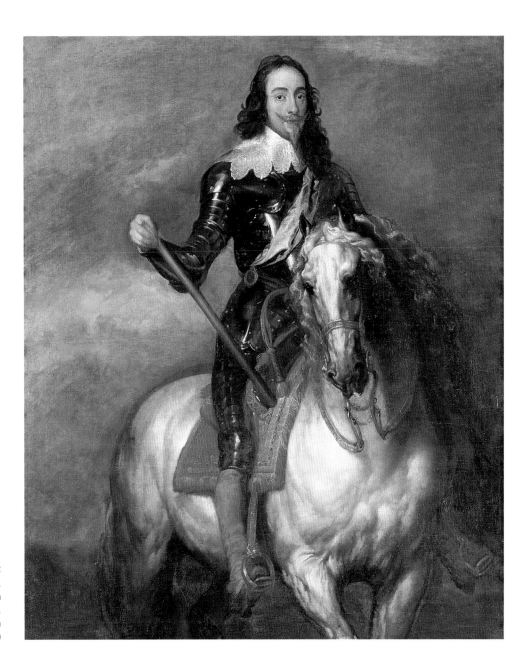

unworldliness. Close comparison reveals the sentiments of the Petworth painter. He has also opened the eyes of the king infinitesimally and given him, again by comparison, a slightly startled air. Here is a hint of vulnerability and a shadow of martyrdom.

If posterity has been one of the collaborators in the creation of Van Dyck's *œuvre*, it has also, in a sense, been shaped in part by it. The coincidence of Van Dyck's English work with the social and political circumstances prior to the Civil War is so close that the imagery can almost substitute for them. It is certainly taken as emblematic of the epoch. Van Dyck painted the Cavalier. Of course, not all his sitters were Royalists. Among the more prominent of his patrons was, for example, the Earl of Northumberland, a supporter of the Parliamentarian Cause. But that is dull historical fact: the Cavalier is a figure of imagination, to be imitated in fantasy and morality almost like the *dramatis personae* of the *Imitatio Christi*. It is a pity that *panache* is a French word.

It is possible to assert that cavalier values are known to the English through the imagery of Van Dyck more than through any other agency. And there are well-known

instances of that imagery, considered morally and aesthetically, populating the imagination of later generations, and serving as a model of style and conduct. It is frivolous catechism; however, the question, 'what do Sir Percy Blakeney, Oscar Wilde, Lupin Pooter and the Monarch of the Glen have in common?' does receive the answer, 'they are all cavaliers'. By the same token, there is something of the Roundhead in Lord Burlington, Mr Gradgrind and Badger (but emphatically not Toad).

Where religious and political division – matters of ideology rather than attitude – dominate, social and cultural differences cease to be relative and become absolute. Cultural objects of the past and the values that they embody can be evaluated in aesthetic and moral terms without discrimination when they are believed to be products of a society at one with itself. The polarisation of civil war, however, is extreme and ramified. As a result, hindsight needs to be almost schizophrenic, or at any rate to be capable of evaluating the stuff of sentiment independently of that of reason. In other words, Van Dyck's English work brings out a historiographical contradiction. There is a history of painting that affirms the quality of his work and sees his example taken up again and again. Then, there is a historical event, the Civil War, that his work seems to be party to, and – an extreme ideologue might insist – even precipitated to some extent, if he would give Van Dyck a role in defining to itself the class of Cavalier. Thus, one eye of hindsight looks back with pleasurable emotions upon the pictures of Caroline England whilst the other, colder one, seeing the watershed of the Civil War and the Glorious Revolution that eventually succeeded it, reprehends a conspiracy of art and political caste.

The motives of English painters in looking back to Van Dyck are equally ambiguous. When William Hogarth (1697–1764) conceived his series, *Marriage à la Mode*, he set up an alliance between lineage and money. But, beneath the surface can be made out a collision, in most general terms, between Cavalier and Roundhead. Lord Squanderfield, the father of the bridegroom, in Hogarth's Plate 1 *The Marriage Contract*, sits before a portrait of himself in armour. It is an image indebted to the type represented by such pictures by Van Dyck as *Hendrick van der Bergh*, in the Prado, or *Thomas Wentworth, Earl of Strafford*. The bride's father, the merchant, is a man of 'roughnesses, pimples, warts and everything'. Another possible allusion to the vanity of the Caroline Age is a detail in Plate IV, *The Countess's Levée*. She is having her hair done in papers, surely the method by which the ladies of fashion following Henrietta Maria in Van Dyck's works acquired their curls.

Thomas Gainsborough's (1727–88) admiration of Van Dyck extended all the way from his handling and his rendering of stuffs and laces to the romance of the society that he depicted. *Mrs Graham*, in the National Gallery of Scotland, is in Vandyckian costume. So too is *Jonathan Buttall* also known as the *Blue Boy*, in the Huntington Art Gallery at San Marino, whose kinship with Charles, Prince of Wales, in such pictures as *The Five Eldest Children of Charles I* (see p. 86), is clear. Joshua Reynolds (1723–92) can be said to have had a 'well-stocked' eye. But Van Dyck was a particularly important influence. Thematically, such ambitious and not entirely serious portraits as *Lady Sarah Bunbury sacrificing to the Graces*, at the Art Institute, Chicago, are indebted to such works by Van Dyck as *Venetia Stanley, Lady Digby, as Prudence* (see p. 101). For instruction in his paint-handling, which owed so much to Titian, Reynolds could study one of Titian's closest students, Van Dyck.

A list of British painters who looked to Van Dyck would be too long, but it would include Thomas Lawrence (1769–1830) and David Wilkie (1785–1841), and

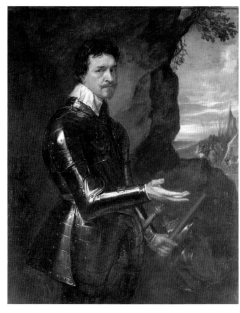

Thomas Wentworth, Earl of Strafford,
1639–40. Oil on canvas, 123.3 x 139.7 cm
Petworth House, The Egremont Collection
(The National Trust)

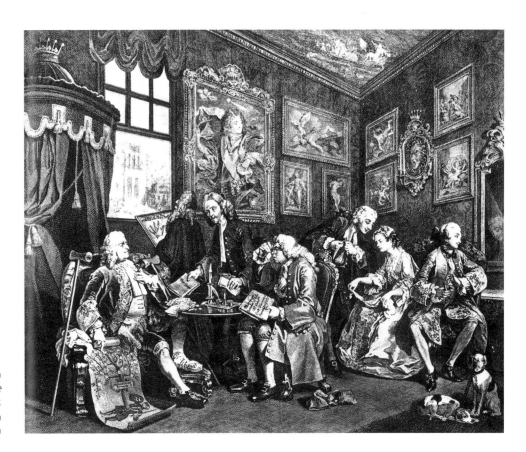

many other artists who were publicly successful. There continued to be a public taste for the kind of painting and art that maintained links with the art and the age of Van Dyck. Perhaps this enthusiasm in artists and public is a sign of double standards, for it seems unlikely that many of them retained an affection for seventeenth-century Absolutism or nodded agreement with the argument for the Divine Right of Kings. But, when put to the point, and seriously determined that painting be more than an occasion for escapism and nostalgia, the critic reasserts the distinction between Van Dyck as an artist and an apologist – a construct of politically minded posterity. It is significant that, when John Millais (1829–96) went to Van Dyck, for *Bubbles*, the historian takes from his action confirmation that Millais, once upon a time the socially concerned Pre-Raphaelite, had ceased to be radical.

History, like vision, always acknowledges the remoteness of its object. Van Dyck's paintings of the ladies and gentlemen of Caroline England must be remote by virtue of this fact alone. They are made doubly remote by the divide of political sympathy, for there cannot be much regret for the direction which political events had taken by the end of the century. But, as an example to painters of portraits, he would not go away. He had also forged or counterfeited an Englishman and Englishwoman which sensibility had assimilated so thoroughly that they remained models in imagination. Perhaps it is the impossibility of them passing as models from the imaginative life into the practical life of their observer – a historical piety prohibits it – that lends them their final melancholy and plaintive remoteness.

15

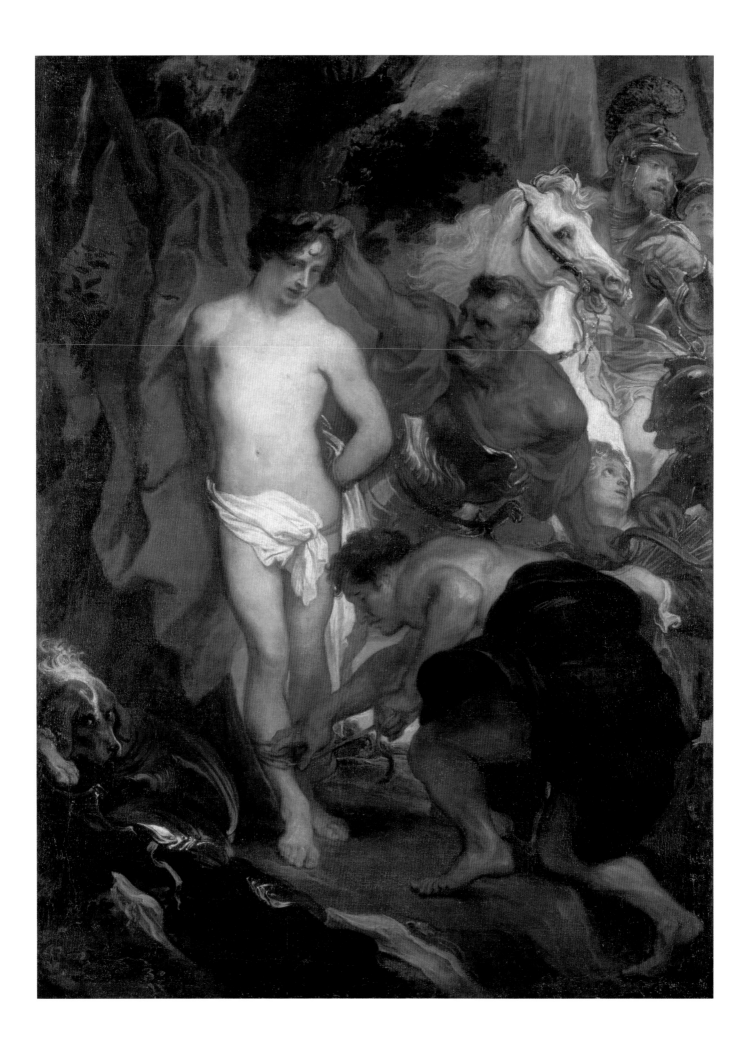

Lives Invented, Lives Observed

Van Dyck as a History Painter

The principal part in the collaboration that creates the portrait must be the painter's. Van Dyck stands so high amongst portrait painters largely because his creative contribution is so conspicuous. Not always is the painter so recognisable in the work. The measure of Van Dyck's prominence is the astounding variety of his production. To scan his *œuvre* as a portraitist is to be struck by a sheer quantity of invention, one surpassing that of his predecessors and successors. It may be that his inventive energy diminished somewhat towards the end of his life and perhaps in response to the relative social insignificance and dullness of some of his sitters; but even under pressure of boredom or making the economies of labour that cupidity demanded, his standard remained remarkably high. Lesser artists fell more readily into the formulaic and, with the resulting tendency to creative disengagement, played a smaller part in the collaboration. Van Dyck, though, easily outdoes Peter Lely, his successor as England's principal portrait painter in this respect, and he leaves Godfrey Kneller (1646/9–1723) far behind. How Van Dyck acquired the resources out of which he was able to create so variously and abundantly and just how he used them are crucial questions.

Van Dyck had a precocious talent and acquired a very extensive artistic education. While still very young, he acted as a principal assistant to Peter Paul Rubens (1577–1640). Thus Van Dyck worked in perhaps the greatest art factory of the period and was under the direction of an artist of vast culture, prodigious energy, boundless invention and mesmerising skill. These superlatives require no pedantic justification. Van Dyck, as will be seen, did not fall far behind Rubens in terms of energy, invention and skill. A story, of a somewhat Plinyesque character, is told by the art historian and theorist, Roger de Piles (1635–1709), to evidence the skill of Van Dyck. High jinks among the assistants in Rubens's studio had led to a half-finished picture being damaged. Van Dyck was prevailed upon by the others to do the repairs, after which, 'Rubens, coming next Morning to his Work again, first went at a distance to view his Picture, as is usual with Painters, and having contemplated it a little, suddenly cry'd out, he lik'd his Piece far better than the Night before …'.[5] Van Dyck's job at this time was to paint in a manner consistent with the house style which was, of course, Rubensian. So much did Van Dyck's handling assimilate to that of Rubens that art-critical squabbles of attribution still occur. For example, the version of *Emperor Theodosius refused Entry into Milan Cathedral*, in the Kunsthistorisches Museum in Vienna, is given by some to the one and some to the other (though the attribution to Rubens, on the basis of the orchestration of the drama, is shown to be the correct one by comparison with the smaller version in the National Gallery in London). A portrait such as that of *Cornelis van der Geest* could easily pass for a superior product of Rubens's studio.

Rubens presided over Van Dyck's career in several ways. It could be said that Van Dyck stalked Rubens, professionally and stylistically. Charles I knighted Rubens in 1630 and Van Dyck in 1632. As has been seen, Van Dyck seems to have hoped to step into Rubens's shoes in Antwerp, when the latter died in 1640, and he hoped at the same period to enter the service of the French monarchy, as Rubens had done in creating the *Life of Marie de' Medici* cycle in the Louvre. But more important than career ambition was artistic ambition. Van Dyck traced Rubens's footsteps not

The Martyrdom of St Sebastian, n. d.
Oil on canvas, 199.9 x 150.6 cm
Alte Pinakothek, Munich

Antwerp Sketchbook,
folio 46 recto, c. 1615–17
Pen with brown ink,
brown wash, 20.6/21 x 16 cm
The Duke of Devonshire
and Chatsworth House Trust

only geographically but also in search of artistic education. And the journey that
was of crucial importance in both their lives was the one that was both geograph-
ical and educational: the journey to Italy. Rubens had made his first, long trip to
Italy almost immediately after his apprenticeship, in 1600. At a corresponding time
in his career, Van Dyck left Rubens' studio and made the same trip. The biographer
of artists, Gian Pietro Bellori (1615–96), credited Rubens with having had the wit
to expel from the nest the bird already capable of flight and implies that he pre-
cipitated Van Dyck's *Wanderjahre.*[6]

For Van Dyck, then, to journey from Rubens was, in a sense, to journey with
him, for they shared an itinerary. Another of Rubens's principal assistants and at
length a painter of considerable individual reputation was Jacob Jordaens
(1593–1678) who did not make the journey. Nor of course, most famously among
artists of the Low Countries, did Rembrandt (1606–69). For Van Dyck, however,

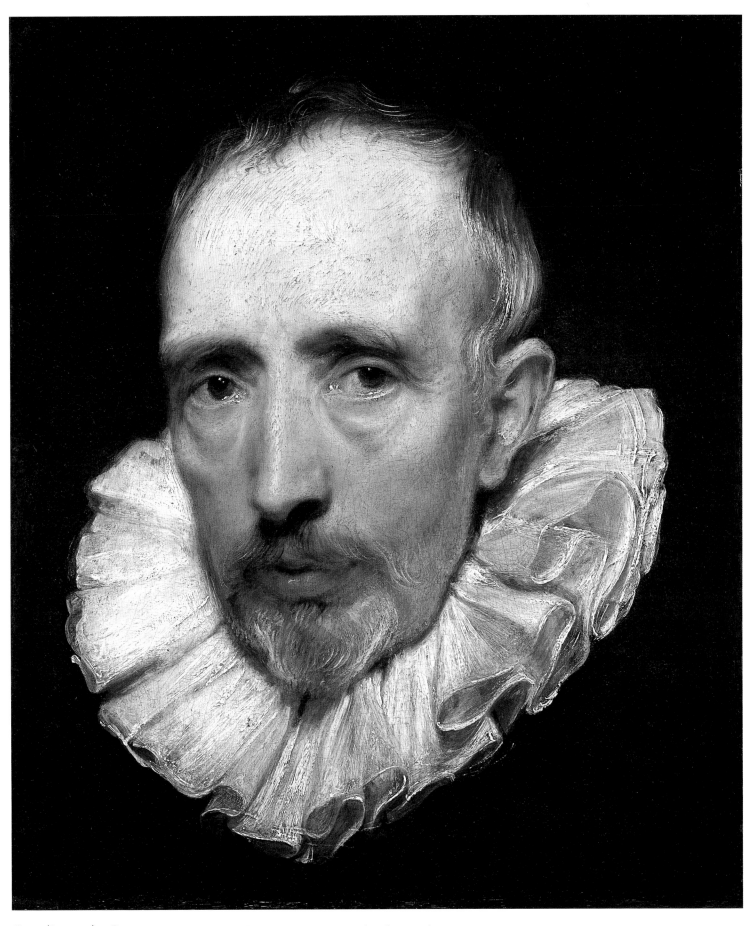

Cornelis van der Geest, 1619–20. Oil on panel, 37.5 x 32.5 cm. National Gallery, London

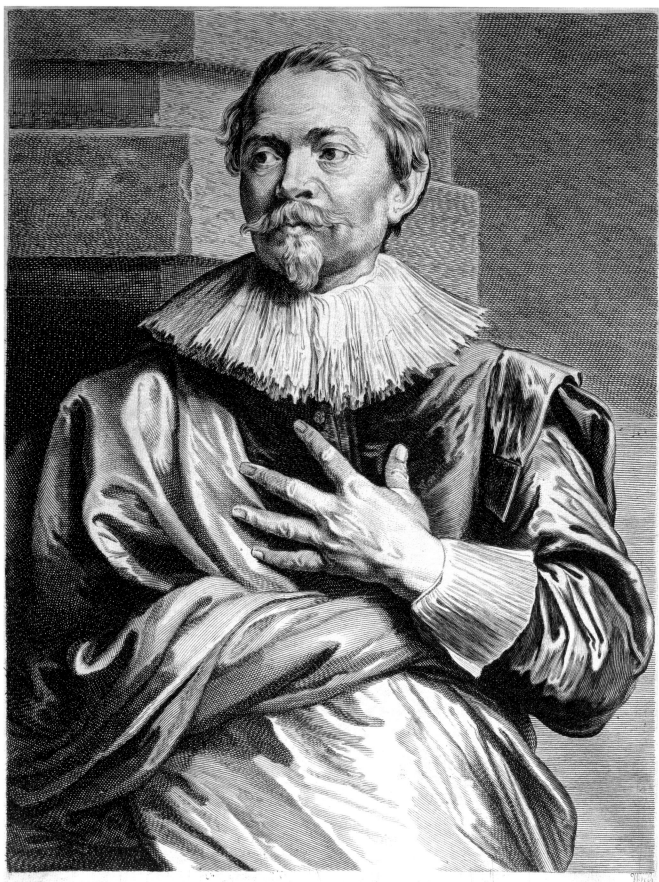

IACOBVS IORDAENS

Ant. van Dyck pinxit
Pet. de Iode sculo.

Mart. vanden Enden excudit Cum priuilegio

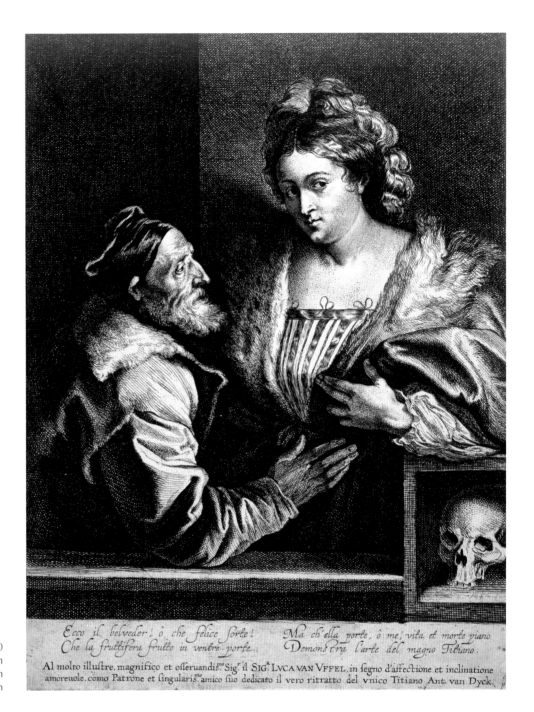

Ecco il belveder! ò che felice forte!
Che la fruttifera frutto in ventre porte.
Ma ch'ella porte, ò me, vita et morte piano
Demons era l'arte del magno Titiano.

Al molto illuftre, magnifico et offeruandiſ.ᵐᵒ Sigᴿ. il Sɪɢ.ᴿ Lᴠᴄᴀ ᴠᴀɴ Vꜰꜰᴇʟ, in fegno d'affectione et inclinatione
amoreuole, como Patrone et fingulariſ.ᵐᵒ amico fuo dedicato il vero ritratto del vnico Titiano Ant. van Dyck.

Titian and his Mistress, c. 1630
Engraving retouched with pen
and brown ink, 30.6 x 23.5 cm
The British Museum, London

Jacobus Jordaens, 1627–35
Engraving, 25 x 17.6 cm
The British Museum, London

there was a pilgrimage to make (to say nothing of opportunities to seize), for the roots of Rubens's painting are to be found in Titian (c. 1487/90–1576), and it would be Van Dyck's direct experience of Titian's work that would be the basis of his technique and sensibility as an artist. Van Dyck followed Rubens to Genoa, Rome and Venice, and, on his return to Genoa, visited Mantua where Rubens had worked in the service of the Gonzaga lords.

Bellori sets the study of Titian and Venetian painting at the heart of Van Dyck's motives for going to Italy: 'But, it seeming to him to be time to go to Italy, he left his home country and arrived ... in Venice, where he immersed himself in the painterliness of Titian and Paolo Veronese, at which source his master [Rubens] had also drunk. He copied and made drawings of the best history paintings ... and in this way dipped his brush in fine Venetian colours'.[7] Roger de Piles describes how Van Dyck went 'to *Venice*, where he skim'd the Cream (if you will allow the Phrase) of Titian's Works, and the Works of the whole *Venetian School*, to strengthen his

own Manner ...'.[8] During his Italian journey, Van Dyck collected data in the form of his own somewhat mnemonic drawings in his Italian Sketchbook, now in the British Museum. His drawing after Titian's *Pope Paul III and his Nephews*, now in Naples, is annotated with identifications of the figures and a reminder that the hanging drapery was cloth of gold. On their own, these would have been insufficient indicators to enable the picture to be reconstructed except in most cursory terms.

He sought out Titian also elsewhere than in Venice. For example, he made drawings in the Villa Borghese in Rome of *The Blindfolding of Cupid* and *Sacred and Profane Love*. In the collection of the Palazzo Ludovisi, he could see Titian's *Worship of Venus* and *The Andrians*, both now in the Prado, which Titian had painted for Alfonso d'Este, Duke of Ferrara. A recollection of the statue of Venus in the one picture reappeared with appropriate modifications in the right background of Van Dyck's *Lomellini Family*, which he painted in Genoa, and the drawing that he made after the other provided much of the figure composition of his own *poesia, Amaryllis and Mirtillo*, at Gothenberg, illustrating an episode in Guarino's play, *Il Pastor Fido*. This picture was painted for the Stadtholder of the United Provinces, Frederick Henry of Orange. The ambition to represent an assimilation of Titian's technique and an evocation of his poetry is particularly complete

Detail from
*Geronima Sale Brignole
and her Daughter*, n. d.
(see p. 54)

The Lomellini Family, 1625–27. Oil on canvas, 269.6 x 252.7 cm. National Galleries of Scotland, Edinburgh

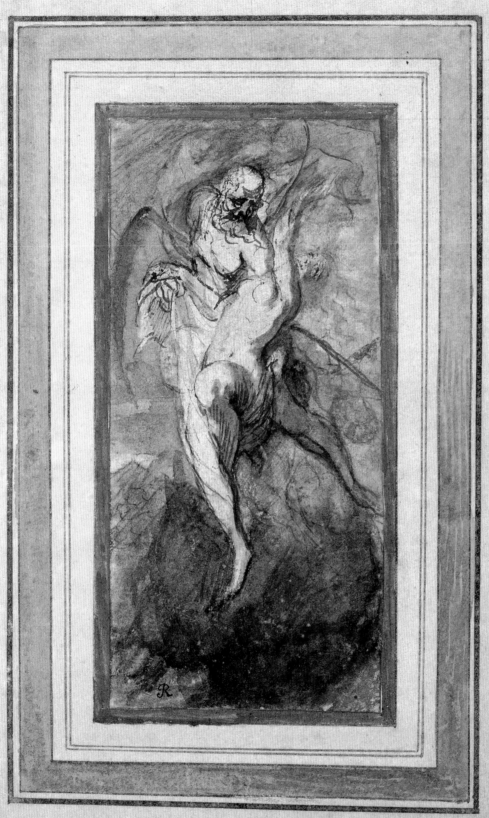

Van-Dyck.

Time Discovering Truth, 1632
Pen and sepia and sepia wash
over black and red chalk, 13.1 x 6.5 cm
The British Museum, London

here. A picture with which it bears comparison and which even more successfully does homage to Titian is *Rinaldo and Armida*. With his treatment of this theme, from Tasso's *Gerusaleme Liberata*, Van Dyck demonstrated in 1629 his credentials as a Titianesque painter to Charles 1 and received £78 reward for his efforts as noted in the royal Household Accounts.[9]

Van Dyck's drawings are remarkably rudimentary in comparison with his paintings. Flesh, colour, light and texture, which are so crucial to the effect, are achieved through other means than these quick notations. The softness of the flesh of cherubs and naiad, the glitter of armour contrasted with the gently silhouetting shadow on Rinaldo, the golden crepuscule and the florid silks are all recognisable from Titian's paintings, but here have other sources than Van Dyck's swift notes. There is memory, there are formulae and learned painterly gestures, and there is an imaginative assimilation of Titian's *poesie* (together with a certain agitation within the action generated by the tumbling compositional diagonal lent by Rubens). These no doubt guided Van Dyck's painting. But in addition he had continuous access to Titian's way of painting. Van Dyck collected pictures by Titian and other Venetian painters.

In his collection were, among the Titians, *The Vendramin Family*, in the National Gallery, London, and *Perseus and Andromeda* in the Wallace Collection. Tintoretto was also represented. An account survives of the collection while it was in Antwerp in 1631. Marie de' Medici saw it and her secretary reported the visit.[10] It was a valuable collection, and after Van Dyck's death, there was some irregularity around its dispersal, to the extent that the father of his widow petitioned Parliament to have works returned by people who had spirited them away.[11]

Man reaching forward, c. 1617–18
Black chalk with highlights in
white chalk on buff paper, 27 x 42.8 cm
Courtauld Institute Galleries,
Witt Collection, London

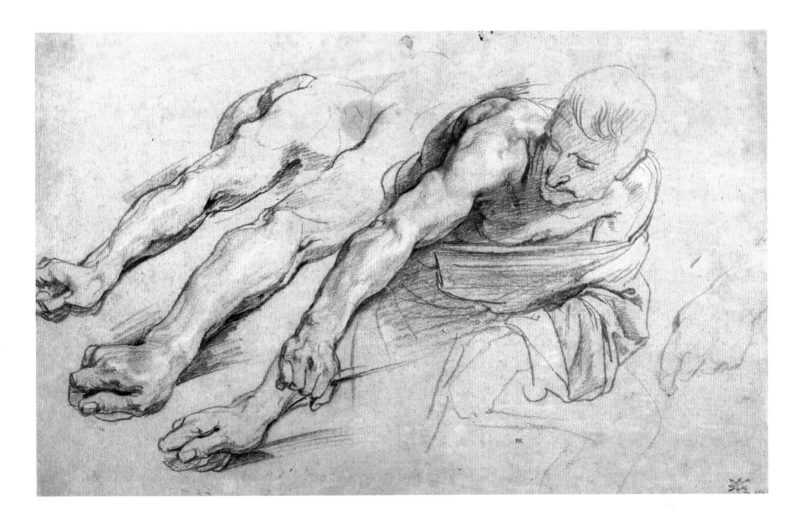

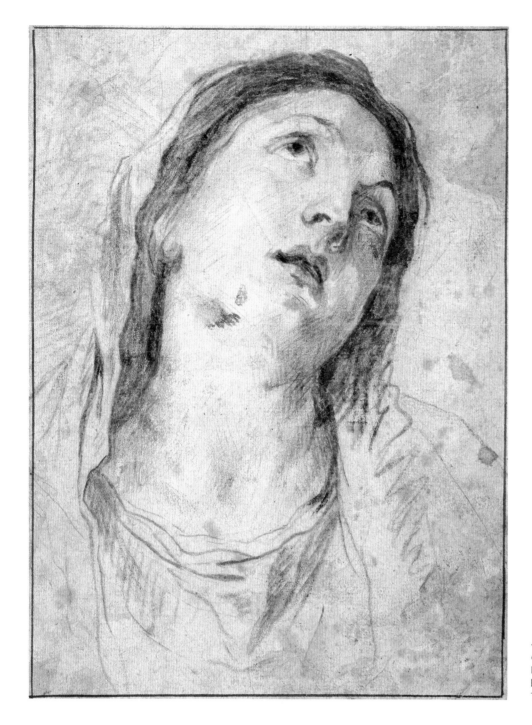

Study for the Head of the Madonna, 1622–27.
Red and black chalk,
border ruled sepia, 19.4 x 14.4 cm
The British Museum, London

When he was in Rome, Van Dyck went to the *Stanza della Segnatura*, in the Vatican Palace, and drew Raphael's *Disputa*. But this was a rare homage; his pilgrimage was not in search of the origins of the Raphaelesque tradition in painting. It was Titian and the Venetian tradition which drew him, almost to the exclusion of all else.

Titian had much to teach. In terms of technique, perhaps the most important thing that he did was to free pigment from its absolute subjugation to the thing to be represented. In Early Renaissance painting, while colours have some residual value in themselves, it is the increasing ability of the blue to turn itself so entirely into, say, the saint's mantle, or the green into the swathe of meadow, or the pink into the warmth of the flesh that was most impressive. Vasari's is the voice of that enthusiasm. To make the transfiguration of the base matter of painting into the universe of represented things was the wonderment of Renaissance naturalism.

Study for
Mary Magdalene, 1632
Brush in sepia over
black chalk, 26.2 x 15.7 cm
The British Museum, London

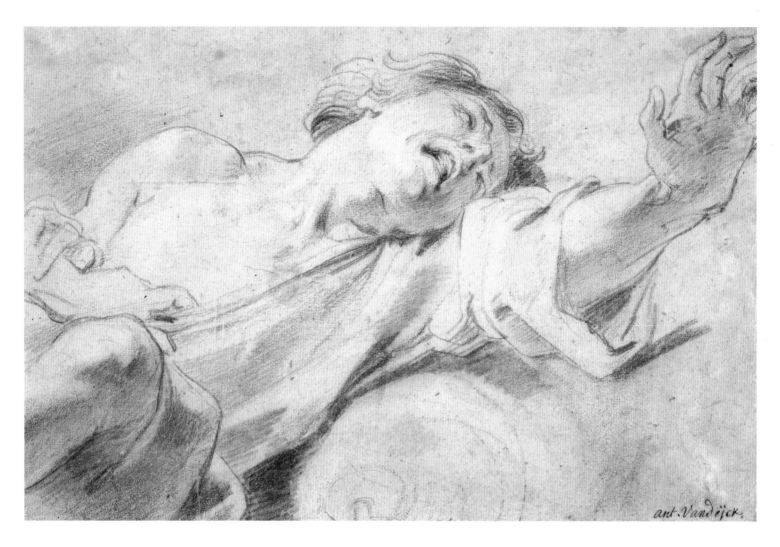

Study for Malchus, c. 1618–21
Black chalk, 24.5 x 37.3 cm
Museum of Art, Rhode Island School
of Design, Providence, Rhode Island
Gift of Mrs. Gustav Radeke

Perhaps, however, Titian retained a recollection of an earlier inconsistency within this system of representation. The gold background or accessories of the Late Medieval picture resisted this transformation. It could not represent, for it was ineluctably its material self. In Titian's painting, pigment represents, and does so marvellously, but it also remains itself, rather as the gold does. It is all a matter of viewing distance. There is a distance from the picture-plane for the viewer – it tends to increase with the size of the picture and Titian's age – at which paint and whatever it is that it represents oscillate. A dialectic between means and ends comes to the point here.

This liberation of paint, realised most clearly by Titian (though accomplished also with the aid of others' example, particularly Giorgione's) set him at the head of a tradition that has been vigorous in Western painting. A freedom is allowed to paint – but not license, for the freedom is always conditional upon its ability to return to its representational task. Perhaps the delight is similar to that of the musician, who is party to a strange alchemy whereby a thing can be denominated by a word, the word can be set in a poem, and the poem can be set to music and sung. Mere breath gives life to mute things. A similar Orphean process occurs within Titian's tradition of painting. An object is transformed into paint, and is then turned into what might be called a performance of painting. Titian, like Rubens and Van Dyck, makes it appear that the picture emerged out of an act purely of painting. It is so much of the moment that painting comes to seem a time-based medium.

Of course, in practice, all three artists planned and – a separable notion – rehearsed their paintings. Titian and especially Rubens drew prolifically. Roger de

Piles reported a conversation with a Cologne banker and amateur, Everhard Jabach, who recalled Van Dyck's working method in the portrait studio. Drawing played an important part in the practice. Sittings lasted an hour, during which, 'After having lightly sketched in the portrait composition, he had the sitter posed in the attitude that he had thought of earlier, and on grey paper with black and white pencils, in a quarter of an hour, he drew his figure and the details of costume which he distributed in a grand manner and with perfect discretion.'[12]

But the role of drawing was not a large one, and it did not cramp the performance. Palma Giovane's famous description of Titian's painting method also contains implications that making paintings was a matter of speed and spontaneous gesture, and capture.[13] The thing most worthy to be painted was the evanescent. Van Dyck's religious and mythological pictures, as well as much of his portraiture, aims at such effects. There is no contribution, for example, that drawing could have made to directing Van Dyck's efforts in representing the tossed locks of Cupid in the speed of his flight towards Psyche.

Such a chaos of marks reminds the viewer of the fact that vision is a remote sense. To get microscopically close might seem to offer the possibility of absorbing the object of curiosity or desire; but that ambition will always be thwarted. Van Dyck, like Titian, holds the observer at that distance at which the object is present to vision; any closer and vision of the object is denied, as if the clock had struck twelve and only mice and a pumpkin were left. Even Psyche turns into paint. Stand back sufficiently, and vision's deficiency as a means of possession or a faculty of understanding makes itself known.

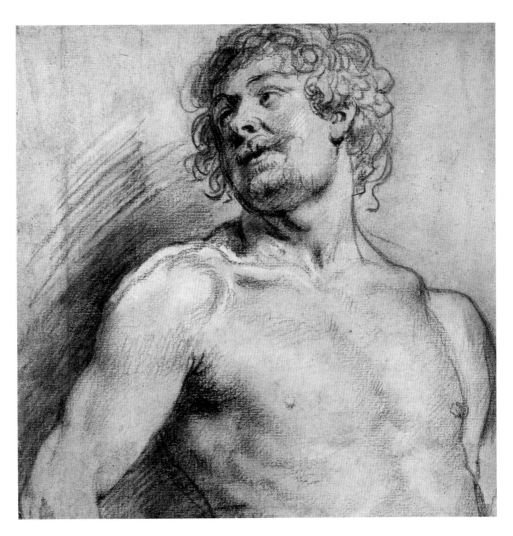

Half Length Figure of a Nude Man, n. d.
Black chalk touched with red,
24.3 x 24.5 cm
Ashmolean Museum, Oxford

Detail from
Cupid and Psyche,
1638–40 (see p. 91)

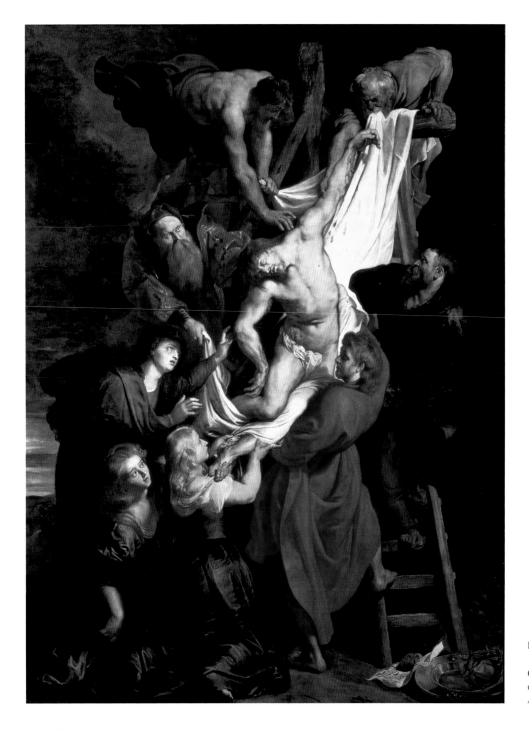

Peter Paul Rubens
The Deposition, 1611
Central piece in triptych,
oil on panel, 420 x 310 cm (whole)
Antwerp Cathedral

Painting that would emulate Titian attempts to catch the sensational aspects of things. What painting, as an art, shares with objects of sensation is visibility; and vision is in the first instance the experience of being bombarded by stimuli of colour. Rubens attempted to evoke all the senses in his work. It is enough to refer to the grimy, bruised and bloody foot of Christ touching the pale skin of the Magdalen's shoulder in his 1611 *Deposition*. But the important thing for him is the engagement of the senses. The role of the eye in the context of painting is self-evident.

At the same time, there is another kind of painting that attempts to fix the significant. If a kind of abstraction of the visual from the matrix of recognition and reasoning characterises the painting of sensation, another kind of abstraction is involved here. It is to remove painting from the conditions of confusion and partial

*Studies for a
Lamentation*,
c. 1627–30
Black chalk with
white highlighting,
on blue paper (faded
to greenish-grey),
53.3 x 45.1 cm
The British Museum,
London

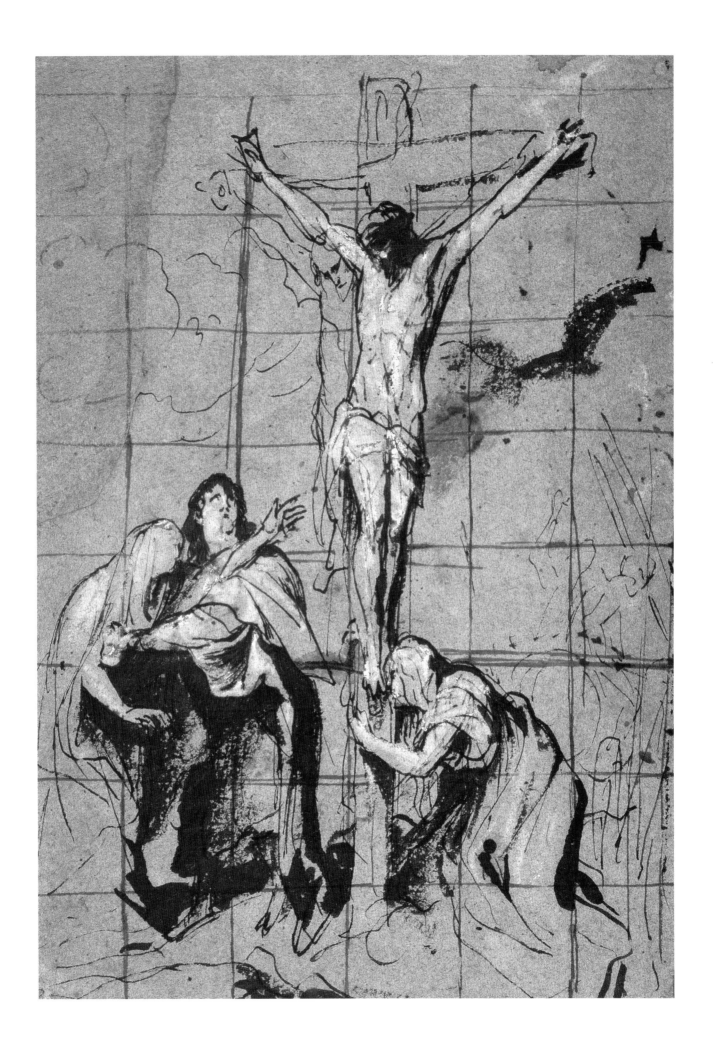

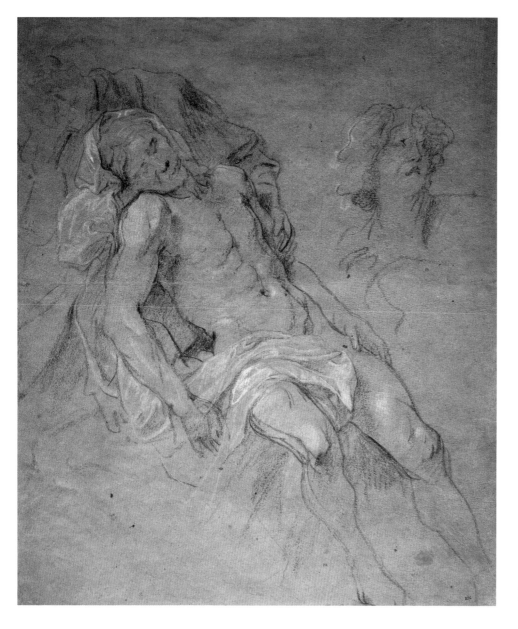

*Studies for a Painting
of the Crucifixion*, n. d.
Pen and brown ink over black chalk,
with brown wash, 30 x 25 cm
The British Museum, London

knowledge that experience, as opposed to thought, presents. The basis of the division between these two kinds of painting is the belief that thought and sensory experience are enemies, and it was one that hardened into the debate later in the seventeenth century between 'Ancients' and 'Moderns', or proponents of *disegno* versus those of *colorito*.

The tradition of Titian, inspiring the work of Rubens, was given the name 'Rubenist', and was the banner of those who argued for colour, a shorthand term referring to what was involved in sensation: a reception of experience rather than an imposition of order. The opposing tradition was called 'Poussinist', after Nicolas Poussin (1594–1665), who traced an artistic lineage to Raphael. The accidents of appearances were regrettable to the ideology of Poussinism. Painting was capable of disclosing to the viewer perennial truths in their stead. These included objects clearly distinguished by species and genus. Drawing, as an act corresponding with definition in the same way that the philosopher understood it, was the key to this kind of painting, and to this system of value. Thus Design, thought of as drawing put to the task of establishing the parts of the definition of an object, was the by-word of the rationalist art of the Poussinists, opposing the sensationalist art of the Rubenists.

The Crucifixion,
c. 1627–30
Pen with brown ink
and brown wash,
with highlights in
white bodycolour
on blue-grey paper,
27.1 x 19.5 cm
The British Museum,
London

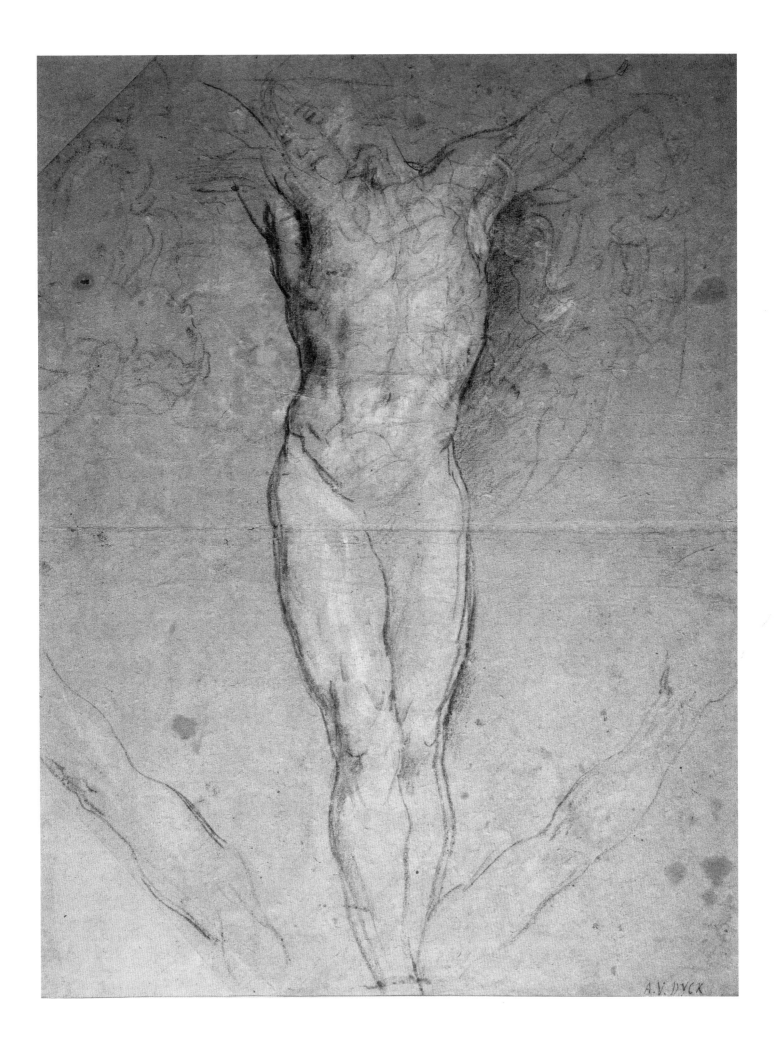

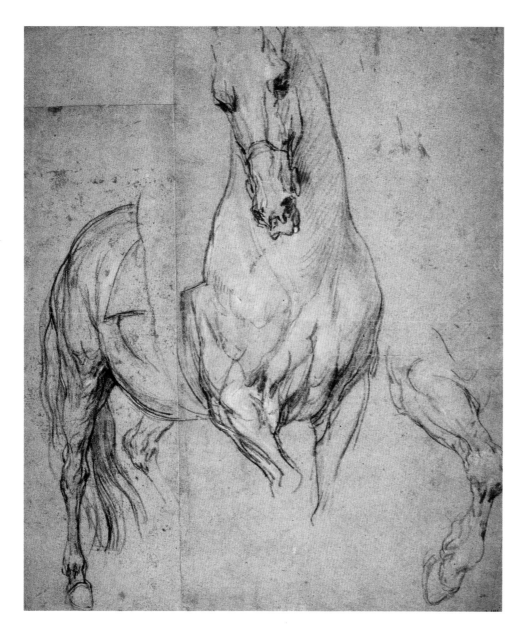

Studies of a Horse, 1633
Black chalk, with white chalk highlights,
on blue paper, 42.9 x 36.6 cm
The British Museum, London

Such ideological debate of course caricatures its heroes. Titian and Rubens were not so tendentious in their celebration of the sensational in the world. And Poussin, especially as a young man, was clearly an admirer of Titian. Van Dyck, however, can be claimed to belong unequivocally in the one camp. Whereas Poussin would construct a religious or mythological picture as a preacher would a sermon, analysing the event to be discussed and working out the moral, Van Dyck's painting in these genres appeals emphatically to the observer's non-rational faculties. This was a point grasped by Abraham Crowley in his poem, *On the Death of Sir* Anthony Vandike, *The famous* Painter. He wrote:

> His all' resembling Pencil did out-pass
> The mimick Imag'ry of Looking-Glass.
> Nor was his hand less erring then his Heart.
> There was no false, no fading Colour there,
> The Figures sweet and well-proportion'd were.[14]

'Colour' is to be understood here in more than its prosaic sense. The idea is that there is something that plays directly upon the apparatus of sentiment, and that is something that is experienced as sensation.

In the seventeenth century, particularly in the Low Countries, there was a trend towards generic specialisation among painters. And, of course, there was a hierarchy: history painting was superior to portraiture, portraiture to landscape and so on. The most eminent painters, however, were not party to the trend. Rubens, the greatest painter in Flanders, worked in all these genres, as well as in that hybrid one where mythology, portraiture and religious painting meet, represented most famously in the *Life of Marie de' Medici* cycle. Of his principal assistants, Jordaens worked as a history and portrait painter, and Frans Snyders (1579–1657), as a

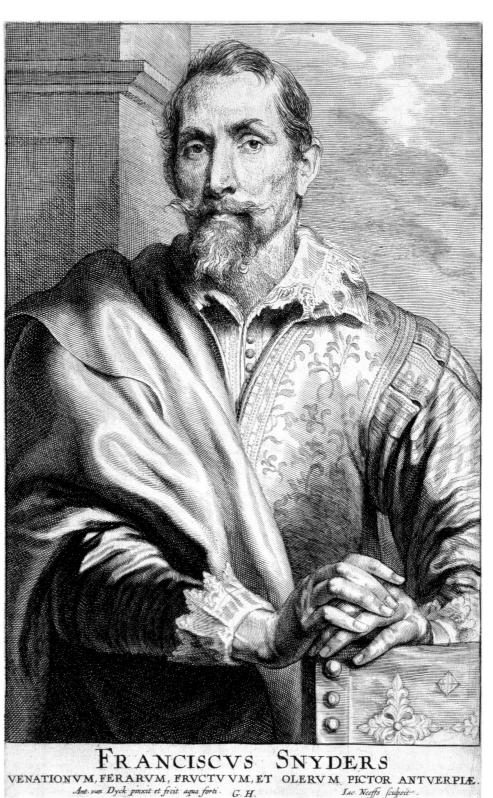

Frans Snyders, 1627–35
Engraving, 24.4 x 15.6 cm
The British Museum, London

FRANCISCVS SNYDERS
VENATIONVM, FERARVM, FRVCTVVM, ET OLERVM PICTOR ANTVERPIÆ.
Ant. van Dyck pinxit et fecit aqua forti. G. H. *Iac. Neeffs sculpsit.*

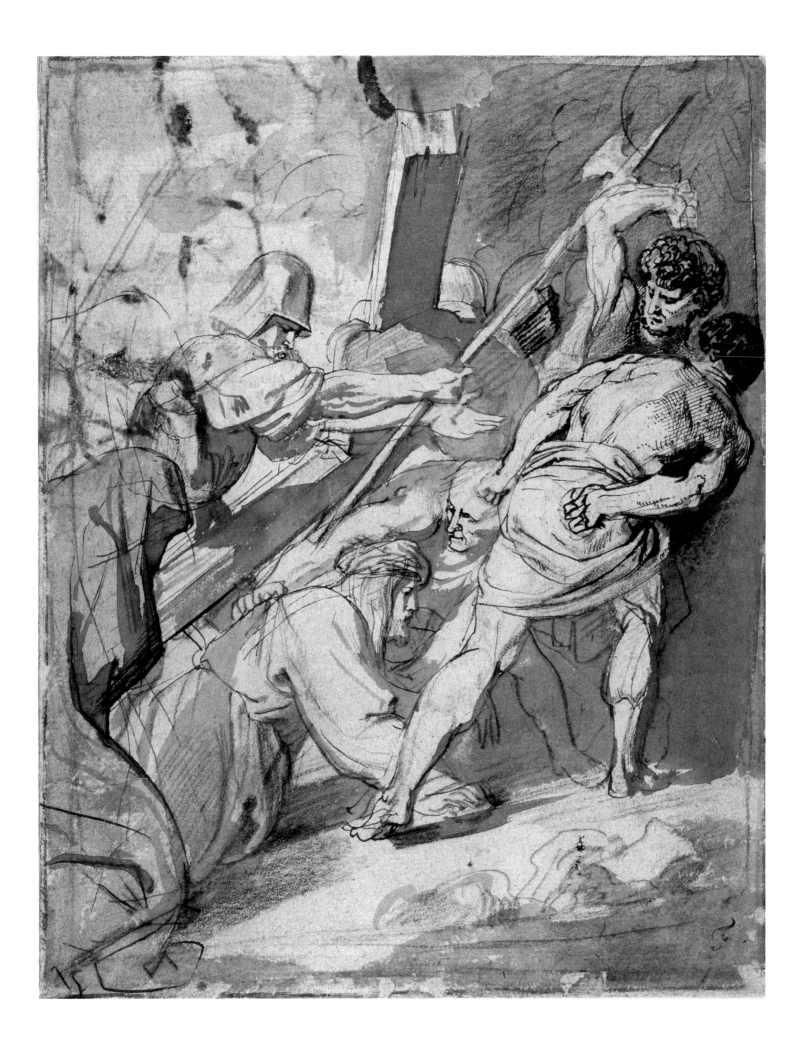

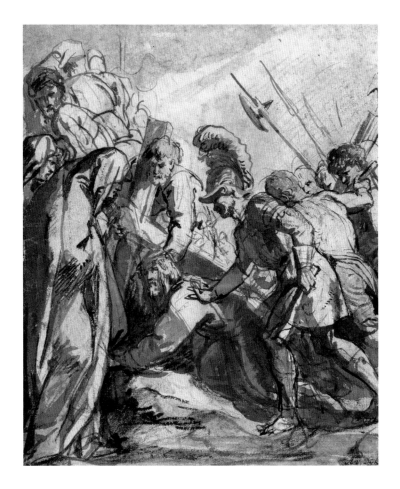

painter of hunting scenes and still life. And Van Dyck was ambitious to be a history painter as well as a portraitist on the grandest scale. *The Garter Procession* which, around 1639, he hoped to create at the Mortlake Tapestry works for Charles I, would have been a vast undertaking, as would have been the Louvre decorations which Louis XIV was planning in 1640.

From the beginning Van Dyck painted mythological and religious subjects. While few portrait drawings in chalk on grey paper survive – perhaps they were usually destroyed in the process of transferring their information to the canvas – large numbers of drawings connected with history-painting projects do. One of Van Dyck's earliest large religious works was *The Carrying of the Cross*, painted for the Dominicans of Antwerp and in the church of St Paul's. Bellori dates this picture – '… the said work adheres to Rubens' early style' – to immediately after his quitting Rubens's studio.[15] Van Dyck worked out his treatment of the subject through drawings, ten of which survive. In the drawing at Chatsworth, his thoughts turned upon the arduousness of the climb and the dragging of burdens, those of the protagonists' own bodies, of Christ, and of the Cross; the strong diagonal of the figure composition entwined about the geometry of cross and spear left ample room – more than in the final picture – for ground. In the idea of the ascent of Calvary, the terrain is a protagonist too. Another thought generated the drawing at Providence, Rhode Island; it was of the encounter of Mother and Son. But the diagonal of the composition rose to the standing Madonna, her head as it were the goal of the ascent. This was an incoherent concept made the worse by the Roman officer occupying the centre of the picture plane, but without anything very clear to say for himself. The solution that Van Dyck arrived at and which is represented in the squared-off drawing at Antwerp combined both ideas. What was necessary to achieve it was that the Madonna should be shown to be following Christ – not

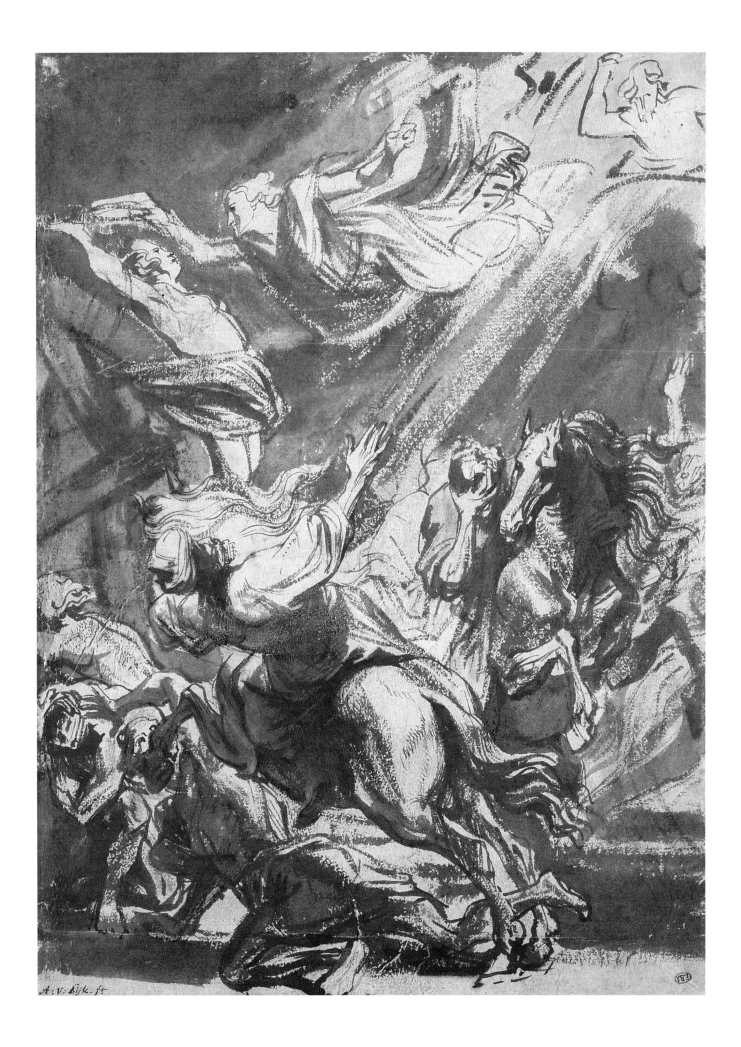

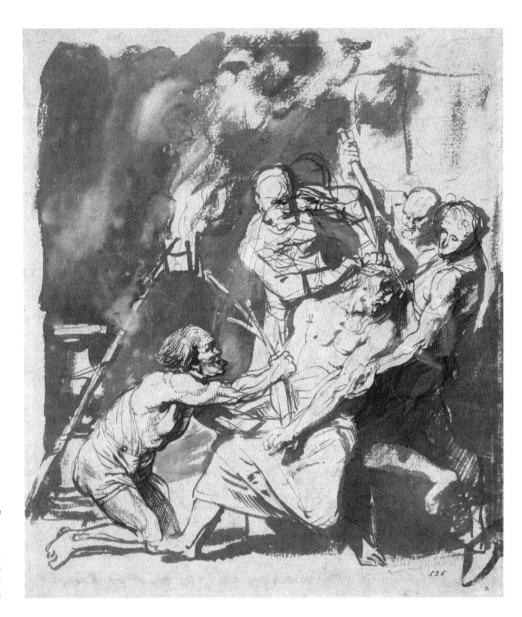

The Crowning with Thorns, c. 1618–21
Pen and brown ink, with brown wash, 23.9 x 20.8 cm
Victoria and Albert Museum, London

Martyrdom of St Catherine, c. 1618–21
Pen and brown ink, brown wash over black chalk, 28.5 x 21.0 cm
Ecole Nationale Supérieure des Beaux-Arts, Paris

having arrived at any point before him – and to be downhill from him. Christ needed to be made to look back, and upwards on the diagonal line of vision and emotion – a line counter to the diagonal thrust of wood and flesh going to the top of the hill. In the final picture, the idea of ascent was played down, with the dawn-lit horizon set just half-way up the picture-plane, and Christ looking up and backward at his mother from out of a bleak darkness.

As Van Dyck's thinking here evolved, there remained a constant; the formal idea that he surely owed to Rubens in the first instance. It was the diagonal, a recurrent device in Rubens's work, lending disequilibrium to composition and drama to narrative. Anyone could see its force in the Cathedral in Antwerp, in the *Raising of the Cross* and *The Deposition*. Reason has no place in events – for protagonists or observers – when the authority of the law of gravity does not prevail. And so a pictorial drama of sensation forestalls reason and presents the heightened spectacle appropriate to Christ's tragedy and to divine intervention, by the orchestration of tilted forms. Van Dyck's drawing for the *Martyrdom of St Catherine*, for example, is a riot. It is a Road to Damascus – an event about being thrown off balance – for the whole multitude attending the scene when the clouds part and the angel with the palm of victory and crown of triumph comes down to the saint. The force of the apparition causes everyone and everything to fall out of plumb.

41

Van Dyck's thinking about the theme of the Martyrdom of St Catherine was still at an early stage here. There is no painting of the subject in his *œuvre*, so it may be an idea for a commission that was never finalised. Finished story pictures, on the other hand, for all that the painting method pretended otherwise, required careful planning. The dramatic theme within the larger story had to be decided upon and a composition had to be assembled; detailed studies of elements might have to be prepared for assistants to transfer to the canvas. In the case of *The Crowning with Thorns*, a version of which is in the Prado, drawings connected with the several stages of preparation of the final picture survive. In the drawing in the Victoria and Albert Museum, Van Dyck was thinking in terms of dramatic narrative. He shows Christ recoiling or fainting away into a compositional diagonal, propped up by his tormentors, one of them, by dramatic irony, anticipating within the Christian narrative the action of St John in receiving the body of Christ in Rubens's *Deposition* in Antwerp Cathedral. But, in this staging, it seemed that Christ was resisting his tormentors. If he would do that, he would forfeit his pathos as Man of Sorrows. Van Dyck therefore shifted Christ onto axis and towards the iconic vertical that the theme traditionally dictated. He maintained emotional narrative within the image by displacing Christ's head and crossed wrists with regard to the vertical axis, and by assembling about him a Caravaggio-like group of tormentors.

Van Dyck's sense of the drama was intimately connected with his recognition of the essential asymmetry of life. His orchestration of narrative often underlines the idea, for a corroborative action frequently enlivens a secondary part of the composition. For example, in *The Martyrdom of St Sebastian*, a detail of action between assassin and victim right over at the left-hand side of the picture throws the composition quite out of balance during the time that the observer ponders it. St Sebastian's open hand is on the point of being grasped by the assassin. Perhaps at an earlier stage in the evolution of the narrative, the assassin's other hand was supposed to be holding the saint's other hand behind his back; but by this stage, a certain comradely concern is indicated by the arm about the saint's shoulder. An ambiguity now marks the interaction of hands, for the assassin's hand retains a claw-like and somewhat ferocious quality at the same time as the imminent holding of hands bespeaks a more tender human bond. Hands also conduct an eloquent secondary dialogue in *Susanna and the Elders*. The older man, using his middle finger, toys obscenely with Susanna's bare shoulder whilst she – in what can be read as ironic inversion of the iconographic type of the Madonna della Misericordia who opens out her arms to cover the faithful beneath her mantle – stretches out her arm to draw her drapery over her and attempts to cover her naked breast with her other hand. Intriguingly, there seems to be a recollection here of Leonardo da Vinci's *Adoration of the Magi* and *The Virgin of the Rocks*.

The reason why history painting – that is, narrative painting of religious, historical and mythological scenes – was the genre held in highest esteem was because it was the most difficult. The more the aim is to affect the audience to the greatest degree, the more disastrous is the effect of a false note. At the same time, the more elements of characterisation, spectacle and plot contribute to the affecting whole, the more distracting from the emotional purpose of the exercise is an ill-integrated detail of form, content or expression.

Van Dyck set himself against the stiffest competition when he took on the subject of Samson and Delilah. Rubens had painted the subject soon after his return from Italy in 1609, and Van Dyck was able to see it in the house of Nicolaes Rockox,

Susanna and the Elders, n. d.
Oil on canvas, 194 x 144 cm
Alte Pinakothek, Munich

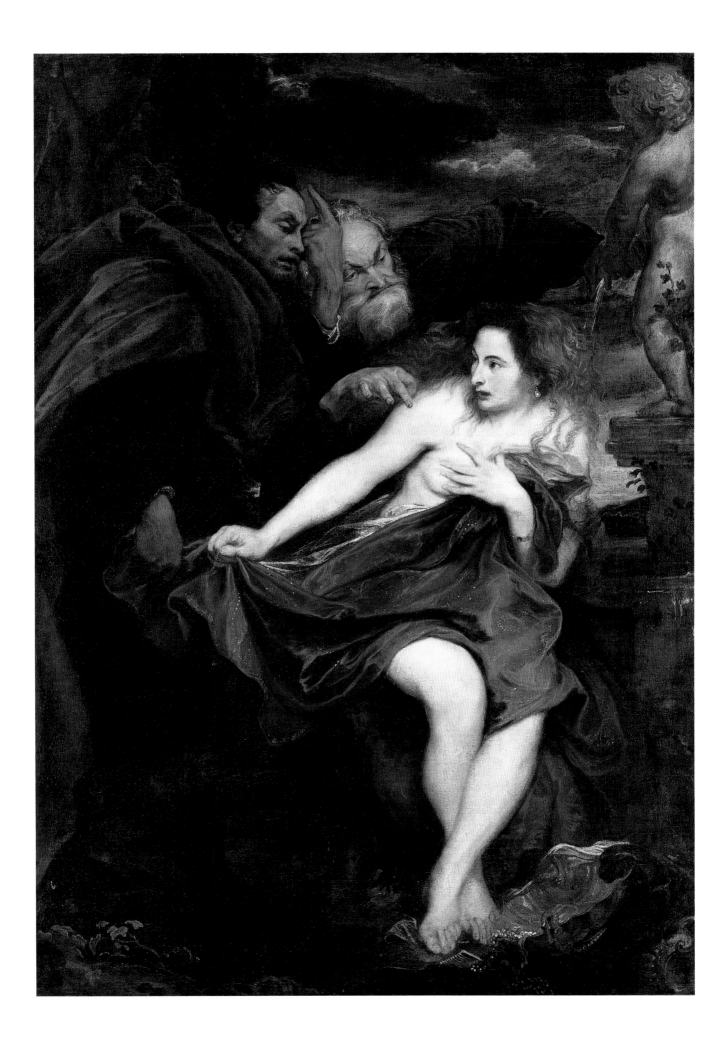

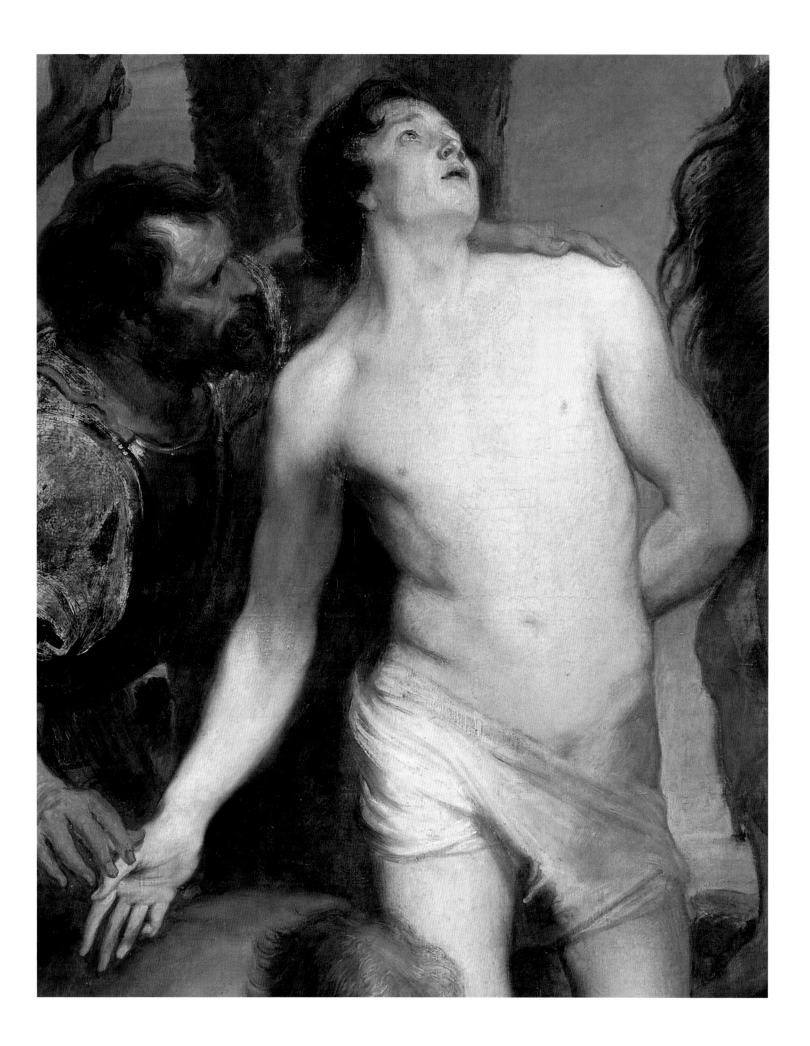

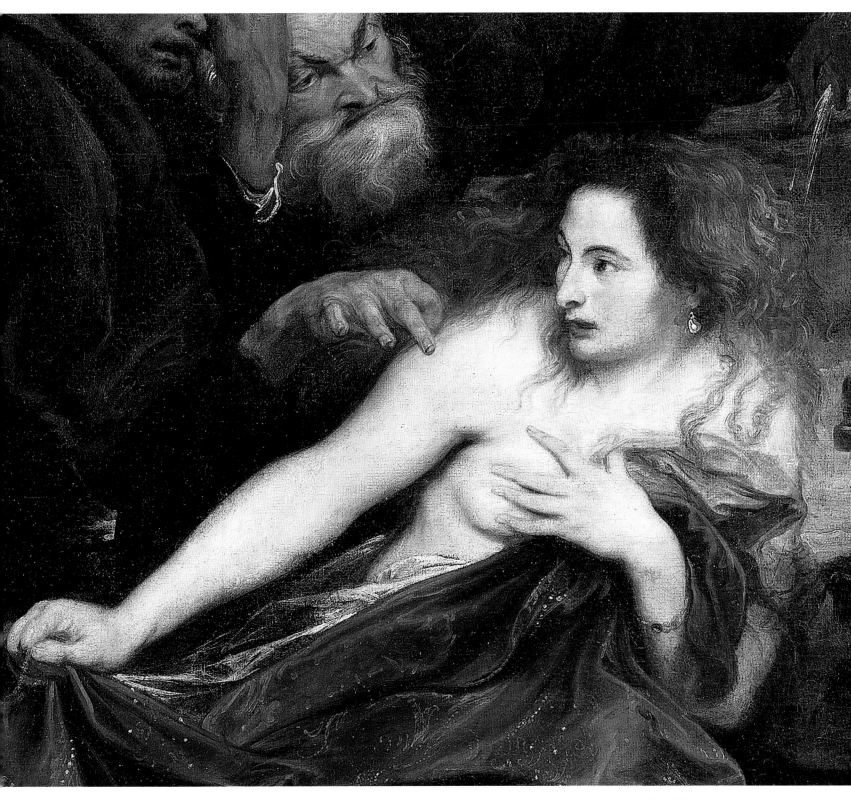

Detail from *Susanna and the Elders*, n. d. (see p. 43)

Detail from
*The Martyrdom of
St Sebastian*, 1619–20
(see p. 46)

45

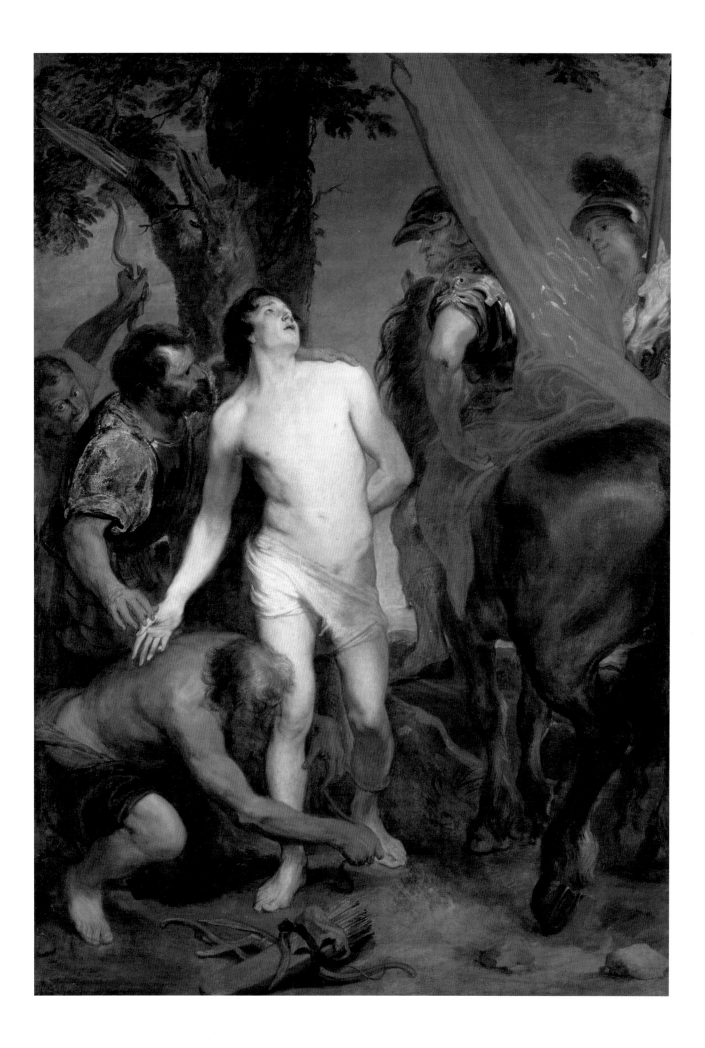

the mayor of Antwerp. In Van Dyck's squared-up drawing Delilah raises her mantle from the head of the sleeping Samson in her lap and raises her finger to her lips, calling for hush from her attendant and the man who is about to cut his hair. In the final picture she lowers her hand slightly so that the gesture visibly rather than aurally enjoins silence upon the two attendants who peer over her shoulder, one with her hand silhouetted against the blue sky, registering her sense of the tension of the moment. The soldiers who will capture Samson when he is deprived of his strength did not appear in the drawing; but at last they lurk beside a pedestal in the background behind the shearer, who now lifts, as delicately as he can, a lock of Samson's hair. There are various other differences, but the principal one is that Van Dyck has moved the action on a small but significant amount from what is shown in the drawing. It is closer to a cliff-hanger.

Resemblances between Van Dyck's treatment and Rubens' are clear to see. But, in the comparison, how much more Rubens has thought of in his composition. The tension of the action revolves around the need for Samson's sleep to be undisturbed. Where Van Dyck has thought of sounds and gestures, Rubens's huge imagination has arrived at the thought that Samson's continued sleep depends upon Delilah's avoidance of the temptation to break the spell. So, her hand continues to repose upon his back. To locate the act of betrayal in this passive and once-loving gesture is a feat of imagination that moves at the same time as it awes the observer. Van Dyck's sheep shearer lumbers in and he attempts a delicacy of action for which he is ill suited. This is not a bad idea. Perhaps Van Dyck lacked the confidence to emulate Rubens's idea. The dramatic focus of Rubens' picture is the convoluted action of a hairdresser's hands. Clumped at the left side of the stage is a conspiracy of effeminacy. Rubens had had the wit to cast a professional for the part. Silence and sleep are at the core of the action, but Van Dyck's picture lacks the visual quality of silence. That Samson should be asleep during the day is perhaps a mismatch of environment and action. Rubens, however, has a temporal and painterly corollary for silence; it is the dead of night, and where there is illicit wakefulness, there are flickering candles and torches, agitating the action.

Van Dyck continued to be a history painter, but his reputation rests upon his portraits. Critics recognised his relative failure in history painting and offered hints of explanation of it. Of course, it could be a very good history painter who was still not as good as Rubens, and Van Dyck's merits are not being denied here. But Roger de Piles pointed to a serious deficiency in Van Dyck himself when he compared him with Rubens as a history painter. He wrote: 'His mind was not of so large an extent, as that of *Ruben's*. His *compositions* were full, and conducted by the same maxims, as were those of *Ruben's*; but his *Invention* was not so learned, nor so ingenious as his Master's'.[16] In other words, Van Dyck fell short in imagination, education and intelligence. Bellori compared him with Rubens and Titian: 'Indeed, he did not have such extensive powers of invention, nor did he have as much feeling or ease in treating elaborate and grand themes. He pursued the greater rewards of portraiture, in which he was out on his own, and sometimes on a par with the marvellous Titian himself.'[17]

There is a slightly sour note in the writings of Bellori and Roger de Piles on Van Dyck. They make sure that they do not hide their criticism too deeply beneath the surface of praise. They hint that he was showy, acquisitive and a bit too ambitious. Bellori likened him to Parrasius, an ancient painter famous for the ostentation of his way of living: 'He vied with Parrasius in magnificence, keeping servants, carriages, horses, heralds, musicians and jesters'.[18] He also compared him to Zeuxis in

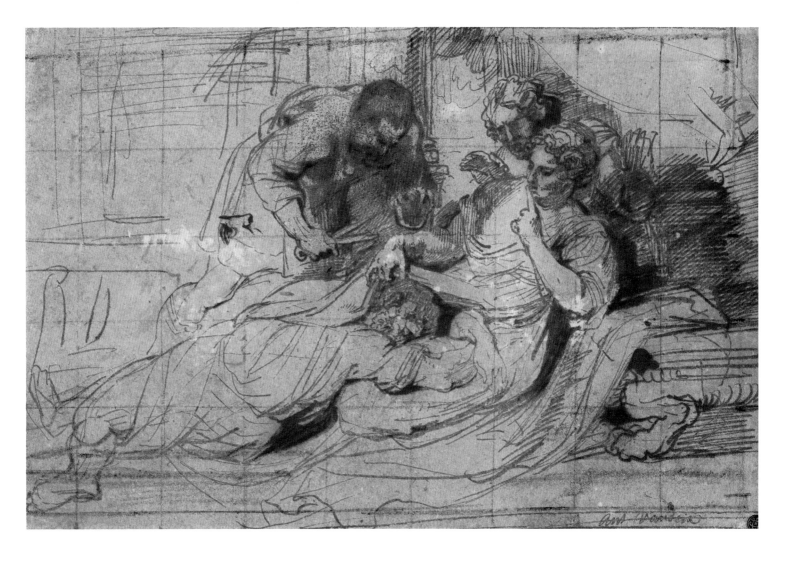

similar terms: 'So, by imitating the pomp of Zeuxis, he attracted everyone's eyes'.[19] In England, 'with the departure of Rubens, Van Dyck succeeded ... and rewards and riches increased at the same time, to fund the ostentation of his way of life and the splendour of his deportment'.[20] Roger de Piles implied a somewhat reprehensible pragmatism in Van Dyck's shift to portraiture. In Flanders, he painted histories, 'but believing he shou'd be more employ'd in the Courts of foreign Princes, if he apply'd himself to *Painting after Life;* he resolv'd, at last, to make it his chief Business, knowing it not only to be more acceptable, but the most advantageous part of his profession ...'.[21] The pursuit of fame was laudable, so long as it was by meritorious conduct; but to trim one's ambitions to the lofty art of history painting for the material advantages of being a portrait painter was clearly somewhat ignoble.

A more grievous vice than vanity and pragmatism, from the point of view of the lover of art, was one that was revealed by the shortcomings of his history painting. Bellori wrote: 'In history painting however he revealed himself to be inadequate and insecure in drawing, nor did he arrive at an idea of the whole, since he was lacking in this respect and in those others that are necessary for the interconnectedness of the parts.'[22] His failings were in *disegno* and *idea* – crucial concepts in seventeenth-century art theory.

The education that Van Dyck sought by his travels, should have provided him with these things as, clearly, in the estimation of his critics, they had equipped Rubens. But he had neglected the important part of his education. Bellori wrote: 'Certainly, he had not come to Rome to study'.[23] Instead, he had come to Rome to

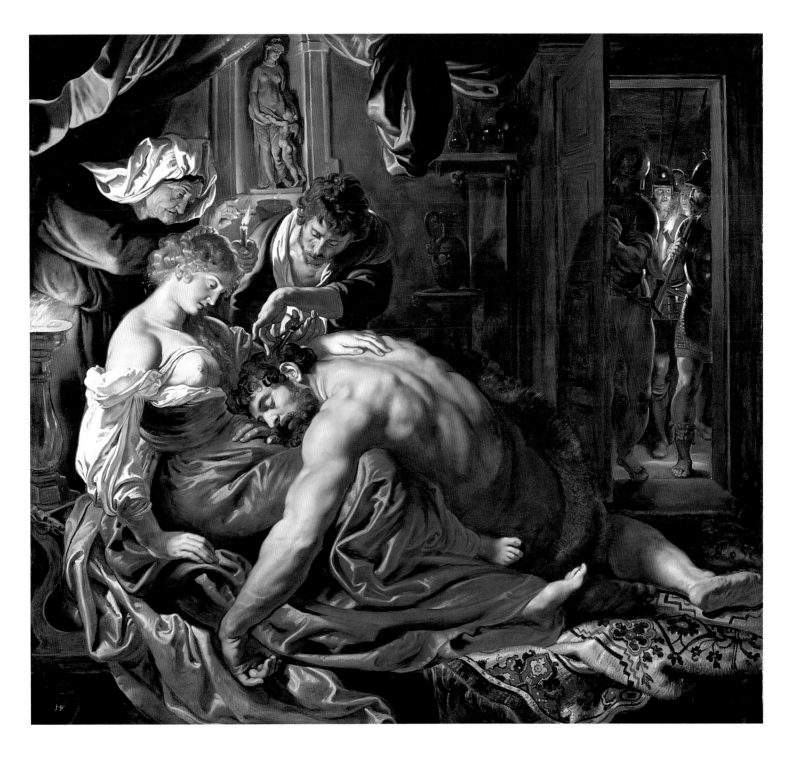

Peter Paul Rubens
Samson and Delilah, c. 1609
Oil on panel, 180 x 205 cm
National Gallery, London

tout for business. Van Dyck's compatriots disapproved of him for this reason and, 'criticising him because he could not draw and could not even paint a head, they ridiculed him, so that, dispirited, he left Rome.'[24] Joachim van Sandrart took up the same theme: 'The rules of painting held in esteem in that town [Rome], the academies, that is to say studies made in a group after the antique or after Raphael, or other serious studies, did not interest him and it is for this reason that after a short time he returned to Genoa'.[25]

There is some truth in the accusation that Van Dyck's history painting suffered as a result of his indifference to what Rome had to teach. He did not draw after the antique and, as has been seen, the drawings of his Italian Sketchbook were not close studies and lengthened meditations upon what he saw but mere *aides-mémoires*.

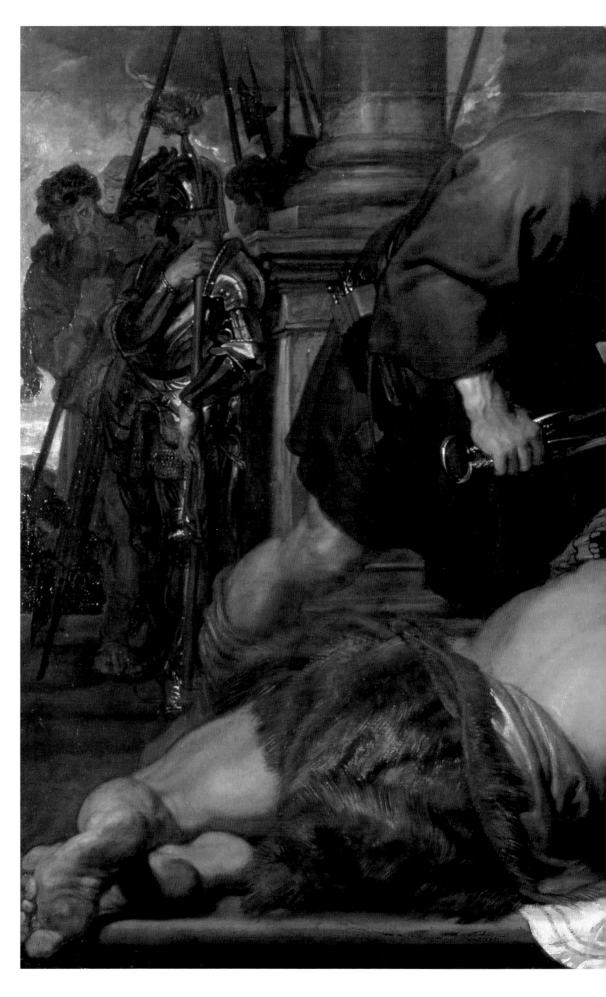

Samson and Delilah, 1618–20
Oil on canvas, 149 x 229.5 cm
Dulwich Picture Gallery, London

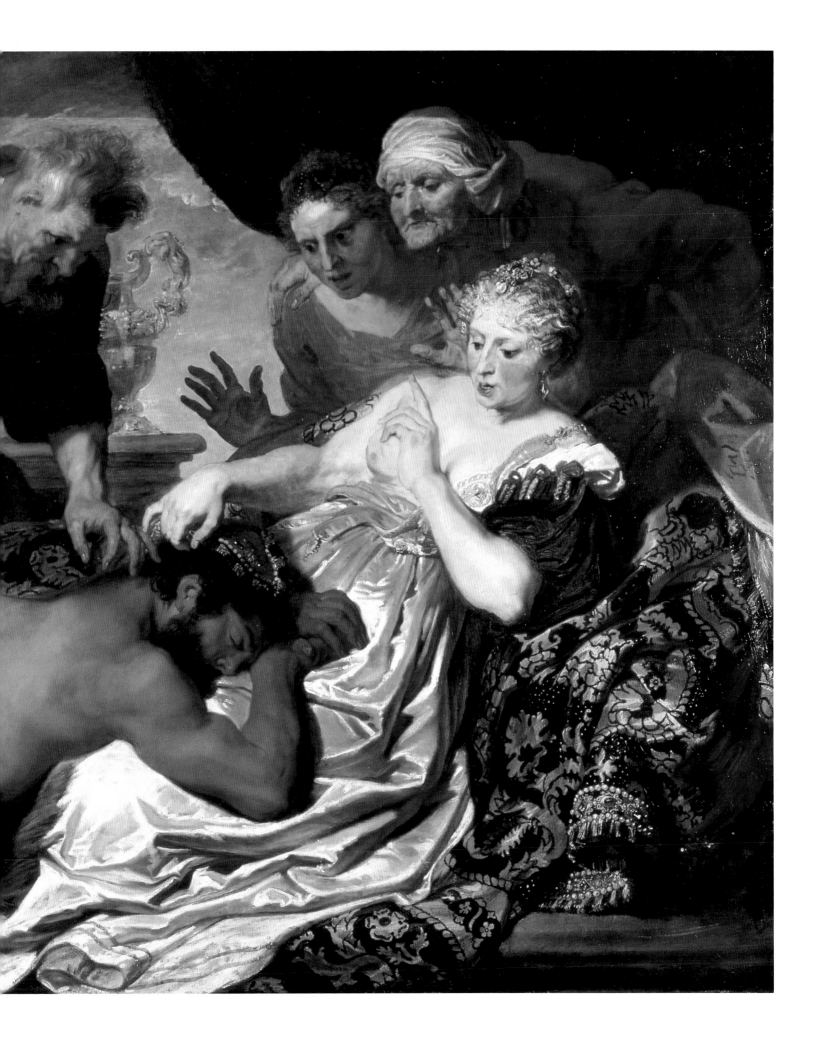

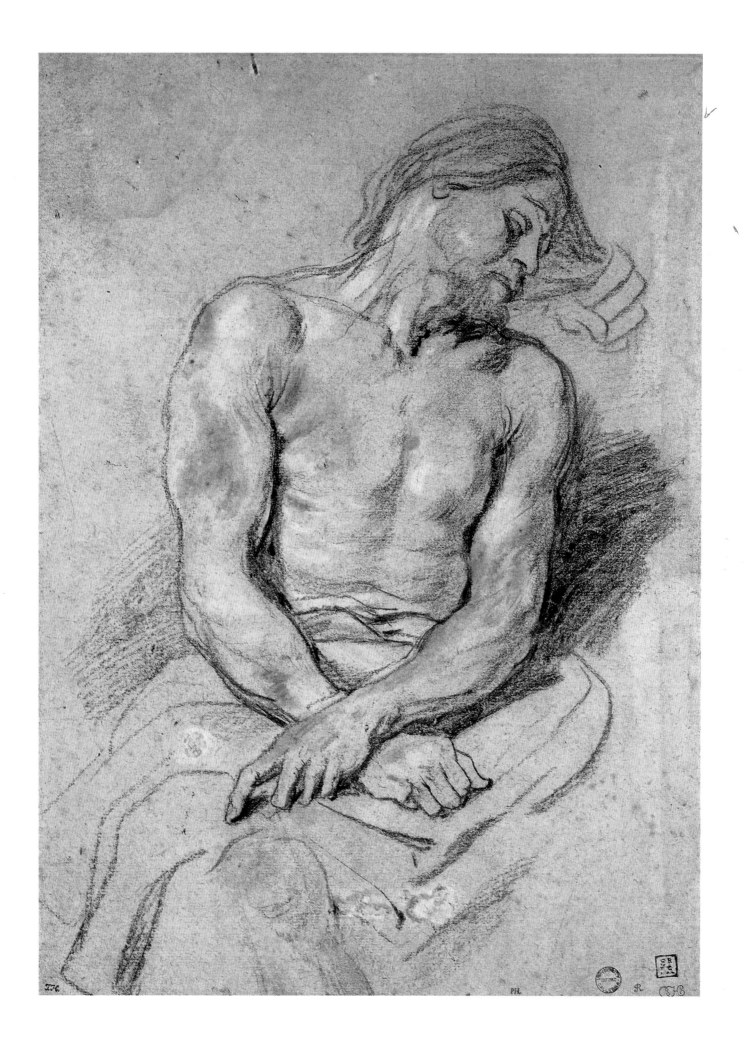

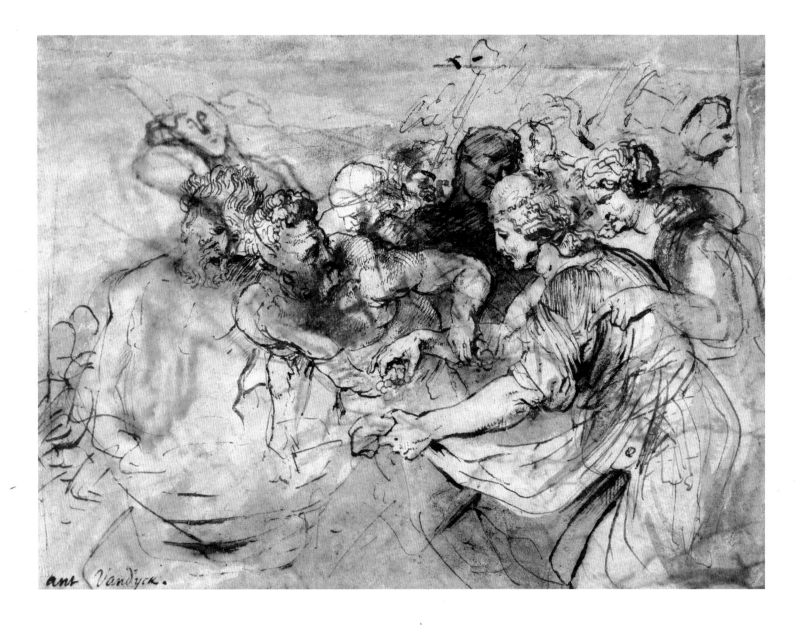

Bacchanal, 1618/20
Pen and sepia, washes of sepia
and blue watercolour, 16.3 x 22.1 cm
The British Museum, London

Christ Mocked
(Study for
*The Crowning
with Thorns*),
c. 1618–21
Black chalk highlighted,
with white chalk, on white
paper (which has been toned
light rose-brown), 37 x 27 cm
Ashmolean Museum, Oxford

Disegno and *idea* are to be got through assiduous study. Van Dyck did not develop an elaborated sense of the ancient epoch: in fact only one drawing by his hand after the antique survives, and that is a casual sketch of Diogenes, a seated and clad figure in the Italian Sketchbook. He did not put himself in the way of appreciating the totality of the human figure as an expressive thing. If he had looked to ancient statuary or the work of Michelangelo or Raphael's painting, these could have demonstrated to him that the greatest and most convincing emotions belong to those whose parts in action are most assuredly connected. Not to have drawn the *Laocöon* was a serious neglect of education.

Of course, the soul moved the body. But that was only axiomatic. Van Dyck was content, like the Tenebrist painter, to express the idea by the juxtaposition of things – heads and hands for example – rather than by drawing and understanding the ligatures of will and sensation that connect them. In his portraiture, cloaks and swathes of occluding drapery frequently serve the staccato function of Tenebrist shadow. Van Dyck's people were not always of a piece. Christ's head, in *The Road to Calvary*, is not joined to his body.

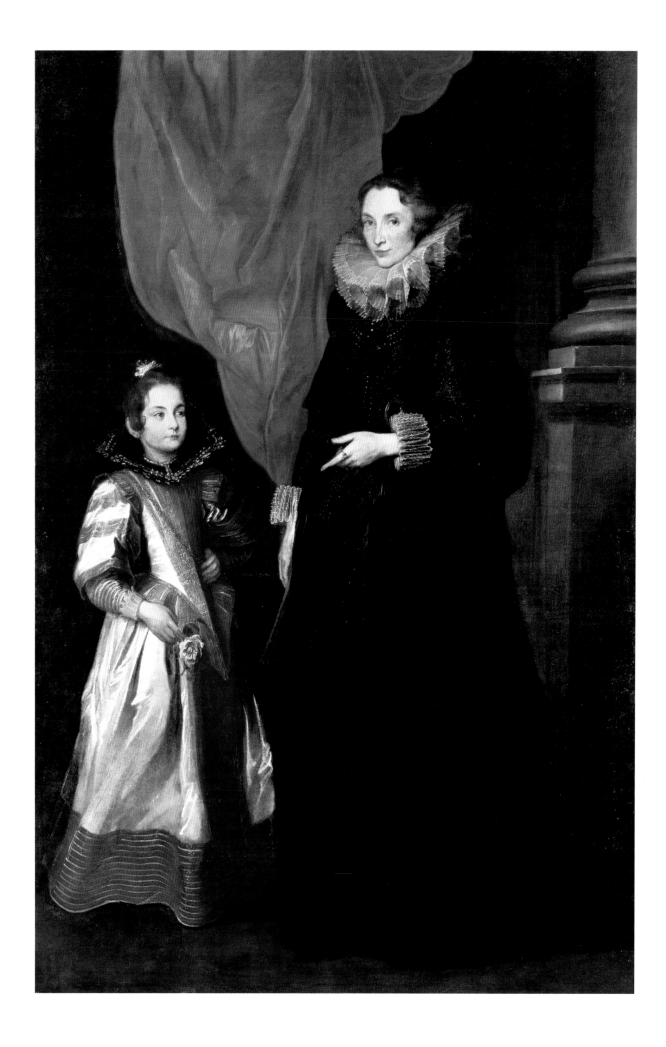

Movement and Destiny

Van Dyck as a Portraitist

In his monograph on Van Dyck, Christopher Brown refers to a guidebook to Genoa of 1780. Ninety-nine paintings by Van Dyck were listed, seventy-two of them portraits.[26] Here is a measure of the predominance of portraiture in Van Dyck's *œuvre*. The seventeenth-century biographies emphasise the huge success that he had as a portraitist in Antwerp, Genoa, Rome, Venice, Palermo, Brussels and London. Bellori proclaimed him the greatest portrait painter since Titian. Clearly, there was a universal recognition of his brilliance. But in what did this brilliance consist?

In the first instance, the portrait must have likeness. Van Dyck was acknowledged as a capturer of likeness. However, he did not supply it in the somewhat restricted way of, say, Holbein, who was described by the English ambassador in Brussels in his day as 'very excellent in making physiognomies'.[27] Such a skill does not distinguish the product of the painter from that of the maker of life-masks. For all that, a likeness is an impressive thing when achieved merely by the artist's skill. On this basis alone *The Jeweller Pucci and his Son* is transfixing. Memory in its most purified form is of something absolutely specific, and one of the most potent mythological accounts of the origins of painting connects likeness and remembrance. The story is of a certain Maid of Corinth whose lover was being called away to the wars. She traced his profile by his shadow cast on the wall by a candle. The more specific and detailed the trace, the more effective her recollection of him and the truer the token. In this tale, the painting has something of the quality of a relic, for presumably the Maid also kept a lock of his hair.

As well as making likenesses in the sense of Holbein and the Maid of Corinth, Van Dyck also did so much more. For that reason, there is a certain amount of rhetorical vapidity in the poem of Abraham Crowley where the painter is praised for making portrait and sitter as like as two peas. But there is surely expression too in the poem of part of the reason for Van Dyck's reputation as a portrait painter:

> Nature herself amazed, does doubting stand,
> Which is her own, and which the Painter's Hand,
> And does attempt the like with less success,
> When her own work in Twins she would express.
> His all' resembling Pencil did out-pass
> The mimick Imag'ry of Looking-Glass.[28]

A way to evaluate Van Dyck 'in making physiognomies' is to consider an instance where another painter also portrayed his sitter. A useful case is Cornelius Johnson (1593–1661), who painted *Thomas Hanmer*, in the National Museum of Wales. Van Dyck's portrait of him is at Weston Park. Obviously, Van Dyck's *Hanmer* convinces the viewer that the man himself will be recognisable in the street. Johnson's *Hanmer* is a face in the crowd. But what, strictly in terms of physiognomy – the physical facts of the face – has Van Dyck done that Johnson has not? Crucially Van Dyck has made the salient features of the head derive their character from the underlying structure. For example, the eyebrow changes its direction in three dimensions, first relatively abruptly and then on a curving path in its journey from above Hanmer's nose. These changes are interesting because they have a job to do, to explain the form of the head. Johnson may have painted Hanmer's eyebrows true

Geronima Sale Brignole and her Daughter, n. d.
Oil on canvas, 286 x 198 cm
Galeria di Palazzo Rosso, Genoa

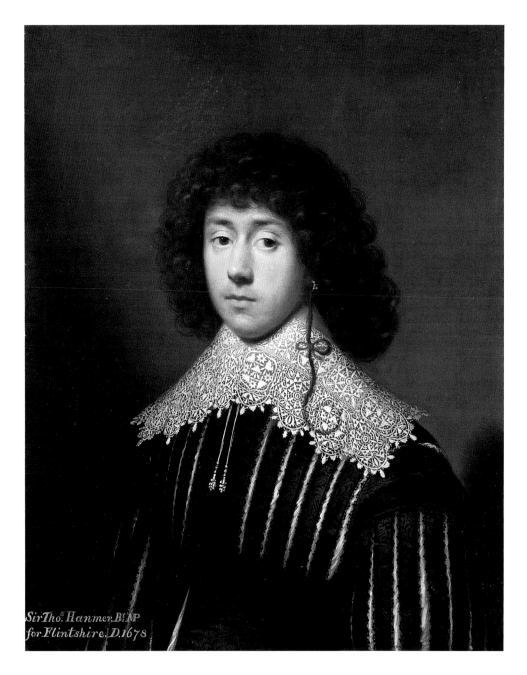

Sir Tho.ˢ Hanmer, Bᵗ MP
for Flintshire. D.1678

Cornelius Johnson
Thomas Hanmer, 1631
Oil on canvas, 77.5 x 62.2 cm
National Museum of Wales

to their appearance, but they lack a task and are without energy as a result. The first change in their direction, in Van Dyck's *Hanmer*, is explained on the far side of the head where the tone-change on the forehead is relatively sudden and indicates a prominent brow ridge towards the middle of the forehead. At Hanmer's temple, his skull is rounded. Van Dyck has also located his cheek-bones and hangs the flesh of his cheek from it, lowering the tone and warming the colour of the flesh in that area infinitesimally, but tellingly. There are no great peaks and troughs on a line that could be drawn from the corner of his eye to the corner of his mouth, but the viewer understands its deviations and knows where the terrain is soft and where hard. Johnson has not seen these transitions and so neither can the viewer.

Van Dyck has also added something to likeness; the art becomes curiouser and curiouser. Hanmer has that mysterious thing, handsomeness. If flattery is part of the painter's repertory, he has another means of impressing his sitters. But it is a gesture to make with extreme discretion, for, beauty or handsomeness being normative, it is the enemy of likeness. Roger de Piles tried to pin down just how Van Dyck combined likeness and improvement to likeness. He identified an improving

Thomas Hanmer, 1638
Oil on canvas, 117.5 x 85.7 cm
The Weston Park Foundation

56

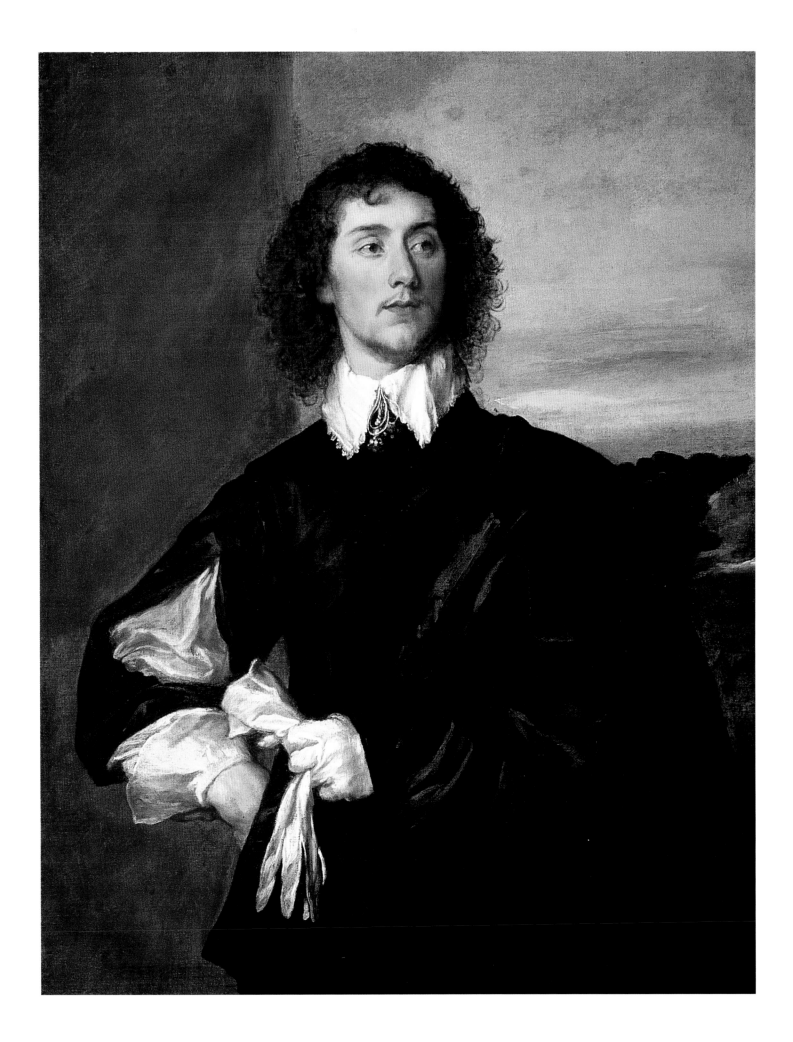

quality that he believed was not inimical to likeness – it was grace: 'When with the delicacy of his choice he observ'd nature faithfully and judiciously; He drew several *portraits* of a *sublime* character: He dispos'd of them so, that it gave them an equal degree of Life and Grace'. He explained what he meant: 'He … took his time to draw a Face when it had its best Looks on. He observ'd its charms and graces, he kept them in his mind, and not only imitated Nature, but heightn'd her as far as he cou'd do it, without altering *Likeness*. Thus, besides the *Truth* in Vandyck's Pictures, there's an Art which the Painters before him seldom made use of. Tis difficult to keep within bounds in doing so'.[29]

Not all critics were as astute as Roger de Piles. There were people who would cheerfully forfeit likeness in the interests of improvement. One of these was the Countess of Sussex. A correspondence from her to Sir Ralph Verney, her kinsman, survives; it eloquently enlarges upon the fraught negotiation between Truth and Beauty, and painter and sitter. She announced herself reluctant to be immortalised by Van Dyck: 'Your Father [Sir Edmund] sendes me worde Sr Vandyke will do my pictuer now – i am loth to deny him, but truly it is money ill bestowde'. However, she put a brave face on it: 'Put Sr Vandycke in remembrance to do my pictuer wel. I have some sable with the clasp of them set with dimons – if thos that i am pictuerde in wher don so i think it would look very well in the pictuer'. But the result was disappointing: 'I am glade you have prefalede with Sr Vandike to make my pictuer lener, for truly it was so fat, if he made it farer, it will bee for my credit – i see you will make him trimme it for my advantage every way'. But if modifications were made, they still did not satisfy: 'I am glade you have got hom my pictuer, but i doubt he hath neither made it lener nor farer, but to rich in ihuels [jewels] i am sure, but it tis no great mater for another age to thinke me richer than i was. i see you have imployede on tto coppe it, which if you have, i must have that your father made before, which i wish coulde be mendede in the fase, for it tis very ugly. i becech you see whether that man that copes out Vandicks coulde not mende the fase of that – if he can in any way do it, i pray get him and i will pay him for it. it cannot bee worse than it tis – and sende me worde what the man must have for copinge the pictuer. if he do it will, you shall get him to doo another for me. Let me know i becech you how much i am your debtor, and whether Vandicke was contente with fifty ponde'. At last though, the Countess was dispirited: 'The picture is very ill favourede, makes me quite out of love with myselfe, the face is so bige and so fate that it pleses me not at all. It lokes lyke on of the windes poffinge – but truly I thinke it tis lyke the originale. If ever i come to London before Sr Vandicke goo, i will get him to mende my pictuer, for thow I bee ill favourede i think that makes me worse than I am'.[30]

Balancing likeness and improvement was particularly important where the portrait could be compared with the actual sitter. Can Lucy Hutchinson have seen Henrietta Maria in the flesh? Her account of the Queen does not tally with that of Princess Sophie, the King's niece. Lucy Hutchison wrote: 'He [Charles 1] married a papist, a French Lady of a haughty spiritt, and a greate witt and beauty, to whom he became a uxorious husband'.[31] Princess Sophie could compare the picture with the original when the Queen went to The Hague after the death of Charles: 'The beautiful portraits of Van Dyck had given me such a beautiful idea of the ladies of England, that I was surprised to see the queen, who I had seen to be so beautiful in painting, to be a little woman, perched on her chair, with long scrawny arms, uneven shoulders and teeth sticking out of her mouth like tusks'. However, like Mrs Worthington's daughter, Henrietta Maria had points to praise: 'Still, after I had scrutinised her, I found her eyes and nose well made, and her colouring very nice'.[32]

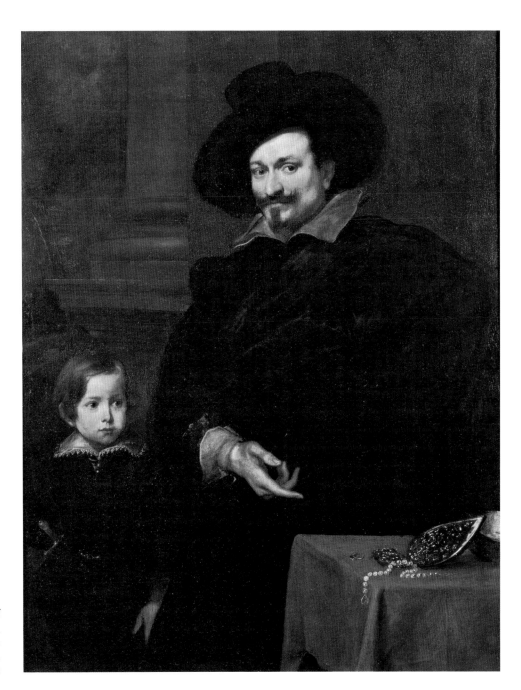

The Jeweller Pucci and his Son, n. d.
Oil on canvas, 125 x 100 cm
Galeria di Palazzo Rosso,
Genoa

Likeness, in Van Dyck's portraiture, emerges from beneath the surface of appearances. It is predicated upon an analysis of the structure of the head of the sitter. And improvement involved, to Roger de Piles's way of thinking, letting a memory of the sitter, at his or her most attractive, suffuse and veil the specifics of likeness. Assuredly, the sitter supplies the face, but the role of the painter, in bringing analysis and sentiment to the task, is clearly indispensible.

However, likeness and handsomeness are still not all that the portrait may have. The Maid of Corinth had a likeness of someone she no doubt adjudged handsome, but so may an effigy. Returning to *Thomas Hanmer*, it is clear that he has something else too. As well as likeness, he has lifelikeness. Van Dyck may have caught a characteristic expression of life in the man but, whether he has or has not, it is he, the painter, who has given life. This is a remarkable power that the portraitist may possess. Proof that the painter is the giver of life is the fact that it is possible to paint a posthumous portrait. It is easy to forget that the death of Henry Percy presented no very serious obstacle to Van Dyck painting a living likeness of him.

This ability of the good portrait painter to add life to likeness in his sitters makes of the portrait something that can be very confusing. Criticism is often unsure – it was the painter's purpose that it be so – about what belongs to the sitter and what is, in a sense, fictional, having been 'made up' by the painter. There are some things that criticism identifies which belong to the sitter considered in terms of likeness. So, physiognomy, stature, indicators of social role and condition belong to the physical part of the sitter. Lifelikeness is not necessary for their identification. But where the critic encounters life in the sitter, non-physical attributes can start to crowd his or her consciousness. Character, expression, mood, temperament, personality perhaps, become the content of the picture too.

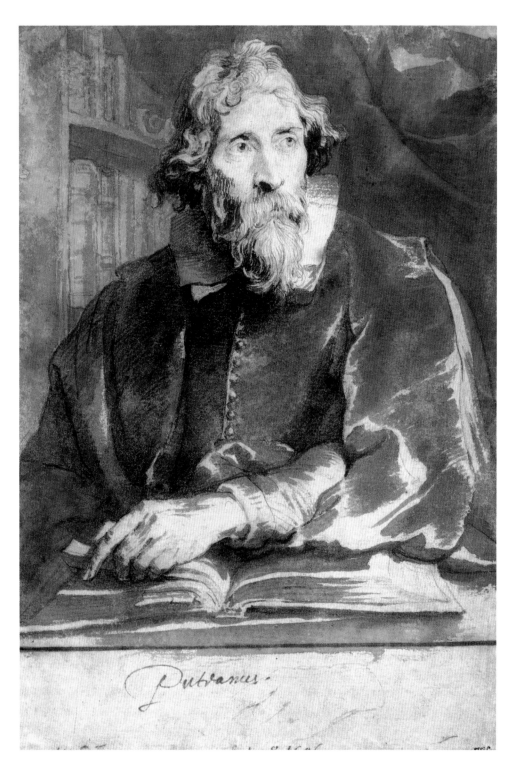

Erycius Puteanus, 1627–35
Black chalk with brown wash,
24.2 x 17.3 cm
The British Museum, London

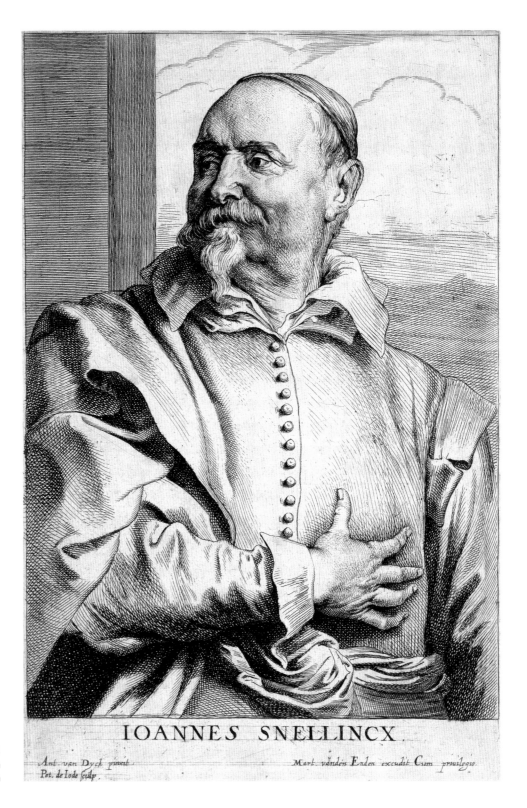

IOANNES SNELLINCX

Jan Snellinx, 1627–35
Engraving, 24.5 x 15.7 cm
The British Museum, London

Writing about portraiture can easily fall into the habit of congratulating itself upon its sensitivity rather than puzzling over what, in the painting – the act of making the picture – gave rise to those feelings. Expression, mood and temperament are ambiguously in the observer and the sitter. So, Oliver Miller can write of Van Dyck: 'His earliest portraits ... are often tinged with an underlying melancholy, an indefinably reticent and introspective mood which sets him apart from the confidence that always pervades a portrait by Rubens'.[33] The question must be, what is the painterly anatomy of melancholy? It is unclear whether the reticence and introspection belong to the sitter or the painter, for they are predicates of his

61

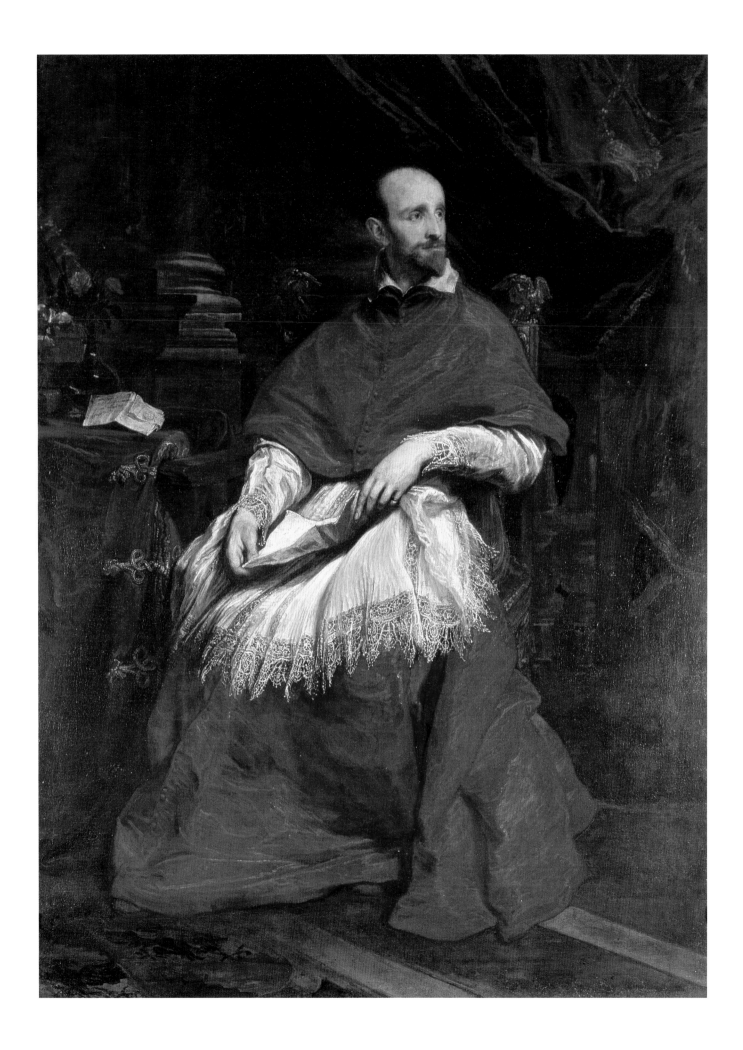

portraits at the same time as distinguishing characteristics of the painter, setting *him* apart. It is an expressionist theory of art that disregards the distinction.

If the aim is to understand the art (and retain command of suspension of disbelief about the sitter), it is important to be ready to resist the painter's pretence that the picture surface – the place of the art – is completely transparent. Even David Freedberg, in his fine article about Van Dyck in Rome, was able to write: 'In the Bentivoglio portrait the high forehead, keen and searching gaze, and delicate features are all testimony to a refinement and honesty of spirit that emerge with great clarity in the literary works of the cardinal ...'.[34] In real life, it might be questioned which of the cardinal's visible characteristics really do connect with his moral attributes? Is phrenology still a respectable science, that a student of morals would predict virtues from the evidence of a high forehead and delicate features? How many people of unprepossessing features are damned not just in common estimation, but even before the throne of eternity by such a science? A 'keen and searching gaze' belongs in a different category of characteristics, for it is something that a sitter does rather than has. In discussion of portraiture, this sort of confusion is common. If the writer had not confirmed his high opinion of Bentivoglio by reading his works, the reader of the article would have allowed that he was simply submitting, as the painter intended, to the suggestions of painting. But, as it is, Freedberg has claimed to see past the painting to the reality of the man, and has abandoned scepticism. When Malcolm Rogers, in his admirable article, says of William Crofts in the double portrait with Thomas Killigrew that he was a 'hot-tempered, quarrelsome youth', he has gone outside of the picture for his information.[35] The critic might ask why that document has credibility over the one that is the picture itself.

Van Dyck's portrait of *Cardinal Bentivoglio* is brilliant and artful. The idea at the centre of it is of a divergence. Bentivoglio looks off to the side and slightly upwards. His hands and the letter (there is a seal on the other sheet on the table) form a cascade going downwards in the opposite direction. His higher, left hand has let fall the letter whilst the lower, right hand still holds onto it firmly. When the picture is read as a composition of actions, it has, at one end of the cascade, the action of holding, and, at the other, seeing. Bentivoglio is in a state of distraction from his business – a quotidian matter – and looks outwards and upwards, without undue emphasis, to the light. The light and its whereabouts, put together with the action of holding, letting go and looking, comprise the moral spine of the portrait. It is not a 'keen and searching gaze'; the relaxation of the pose as a whole belies such fixity of attention. There is, however, something of 'honesty and refinement of spirit'; it consists simply in a quiet turning of thought away and a little upwards.

The portrait becomes an invitation to think about a life and a predicament. Thought about in this way, the pretext of the picture is to be found in the culture at large. This ecclesiastic relives a dilemma as old as his religion, that between God and the World, the *vita contemplativa* and the *vita attiva*. People of humanist education could recognise the quiet tension, even desperation, of the picture.

The painterly turbulence of the hands, letter and rochet contrasts with the calm of Bentivoglio's head. His beard is neat, but he has an ascetic frailty that contradicts the richness of his cardinal's robes. If, by the turn of his head and by his looking up towards the light, Bentivoglio would be elsewhere, it would perhaps be to the condition of St Francis at La Verna or of some other ascetic saint in retreat. Such a general speculation is encouraged by Van Dyck's placing of the lights in Bentivoglio's eyes. The principal lights are towards the tops of his irises, but there

Cardinal Bentivoglio, 1623
Oil on canvas, 196 x 145 cm
Palazzo Pitti, Florence

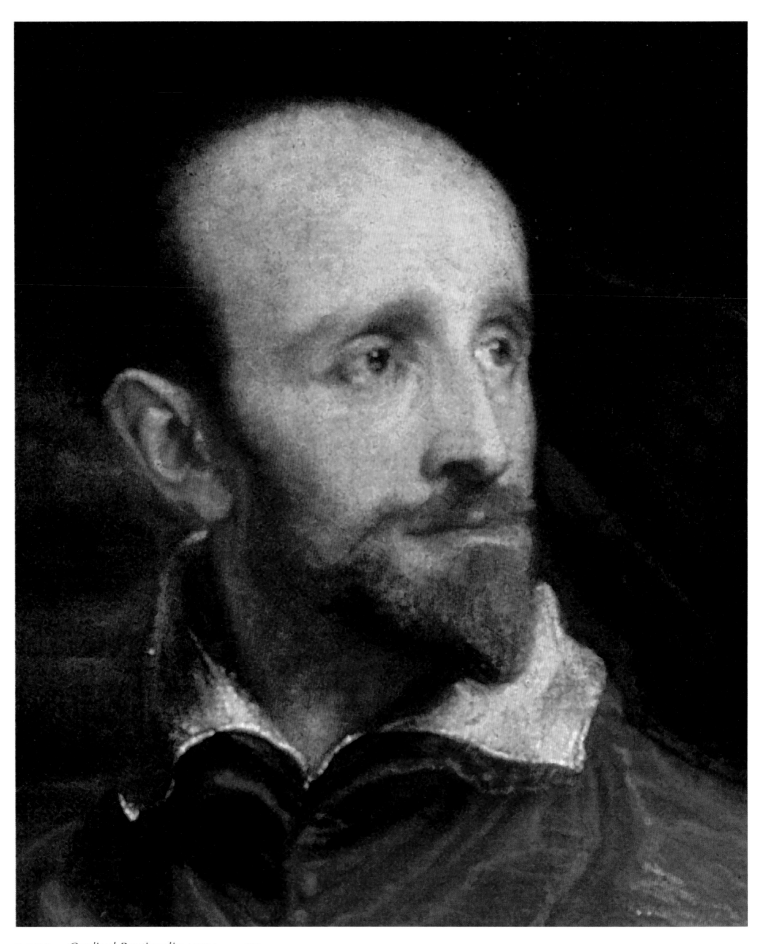

Detail from *Cardinal Bentivoglio,* 1623 (see p. 62)

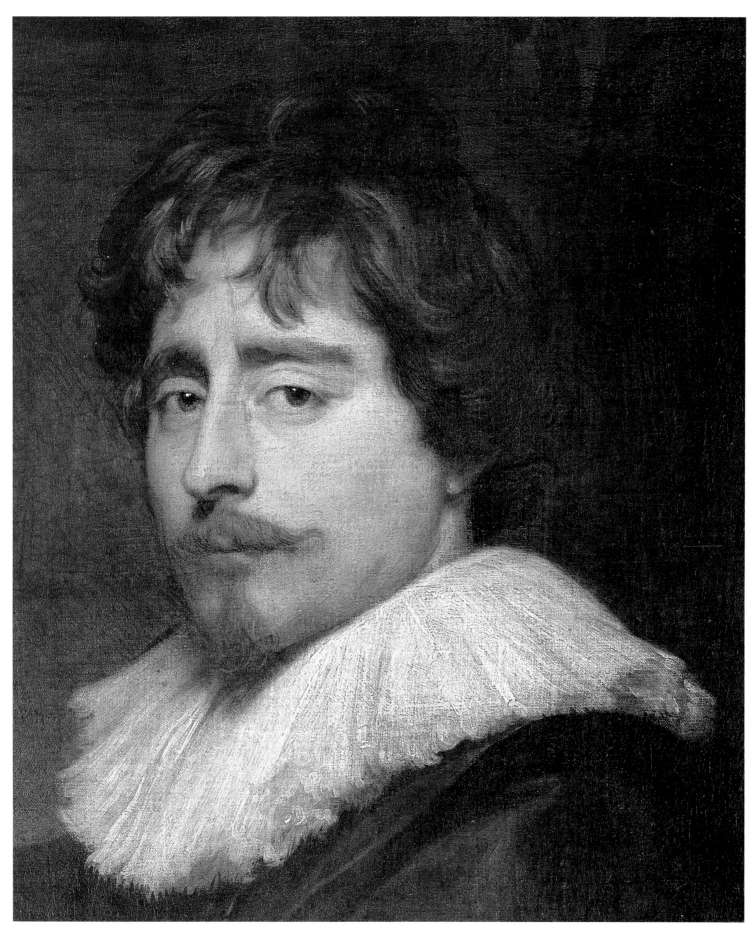

Detail from *François Duquesnoy*, n. d. (see p. 67)

are secondary lights running horizontally about a third of the way up. These have the effect of hinting at that lower light that was conventionally used to indicate ecstasy or pain seeking relief in heaven.

Reading the portrait of Bentivoglio in this way depends upon the viewer identifying an action and constructing for the picture a passage of time. There was a previous moment when the cardinal's head and eyes were downcast upon the letter that he was dutifully reading. It is his movement out of that position and action that is the stuff of the life that he possesses in the moment that Van Dyck has actually constructed for him. If the nub of likeness is observation and analysis, and improvement is assimilating the particulars of the sitter's appearance to the norms of his or her type, life consists in endowing the sitter with the power to move.

Bellori found that power in the portrait of Bentivoglio: 'Anthony [Van Dyck] presented the cardinal as seated with a letter in his hands and, as if having read it, turning away ...'.[36] Jonathan Richardson praised Van Dyck for his grasp of the principle of movement in the sitter, referring to the 'moving features, which are as much part of the man as the fixed ones'.[37] Edmund Waller (1606–87), in his poem, *To Vandyck* identified a principle of Promethean movement in his work, the volatile element:

> Strange that thy hand should not improve
> The beauty only, but the fire;
> Not the form alone, and grace
> But act and power of a face.[38]

Life is a function of motion where painting is concerned. The law of nature that painting (and sculpture) has derived to this end is that the soul moves the body. Thus, all motions of the body are indicative of motions of the soul. Thought and feeling are expressed within this art. And all motion is a deviation from stasis. In painting, stasis is indicated in the first instance by axial symmetry. So too are those human actions within which the individual denies himself – the soldier at attention, the judge at the bench, the priest enacting the ritual. Whatever deviates from the axis of symmetry announces life, however flickering. So, for example, it is not a corpse, should the eyes cease to stare straight ahead. The relationship of life and motion, and therefore asymmetry, was a rediscovery of the Renaissance. Van Dyck used it as a tool of expression with astounding dexterity.

The portrait of *Philippe le Roy, Seigneur de Ravels* can serve as an example. His cuffs and collar tied at his throat, his goatee beard, moustache and centre-parting all argue his axial symmetry. As he shot his cuffs, tied his collar, trimmed his beard, waxed his moustache and combed his hair before the mirror, he sought perfect balance and symmetry. What the observer of the picture encounters is a man attempting to retain that formality of self-presentation. But *Philippe le Roy* has not encountered the observer on quite the terms for which he prepared himself before the mirror. He is obliged to look to his left; and the observer sees symmetry and the poise that it represents deconstructed. His cloak has fallen aside to reveal his dressy sleeve: that hand plays with the dog's head. These visual incidents and that action form a strong diagonal. Meanwhile, his other hand is altogether more serious, as it rests on the hilt of his sword isolated against the unbroken darkness of his sober cloak.

Philippe le Roy acquires psychological complexity from the asymmetry of the subject's stance, action and encounter. To these, Van Dyck adds another element – close up, intimate and expressive of the inner man as opposed to the active individual. He has placed highlights in the subject's eyes. But they are not identical. The more distant one is larger. Thus, that eye seems to be more dilated. If the viewer is

François Duquesnoy, n. d.
Oil on canvas, 77.5 x 61 cm
Musées Royaux des Beaux-Arts
de Belgique, Brussels

66

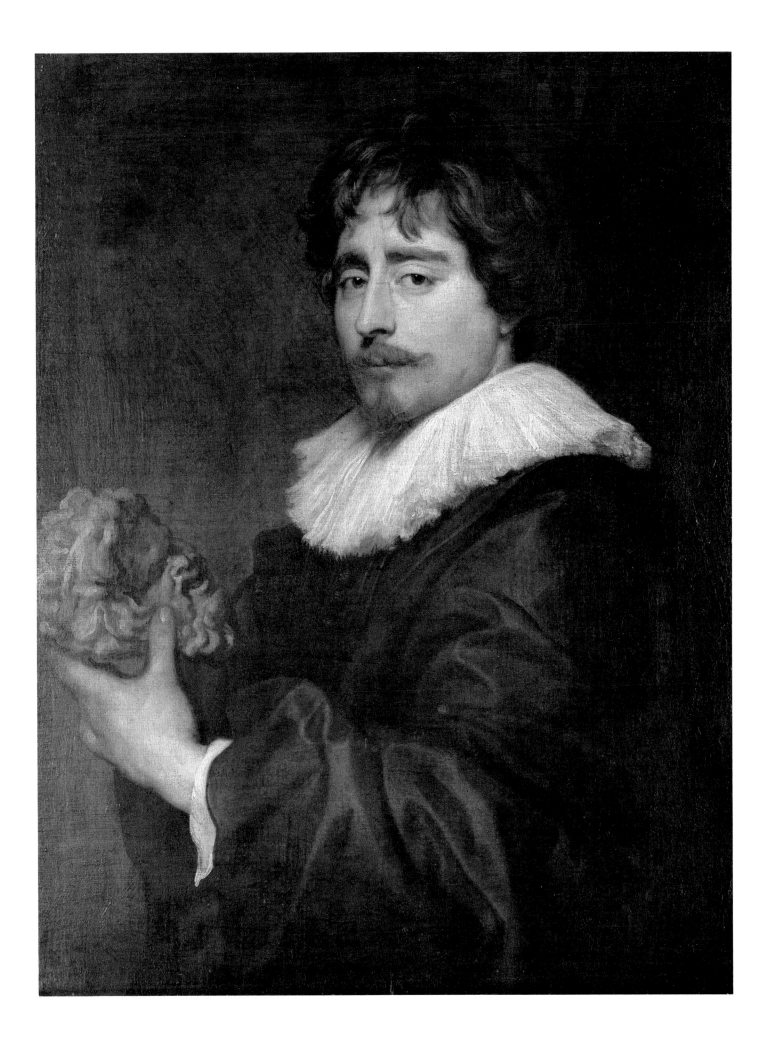

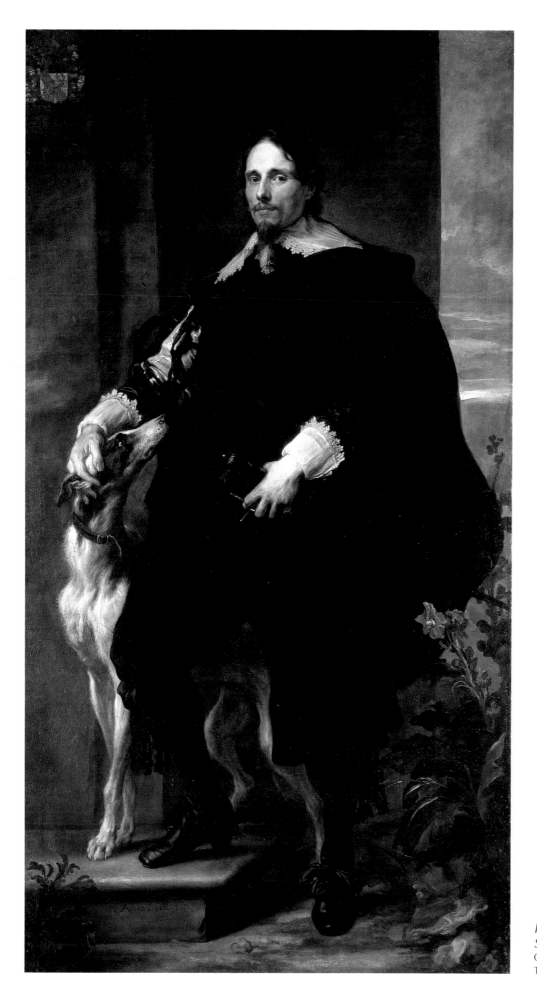

Philippe le Roy,
Seigneur de Ravels, 1630
Oil on canvas, 213.3 x 114.5 cm
The Wallace Collection, London

capable of reading the expression of the eyes separately, it will be apparent that self-possession belongs to the gaze of the near eye and, because of the vulnerability of the eye that is more open, an anxious alertness in the other. *Philippe le Roy* is in two minds.

The painter's means of expression are limited but they are sufficient for infinite subtlety and nuance. All the painter can do is give motion. After the eyes themselves, that means a deviation from the main axis. The head itself is the primary expressive element. Every tipping of the axis parallel to the picture plane or in the three dimensions of the picture space makes the sitter's expression change, because time is implicit in the movement or deviation. Bentivoglio's relative quiescence comes from the fact that he gazes straight ahead; there is confidence (the confidence of faith) in that. Philippe Le Roy's gaze does not deviate much from the direction of his head, and to that extent his encounter with the observer has not greatly disturbed his balance and equanimity. *François Duquesnoy* is given slightly more animation, for he turns his face towards the observer while his body faces almost at right angles to the line of sight that connects sitter and observer. However, he has not turned his head with a suddenness that would compromise his self-possession. There is a price to be paid for that, which is that he must turn his eyes quite sharply. It would be possible to draw a graph representing, at one end, self-possession and, at the other end, absorption in the encounter with the observer. The painter can locate the mean wherever he wants between these extremes, or he can make these extremes approach one another: the iconic full frontal image can be disturbing because it is a meeting of opposites. Duquesnoy is set at a point of perfect equilibrium between friendship and formality.

It is now possible to see why *Thomas Hanmer*, as painted by Van Dyck, is so alive compared with Johnson's version of him. Insofar as Johnson's *Hanmer* makes eye contact with the observer, and Van Dyck's looks away, he ought to be the more animated in the first instance. But deviation from axis is the crucial thing, and Van Dyck's *Hanmer* orchestrates several of them. The hands perform different actions over to one side of the picture plane, to which the body is askew. Then, the head is made to have turned from the line of the body all the way past frontality *vis-à-vis* the picture plane and, with energy and some swagger, looks off at some distant object. The heroism of the portrait derives from the observer's awareness of his own closeness of vision compared with Hanmer's focussed attention upon something distant and unknown: narrowness versus breadth. At the same time, Van Dyck weaves sensibility into boldness, for he has tilted the head backwards ever so slightly, and is therefore able plausibly to put a prominent light into the near eye, over white and iris; a vulnerable condition.

What Van Dyck is manipulating here are the same elements or instruments of expression that animate his history painting. Every movement should communicate meaning, the action or the inner life of the protagonists. And Van Dyck's sitters are to be thought of as enacting small dramas. When the observer identifies the drama, he adopts psychologically the role of the audience, hushed so as not to disturb the action, and empathetically identifying with the person depicted. We laugh with those who laugh and we weep with those who weep. There is a sense, at this point, in which the portrait is a mirror, or rather that the observer is a mirror, assimilating himself or herself to the mood and predicament of the sitter. Abraham Crowley claimed for Van Dyck's portraiture the power to do what Aristotle reserved for drama in *The Poetics*:

> ... for none his works could view
> Unmoved with the same Passions which he drew. [39]

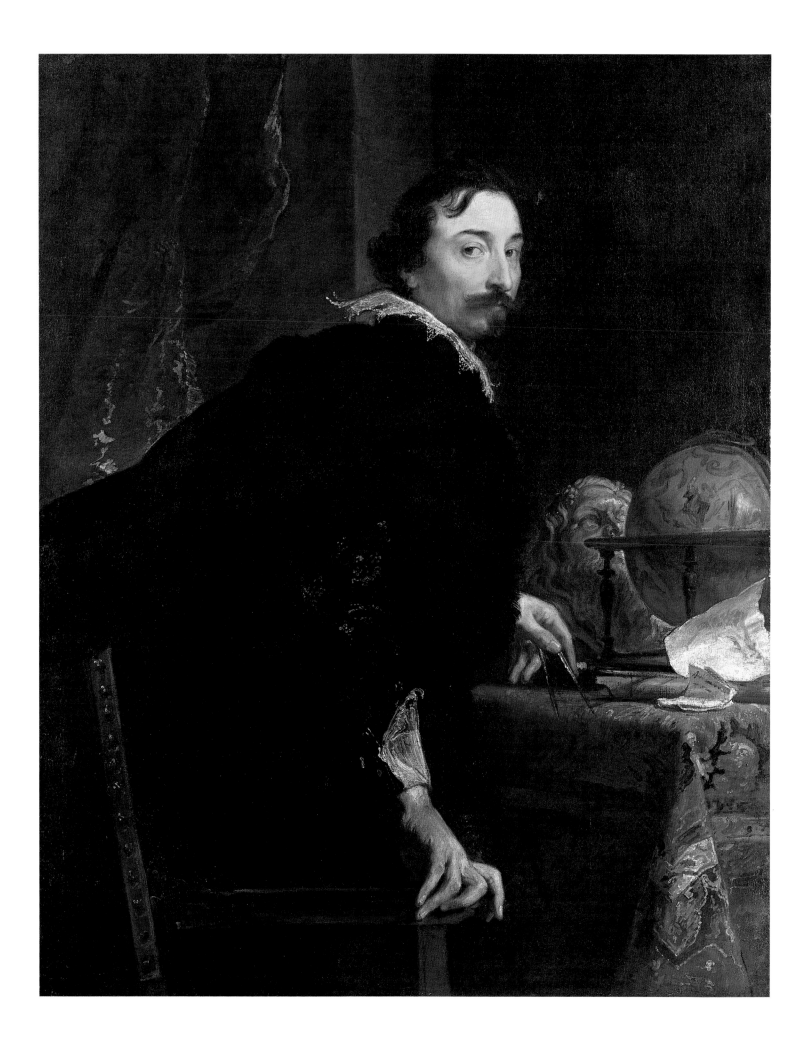

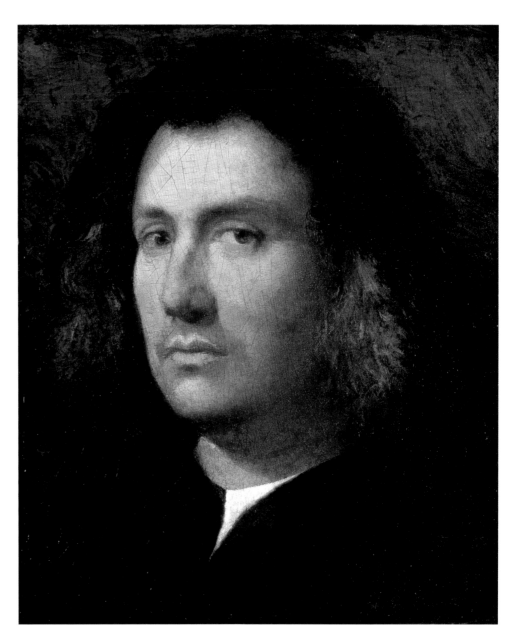

Giorgione
*Portrait of a
Young Man,*
c. 1510
Oil on panel,
30.1 x 25.7 cm
San Diego Museum
of Art, USA.
Gift of Anne R.
and Amy Putnam

Lucas van Uffele, n. d.
Oil on canvas, 124.5 x 100.6 cm
The Metropolitan Museum of Art,
New York. Bequest of Benjamin
Altman, 1913. (14.40.619)

Where this empathy, or psychological mirroring, takes place, there is a sort of acknowledgement of the audience. That happens explicitly in the portrait where observer and sitter have eye contact. It can be an odd experience for the observer to find himself scrutinised by a fiction.

Odder still is the experience of encountering *Lucas van Uffele*. He rises abruptly from his chair, interrupted in his thoughts about measuring and harmony, turning head sharply and eyes more sharply still to the viewer. Here, Van Dyck has created a fiction that the action of the sitter is actually caused by the observer. In such circumstances, there can be no picture plane: the fiction supposes, to an extreme degree, that the sitter and the observer are in the same place. Rembrandt used the same device in the figure who rises to greet the visitor, in *The Syndics*, in the Rijksmuseum. And it was very much part of Frans Hals's (1581/5–1666) stock-in-trade to have sitters react in lively fashion to their observers. The foreground figure, centre right in his *Banquet of the St George Militia Company* of around 1626, in Haarlem, reacts to the viewer with equal suddenness.

There was contact between Van Dyck and Hals. Arnold Houbraken told a Pliny-esque tale of Van Dyck paying an anonymous visit to Hals and the latter recognising

him by the speed and dexterity of a performance of portrait painting that he put on.[40] However, Van Dyck's idea of the viewer as the mover of the sitter was not generated only within the artistic *milieu* of the Low Countries. In the suddenness of his action, *Van Uffele* recalls Caravaggio's (1571–1610) pilgrim in *The Supper at Emmaus*. And the idea of the sitter's action, psychological as well as physical — for *Van Uffele,* in the peace of his study, has suffered a rude interruption — being caused by the viewer can be traced back to Giorgione. His *Portrait of a Young Man* turns away from the viewer and tips his head back slightly in recoil from a grosser presence, eye contact maintained out of the corner of his eyes, so that he can

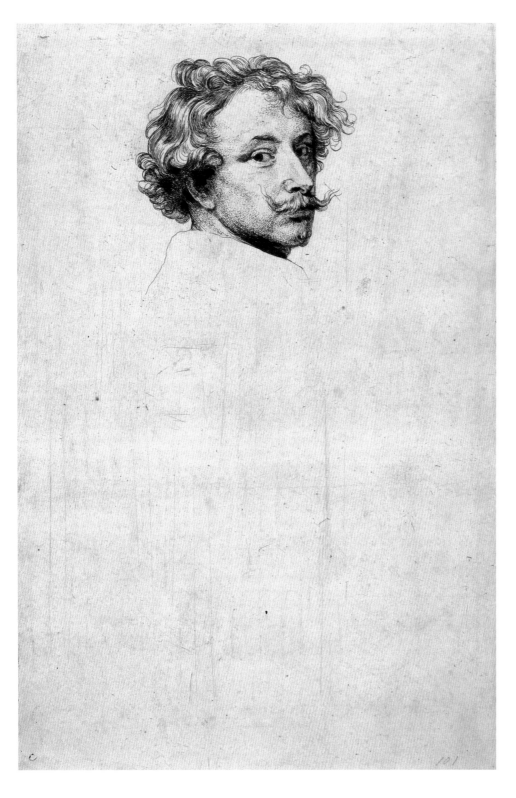

Self-portrait, 1633–34
Black chalk, 24.5 x 15.7 cm
The British Museum, London

72

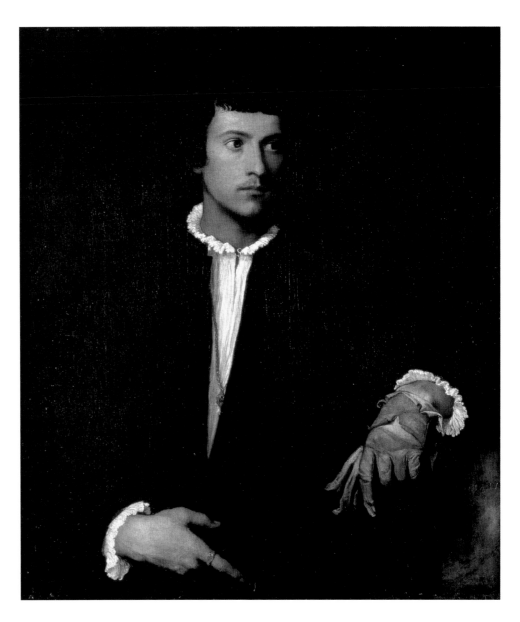

Titian
*Man with a
Glove*, c. 1520
Oil on canvas,
100 x 89 cm
Musée du Louvre,
Paris

sustain it without discomfort for little more than the length of time of a glance. *Van Uffele* is a psychologically more robust individual, almost entirely by virtue of the fact that his head remains absolutely vertical and balanced.

This idea seems to have been an important one for Van Dyck, for he used it repeatedly in various versions of the self-portrait in which he looks back over his shoulder as if to be engaged by the viewer. A displacement of axes – body, head and line of sight – one from another maximises movement, diminishes comfort, abbreviates time, and maximises life. This is what Van Dyck has – his head tipped backward and turned, his glance out of the very corner of his eye. The extremity of the action seems to be designed to say something about his art. This self-portrait cannot have been created in the ordinary geometric configuration of painter, mirror and picture, for the painter has chosen an uncomfortable obliquity to the mirror. He has proved his ability to create the momentary, the glance, the life.

Van Dyck's portraiture derives its expressive means from history painting and both articulate varying lengths of time – religious, mythological or secular. It is the painter who has created these fictions which enfold the sitters. The portrait is implicated as movement within a greater or a lesser envelope of time. Sometimes it is very short. The idea that the action of the subject of the portrait is to do with the exchange that passes between him and the observer gives momentariness and

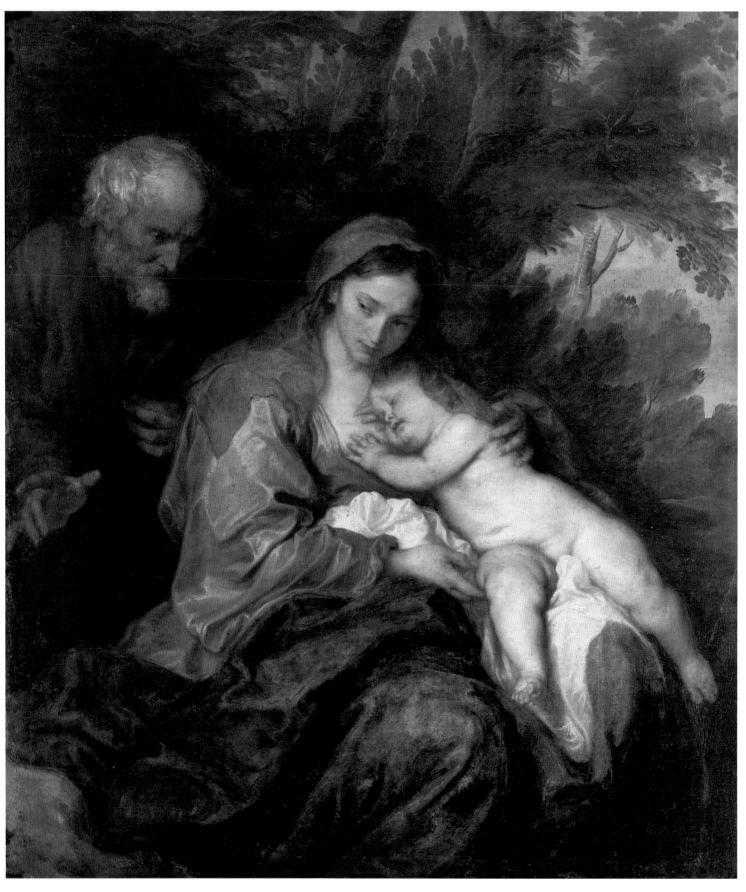

The Rest on the Flight to Egypt, c. 1630. Oil on canvas, 134.7 x 114.8 cm. Alte Pinakothek, Munich

singular liveliness to some portraits. Sometimes, Van Dyck creates more meditative poetry in the little dramas of his sitters.

The simplest action can evoke the meditation. For example, Paola Adorno holds the hand of her small son. The viewer who is primed to take the empathetic part will perhaps recall Michelangelo's *Bruges Madonna*, who holds the hand of the Child, as he considers the step he is about to make down onto the altar, with all that that implies. Common humanity knows the mother's dilemma. The idea of the mother in conflict with the destiny of her child is also present, with delicate understatement, in *The Lomellini Family* (see p. 23). The picture tumbles into colour and informality in the lower right, the territory of the two small children and the yelping dog. The two mature gentlemen of the family, by the repetition of isocephaly, are advertised as a matching and contrasting pair. Van Dyck has also insinuated the theme of conflict and destiny into the group of the children by having the mother hold the boy's hand while he rests his other on his sword hilt.

Early on, Titian recognised that there was a channel whereby the psychological plausibility upon which history painting and *poesia* depended could feed portrait painting. His *Man with a Glove*, for example, is placed at a crossroads, in its own way not unlike that of Hercules or Christ in the Garden of Gethsemane. Of course, the picture is not a specific re-enactment of those specific choices; but it comes out of the same imaginative rehearsal of the experience of being drawn in different directions that was necessary for the treatment of such themes. The beginning of the meditation and imaginative identification of the Man is the emblem of the gloves. There are of course two. And a question arises. Will he take off the glove he still wears or put on the one that he holds in his gloved hand? His future is mapped out by whichever action he chooses. The observer looks for an answer in the face of the Man, and in the hints that the painter has given to his sensibility.

It is an asymmetry that the observer has been drawn by. Before or after, there will be symmetry – both hands gloved or bare. But, now, there is a discontent. Rembrandt engaged with the same sensibility in his *Portrait of Jan Six*, in the Jan Six Museum, and Van Dyck did so too in his *Thomas Hanmer*. In a passage of painting worthy of Titian himself, a hand tensely holds a glove, and the observer asks again if Hanmer goes into the world or retreats from it.

There is Christian sensibility in this. What is affecting is the simultaneous presence of opposite possibilities. That was the creative contradiction at the heart of Renaissance religious painting: was Christ god or man? Van Dyck was attuned to the poetic possibilities of the paradox. In *The Rest on the Flight into Egypt*, the Madonna is invited by Joseph to turn her attention. This will involve waking the child from his entirely human slumber. There is *tristesse* in the Madonna's inclined head and oblique and downward gaze, because there will be movement and it will be in the direction of a destiny.

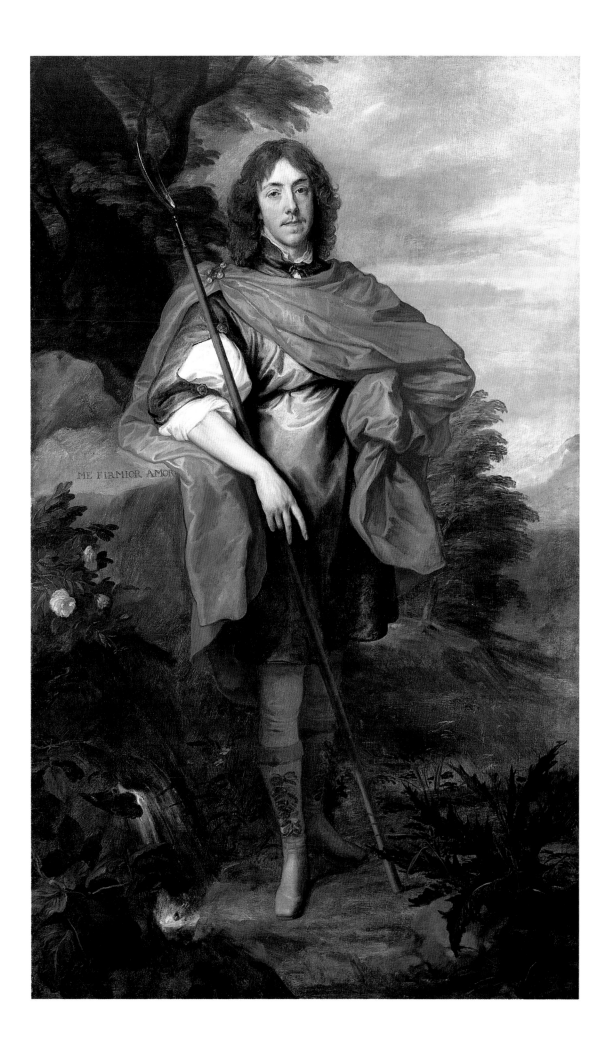

Public Roles and Private Sentiment

Van Dyck as a Court Painter

Play-acting was part of the life of the ladies and gentlemen of Charles I's court. The masques that were designed by Ben Johnson and Inigo Jones had parts for the amateur performer to mum the actions of gods and goddesses, nymphs, swains, heroes and allegorical types. The values that ought to direct human actions were universal and ideal, and could readily be personified in the *dramatis personae* of the masque. The person of moral ambition would attempt to assimilate his or her actions to those of such exemplars.

In a somewhat similar relation to the individual stands the portrait. It had a role to perform, to represent the individual and to connect him or her to a generally understood system of values. Van Dyck was the ideal servant of this ambition because he was adept at identifying the points at which the specifics of appearance of the sitter should cease to be his concern, and the generality of grace and at length the fiction of lifelikeness should make their contributions. The portrait could address an audience because, in life, it spoke of universal as well as particular things. The sitter – or the society – had a role for the portrait in the theatre of society at large. Thus his or her contribution requires acknowledgement alongside that of the viewer and the painter.

The contribution was sometimes quite specific. As has been seen, the Countess of Sussex chose her fur and jewellery. It was surely Lord George Stuart, Seigneur d'Aubigny himself who programmed the picture in the National Portrait Gallery in London, in which he stands in a rocky landscape in the fancy-dress of a peasant, in blue and gold silks with buskins, and holding a spud, or long-shafted trowel. Philip, Lord Wharton, had himself similarly accoutred, minus the boots so far as can be seen, for he is in three-quarter length, in the picture in Washington. The gentlemen are clearly engaged in theatricals and can claim extra responsibility for their portraits. Sir John Suckling was a literary figure at court. In the Frick Collection picture, he stands in a rocky landscape wearing scallop-edged silk tunic and cloak, and holding a folio of Shakespeare. Van Dyck has done his bidding too.

The contribution of the sitter is to be sought out and acknowledged also in less obvious instances, for it is the case that the sitter, having to a certain extent represented himself or herself, has created a sort of mirror. The representation is moral as well as material and to that extent is a promise of conduct and a reminder of his aspiration. If the sitter makes the portrait, the portrait also makes the sitter in a predictive sort of way.

Van Dyck seems to have done as much as he could to be a member of the class which he was serving. As an artist, his values chimed with those of his patrons, to the extent that the master – servant relationship implicit in that term gave way to that of client and professional. This is an inference that can be made from the description of Van Dyck's practice as reported by Roger de Piles. The sitters' role in the creation of the portrait was assured by this identification of the artist with their values. Van Dyck was a courtier. Charles I knighted him just as he had done Rubens, and his namesake, the Holy Roman Emperor, had knighted Titian. Earlier yet, Lodovico Gonzaga of Mantua had knighted Andrea Mantegna. These actions announced, effectively, that the painter was the hand of the ruler, rather as the warrior knight was his arm. In this way, the ruler and the class of his immediate

George Stuart,
Seigneur d'Aubigny, c. 1638
Oil on canvas, 218.4 x 133.4 cm
National Portrait Gallery, London

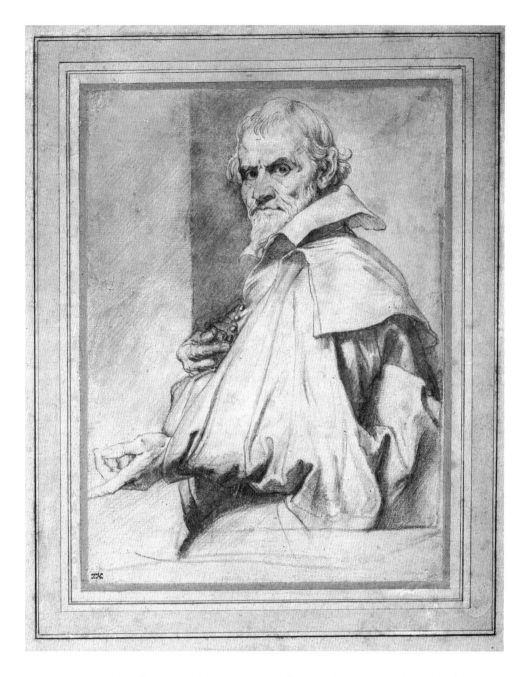

Orazio Gentileschi, 1632
Black chalk with grey wash, few
sketches of pen and sepia, 24 x 17.9 cm
The British Museum, London

supporters can be thought of as continuously exercising themselves ideologically through the agency of the painter.

Certainly, Van Dyck acted the aristocratic part both on the continent of Europe and in England. Bellori wrote of him as a young man in Rome: 'His manners were more those of a lord than a private person, and he was conspicuous by his rich bearing in costume and livery'.[41] As has been seen, the extravagance of his way of life drew comment. As a picture collector, Van Dyck acted the gentleman and, in his special enthusiasm for Titian, resembled no one more than Charles I himself. And, of course, as a painter, he proved the depth of that enthusiasm by the Titianesque character of the piece that Endymion Porter commissioned from him on Charles's behalf, *Rinaldo and Armida*.

Van Dyck, having some notion of the warmth of Charles's feelings for Titian, and being so adept a mimic of Titian's style, could hope for much from his removal to England. His eminence was properly signalled at large by the size of his pension. He was promised £200 per annum, whilst Orazio Gentileschi (1563–1639) received only £100.[42] Cornelius Johnson and Daniel Mytens (c. 1590–1648) were also

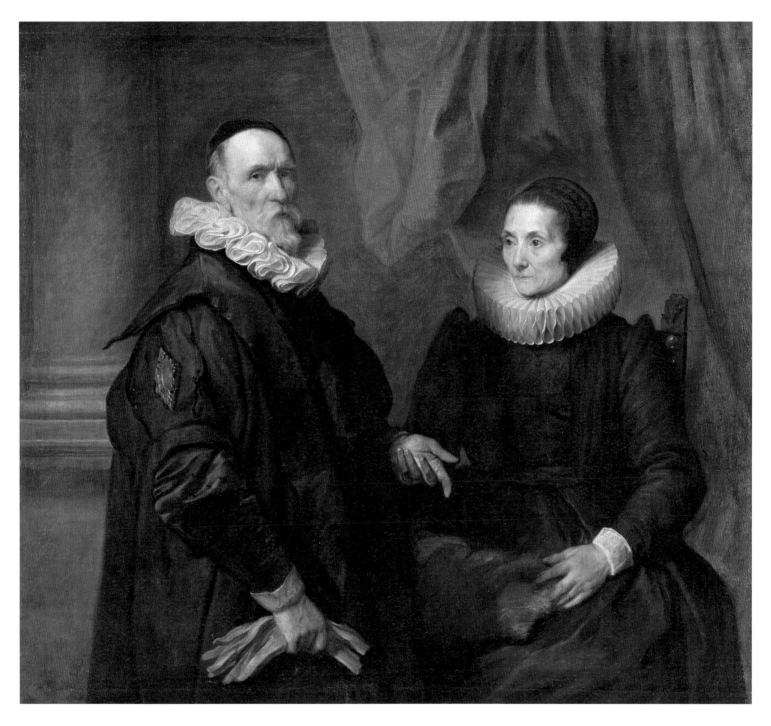

*The Painter Jan de Wael
and his Wife,* 1629
Oil on canvas, 125.3 x 139.7 cm
Alte Pinakothek, Munich

relegated in importance by Van Dyck's arrival. In his self-portraits, the latter dressed the part, usually with a gold chain symbolising perhaps, in the case of his *Self-portrait with a Sunflower,* the sacred strength of his bond to the King. Insofar as portraiture was a genre – a generic category – its task was largely to satisfy expectations and to be legible.

In Genoa, a visitor to the palace of the Lomellini (let it be another member of the local aristocracy) would not have been surprised by Van Dyck's group portrait, but rather would have found it reiterating values to be found in the artist's works at home. Paola Adorno or *Battina Balbi Invrea*, in the Palazzo Durazzo-Pallavicini in Genoa, would have found a sister in spirit in the mother, who is usually identified as Paola Doria. *Philippo Spinola*, now in Brisbane, is the 'brother' of the armoured member of the *Lomellini Family*. Insofar as it conformed to generic expectations, portraiture was a public art.

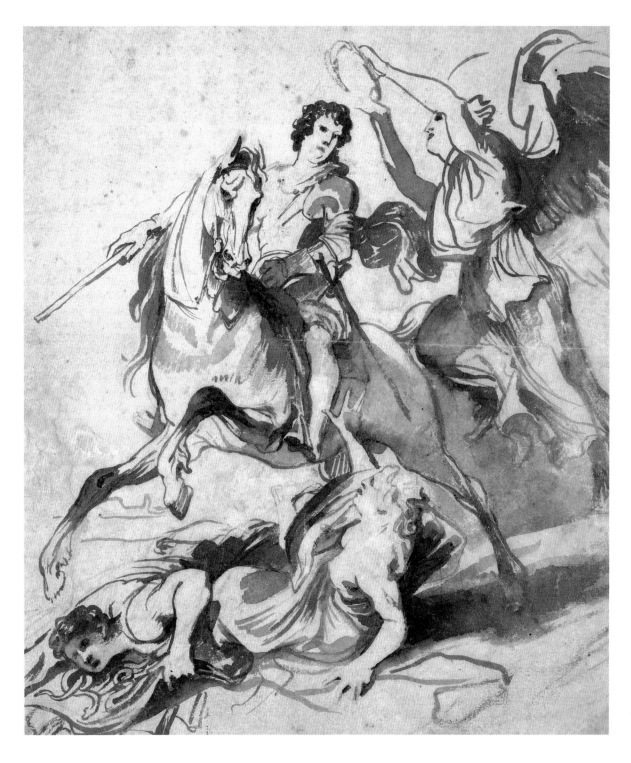

*Commander Crowned
by Victory*, 1632
Pen and sepia,
sepia wash, 21.7 x 18.5 cm
The British Museum,
London

The public man, such as the aristocratic Van Dyck as described above by Bel-
lori, emphasises not his appearance in its specific sense, but his attributes. The por-
trait, thought of in terms of genre rather than the individual aspect and life of the
sitter, is connected with his or her role. What qualifies a person for his or her role
is, properly – and un-Romantically – generic rather than specific. Thus, in the
context of portraiture, it is appropriate to talk about general moral representation
as well as the physical depiction. Representation is here thought of as being akin
to advocacy or the offering up of the morally exemplary. The idea that the public
person should be depicted as an individual as well as be represented in terms of his
or her moral qualities goes back to the Renaissance period and the revival of the
medal shortly before the middle of the fifteenth century. Typically, a profile portrait

appeared on one side, and an emblem, perhaps accompanied by a motto, appeared on the other. The type entered painting in the double-sided diptych of *Federigo da Montefeltro* and *Battista Sforza*, by Piero della Francesca, in the Uffizi, and eventually the emblematic and the physiognomic representation became enmeshed in the single view of the sitter. The challenge to a painter like Titian was to combine, in the single view of, say, *Charles V at the Battle of Mühlberg*, the man and his virtues, in such a case those as general and ruler. Van Dyck inherited the task. In a public portrait such as that of *Hendrick van der Bergh*, in the Prado, he gave the General the power of command in the emblem of the baton and in the gesture of the left hand directing the receiver of his instruction to his left. The commander of the Spanish army epitomises in his action, the wisdom of command; in his armour, fortitude, and thanks to the fluttering silk cloth tied to his upper arm, valour.

There are exemplary virtues, and ancient history offered their exemplars. Piety was one, and Aeneas epitomised it. There was Clemency exemplified by Titus, Continence by Scipio, and Magnificence by Augustus. The Cardinal Virtues had their epitomes too. The annals could be searched for cases of Fortitude, Justice, Prudence and Temperance. But if Renaissance humanism did anything, it persuaded rulers, at first in Italy and eventually across Europe, to focus their thinking about

Diana and Actaeon, c. 1618–21
Pen with brown ink and
grey washes, 15.5 x 22.3 cm
Musée du Louvre, Paris

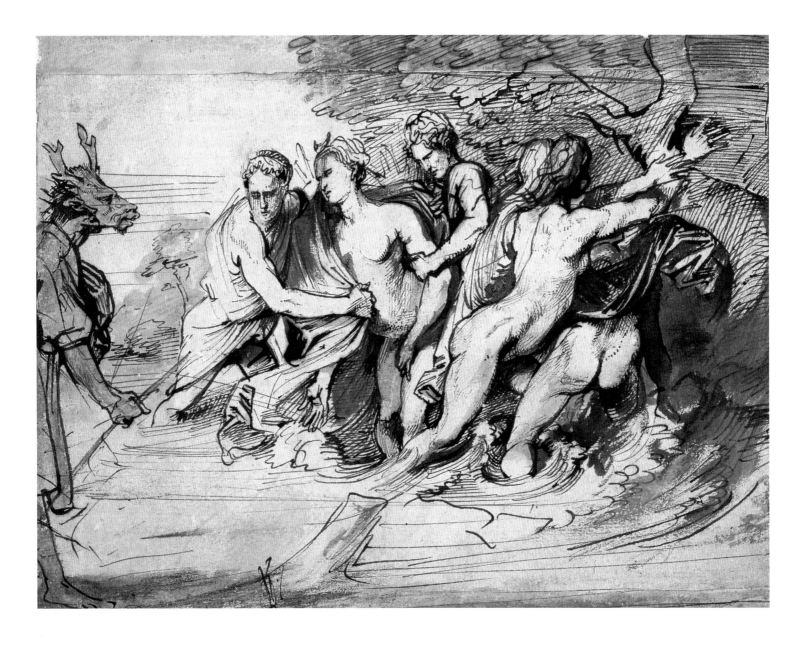

virtues anew. The arts of war still needed to be mastered, but humanism argued persuasively the case for the arts of peace. The role of the prince or lord could be enriched by his mastery of these arts. The virtues that oversaw them were, ironically, just those represented by the goddesses of the Judgement of Paris: wealth and power, wisdom, and humanity. When humanity, or rather *humanitas*, became a ruler's virtue, he found himself in need of a new language of expression. *Humanitas* also came from a changed emphasis within Christian piety; contemplation of the life and humanity of Christ being increasingly emphasised at the expense of the untouchable and eternal verities of theology. A visual language of expression was developed. Its creators were, in Italy, the heroes of Vasari's history of art – Giotto, Masaccio, Leonardo, Raphael, Michelangelo and Titian. Its context was narrative painting.

With the role of the prince or lord being elaborated in this way, so came to be its generic representation: for present purposes, the portrait. The historiography of Vasari, the moral universe of the ancients as reconstructed by the humanists and the art of the Renaissance all informed the new imagery. The portraiture of 'role' was made to amalgamate with the portraiture of *humanitas*, or 'sensibility'. It was another creative contradiction.

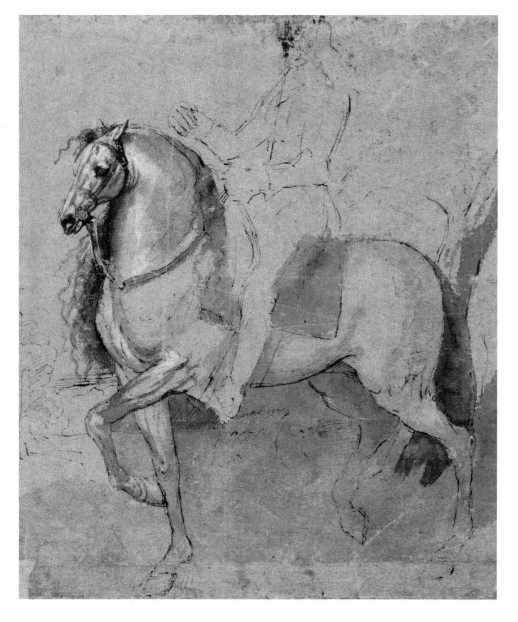

Charles I on Horseback, 1636
Pen and sepia, 28.3 x 23.9 cm
The British Museum, London

Charles I on Horseback with Monsieur de St Antoine, 1633
Oil on canvas, 368.4 x 269.9 cm
Her Majesty Queen Elizabeth II

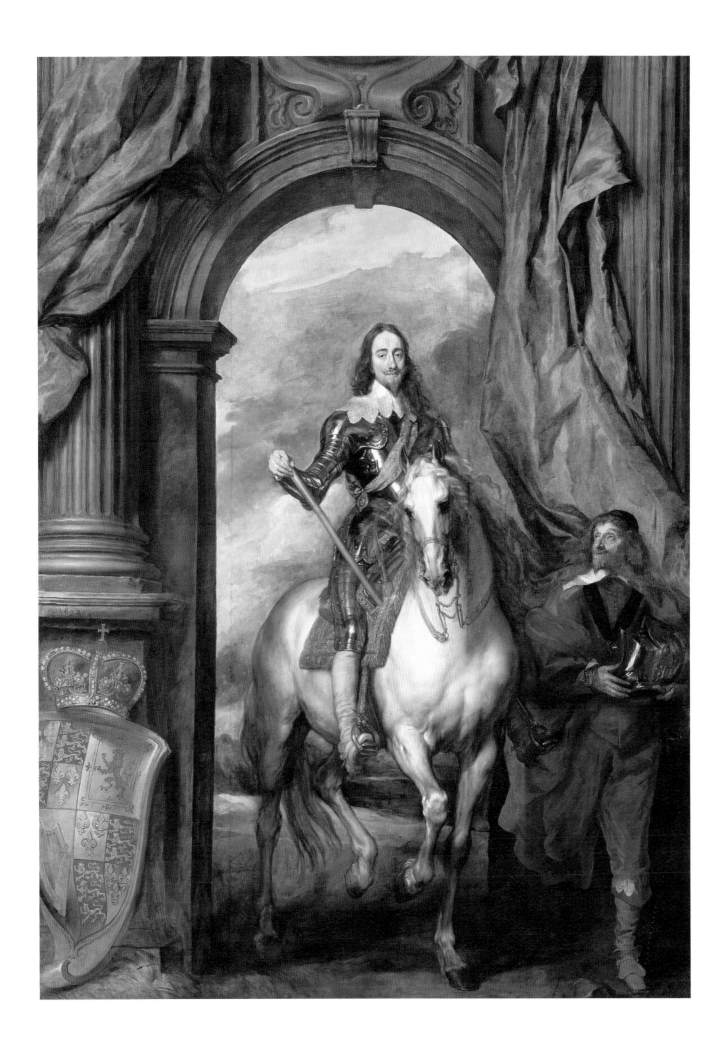

So, the self-representation of Caroline England, as the place that had learned the idea of Renaissance, conducted itself between the poles of what are being called role and sensibility in terms of expression; the public and private in social terms, and the royal and aristocratic in generic terms. It was a complicated undertaking, for these were overlapping scales, but one that by background, education, imagination, sympathy, and ambition Van Dyck was able to shoulder.

Van Dyck's first task in England was to make pictures of Charles I and the monarchy. Perhaps the most surprising thing about his portraits of the king is how diffidently they propagandise Charles' conception of his role. Of course, some pictures are more public than others, and more private imagery would be expected to emphasise *humanitas* or sensibility at the expense of role. But Charles I's conception of his role was very grand indeed, and some of the pictures of him are physically very big. The theory of Divine Right that the Stuart monarchy developed equated king with priest. Just as the priest policed the traffic between heaven and earth, so the king exercised his power as God's agent on earth. Since both priest and king stand, like archangel or Mercury, between nature and supernature, they need to represent themselves as being potentially out of this world. An epic sort of representation is called for.

There did exist, in the form of the masque, a means of representing the ruler in more than human terms. Jove and Apollo were waiting to be called upon as were the other inhabitants of Olympus and Helicon, not to mention the heroes of British and Classical mythology, to lend authority and glamour to the ruler's actions. There was a genre of painting too that functioned like the masque, and could place rulers in company with the inhabitants of supernature. In the *Life of Marie de' Medici* cycle, of 1622–25, Rubens arranged it, for example, that Neptune and his retinue of Nereids had given safe conduct for Marie de' Medici from Leghorn to Marseilles. The general rejoicing at her safe arrival was shared by the very angels in the sky. When Maffeo Barberini became pope, as Urban VIII, the event was celebrated as the working out of Divine Providence, in Pietro da Cortona's great ceiling fresco, of 1633, in the *salone* of the family palace. The skies opened, and angels and allegorical actions underscored the philosophical Necessity of it all. In England, the painting cycle that did aspire to the supernaturalism of the masque was the Banqueting House ceiling, begun in 1629 by Rubens, proclaiming the wisdom of the rule of the Stuarts. However, when Charles I had himself represented by Van Dyck, he came closer to earth.[43]

One of the very first pictures that Van Dyck painted for Charles I contains a typical equivocation between public and private values and between an appeal for respect of an office and to the sentiments of the observer. Of course, it announces a message of dynastic confidence, for it tells the observer that the succession is secured, but the picture of Charles I and Henrietta Maria with Prince Charles and Princess Mary that was called 'One greate peece of Oᵣ royal self, consort and children' when it was paid for in 1632, is a painting of parents and small children.[44] The intimacy of its subject is contradicted by its enormous size. It could only go in a public – or relatively public – place. It originally hung at the end of the Long Gallery at Whitehall.

Of almost exactly the same size was the representation of the king of the following year, on horseback. The softer sentiments have no place in this more unequivocally public picture, *Charles I on Horseback with Monsieur de St Antoine.* Mounted, in armour and carrying the marshal's baton, Charles I is showing himself as master of the art of war. From the turn of its head and the tossed hair of its

Le Roi à la Chasse, c. 1635
Oil on canvas, 272 x 212 cm
Musée du Louvre, Paris

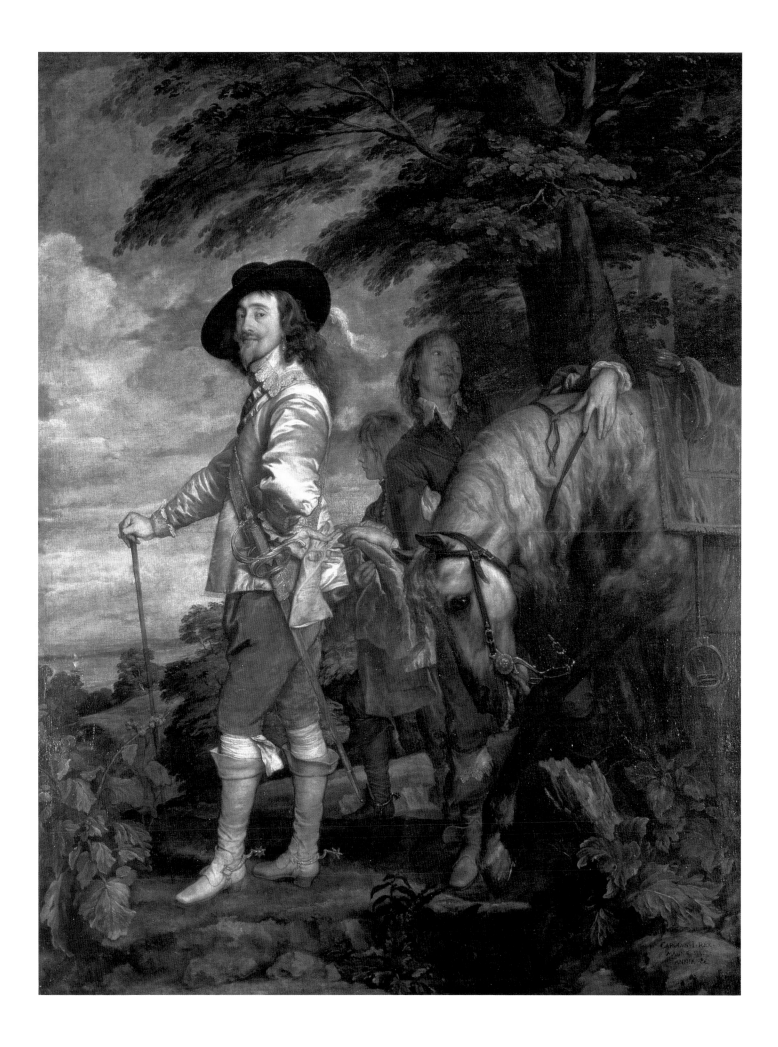

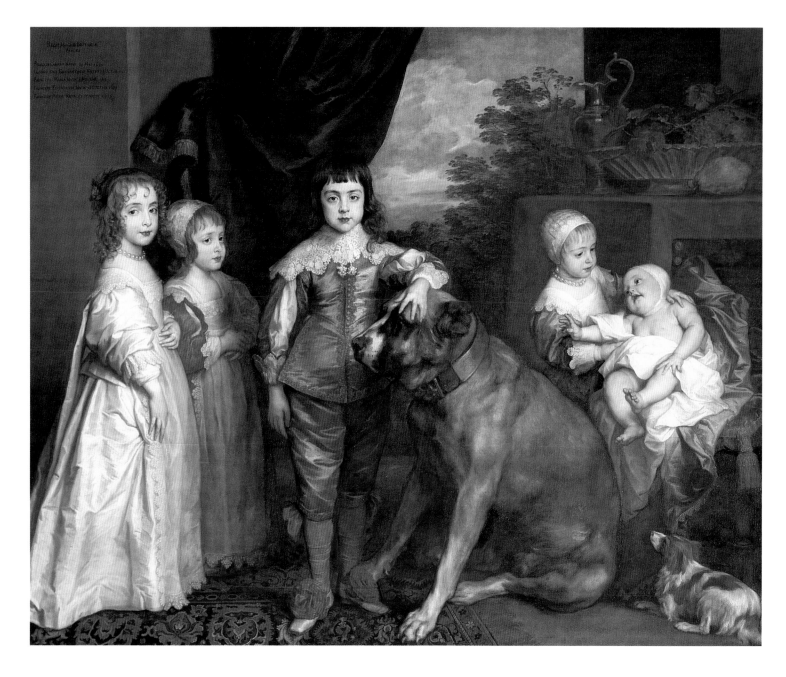

mane, it is clearly a spirited horse that Charles masters with such insouciant author-ity. All sorts of perspectival sharp practice contribute to the air of authority of the triumphant general. M. de St Antoine, his riding instructor, strides towards the pic-ture plane, holding the King's casque, and looks up. To be mounted, in the present instance, is to be enthroned as a lofty object of admiration. Charles I's head locates a horizon of its own, different from the horizons of M. de St Antoine, the cornice element at which the arch springs, the pedestal and landscape, for it has not been painted *di sotto in su*. There is a pre-Renaissance perspective sytem that is called 'herring-bone', because it allows viewing height to be shifted up and down the viewing axis, with the result that the orthogonal lines, rather than converging on a point, run parallel with one another. Van Dyck's picture, with its multiple horizons, is almost medieval in its perspective, and also in its relation of figure to architec-ture. As in medieval art, the architecture is made to defer to the figure. Here, the need for the arch to create a halo for the king has forced a miniaturization of the triumphal architecture, for his head has nearly reached the springing level. In order that this little arch should not seem to minimise the Triumph, Van Dyck tried to

The Five Eldest Children of Charles I, 1637
Oil on canvas, 163.2 x 198.8 cm
Her Majesty Queen Elizabeth II

Henrietta Maria, n. d.
Oil on canvas, 71.8 x 56.6 cm
Her Majesty Queen Elizabeth II

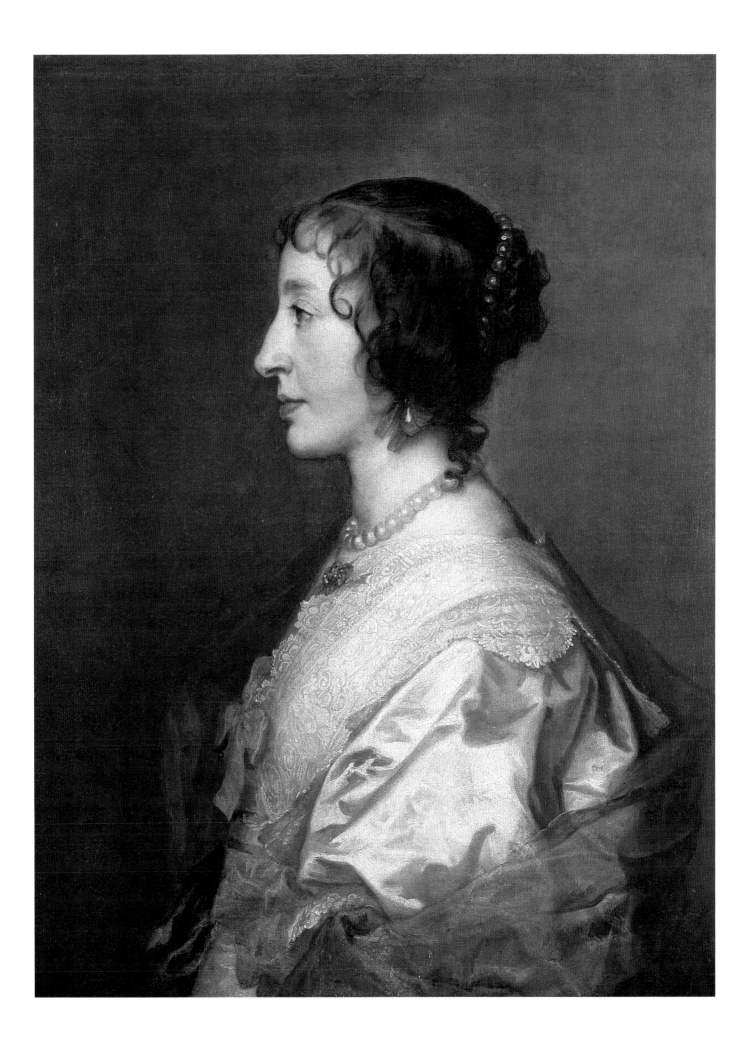

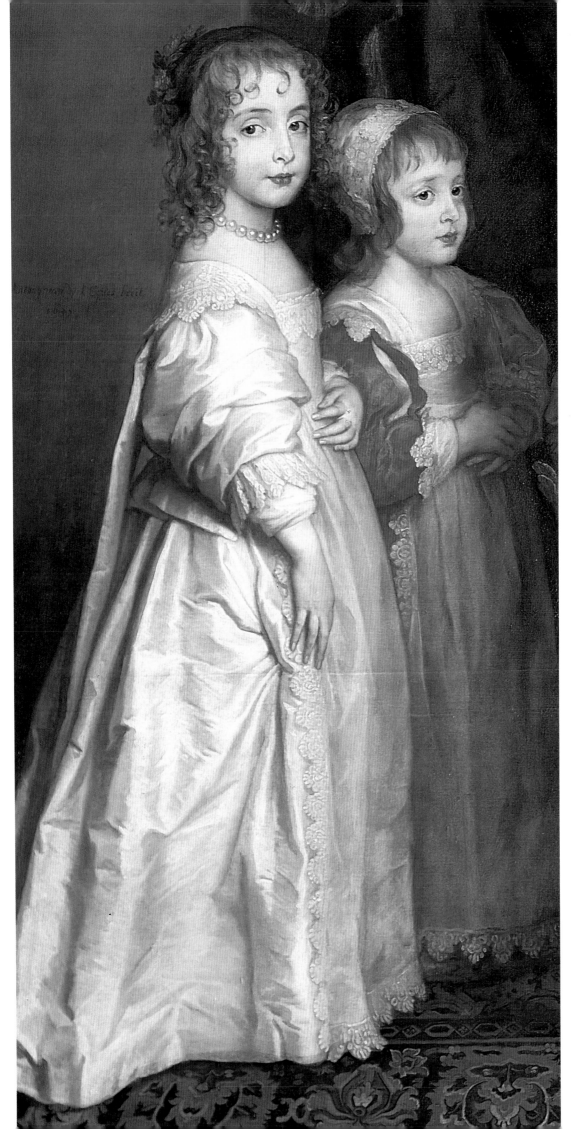

Detail from
*The Five Eldest Children
of Charles I*, 1637
(see p. 86)

Study for Henrietta Maria's Dress, 1633
Black chalk with white chalk highlights, and touches of red and yellow chalks, on blue paper, 41.9 x 25 cm
Ecole Nationale Supérieure des Beaux-Arts, Paris

make it look like a monumental structure by applying large fluted columns on high pedestals. However, if these columns were to have the height that the Classical rule of proportion demands, the capitals would come twice as high as the arch itself, which would diminish to the scale of a cat-flap. The column could not be permitted to dwarf the hero to such an extent. So Van Dyck hung a drapery over the top of one column and the base of the other, thus telling the viewer that there is no point in thinking about it.

The portrait is highly rhetorical, not too far removed from the lofty themes of the masque and the Baroque painting that makes the same sort of arguments. For the idea of the Triumph is that the victor has made a journey from mortal life to eternal fame. Another image of Triumph of a sort is *Roi à la Chasse*. However, it is without the staged quality of the picture of Charles in Triumph. Whereas Charles I, in the earlier picture, had set himself at the apex of a pyramid, at the base of which stood M. de St Antoine and the royal coat of arms, with the ritual eminence that that implies, he now stands, surprisingly and almost subversively, off-axis and facing in the direction of the near edge of the canvas. His horse and the busy grooms occupy the tree-shaded zone behind him on the other side. Also subversive of expectations is the star-burst composition of the lines of vision of the protagonists; it is the reverse of an interaction. At the same time, the asymmetry of the composition tells the observer that this is an action, not an icon. By a turn of his head and his glance, Charles makes acknowledgement. He has dismounted, removed a glove and received a stick from his younger attendant. Again, he is rewarded, this time with a break from the arduous business – or *negotium* – of statecraft. The landscape which he proposes to survey and walk in is a peaceful place. The effect of good government is the peace of the land. *Roi à la Chasse*, though smaller than the Triumph, is a large picture, and was thus intended for a relatively public view; but on the scale that runs from role to sensibility it occupies a place towards the latter pole.

Van Dyck's other task was the painting of Charles I's family. As the members were more remote from kingship constitutionally or by order of succession, the pictures, again, located themselves closer to sentiment than role. Henrietta Maria was a frequent sitter. As has been seen, the painter seems to have been required to make some improvements. But it should also be remarked that Van Dyck was not called upon to create an image of the Queen that made particular play of her associations with higher powers. In the early three-quarter length at Windsor, she engages the eye of the observer on a candid level of equality.

The children were documented at various stages. Charles, Prince of Wales, was, of course, given due prominence. He was also treated in a variety of ways appropriate to his later role, now in miniature armour, now leaning with aristocratic swagger against the plinth of a column in the company of his sister, Mary, and brother, James. He has precocious authority in these portraits though sentimental delight in the ways of childhood is not absent. In the picture with his siblings, he steadies both physically and psychologically his baby brother, James, holds the small child's hand who in turn holds on for balance to his forearm. A hand-holding of a very different character appears in the betrothal portrait of *Princess Mary Stuart and Prince William of Orange*, of 1641, in the Rijksmuseum at Amsterdam. The gesture is for the sake of displaying the ring on her finger, and the portrait claims the authority of a treaty between states rather than aims at the documentation of a meeting of hearts.

It is perhaps the political seriousness of the picture that demanded the brilliant and fastidious treatment of Mary's dress. *The Five Eldest Children of Charles I*

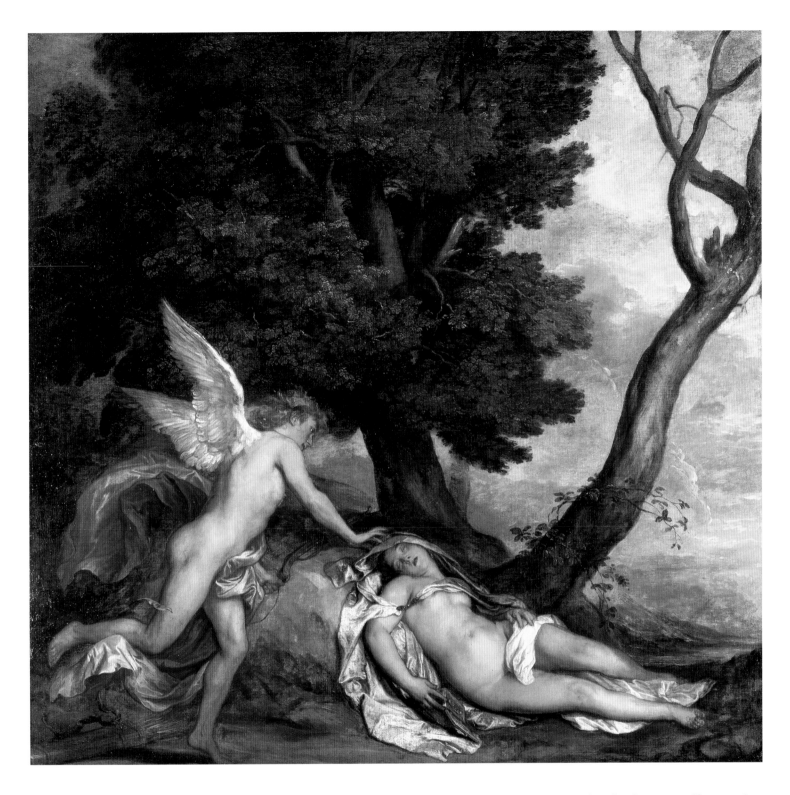

Cupid and Psyche, 1638–40
Oil on canvas, 188 x 195.6 cm
Her Majesty Queen Elizabeth II

choreographs very carefully the passage from undisciplined infancy to self-governing adolescence, with the children's objects of interest being very carefully graduated in terms of their seriousness. Charles, at the centre, his left arm resting upon the head of a massive dog, looks full-frontally at the observer. Mary also engages the viewer, but from three-quarter view, while James, beside her, looks elsewhere. *The Lomellini Family* (see p. 23) had been composed in terms of the same opposition. There, the children in the lower corner were luxuriously dressed and brightly coloured, and were stood on a rumpled carpet. The lively dog also gave informality to their group, contrasing with the grave tone of the rest of the portrait. In the picture of the children of Charles I, the two youngest, Elizabeth and Anne, occupy

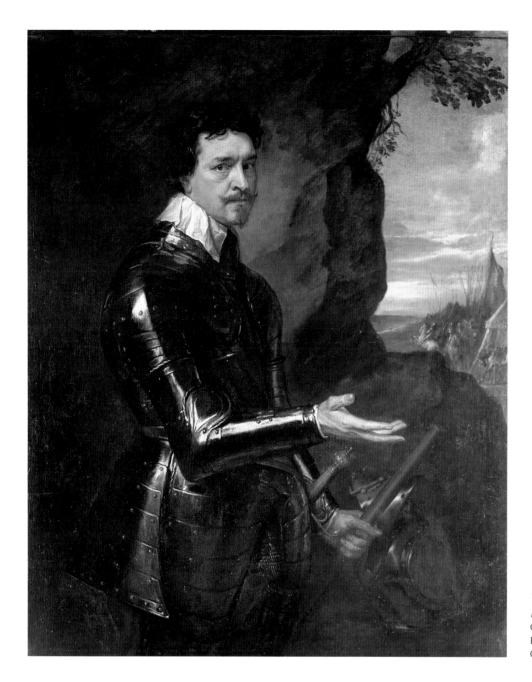

a zone and engage in actions that contrast the degrees of formality on the other side. If the picture is about the duties of government, it is subverted by the scene to the right. The older child's attention is absorbed by the baby who, in turn, reaches out to the object of her fascination, the huge dog. The baby is nude. For the painting to start the saga of the process of growth to maturity and responsibility at so early a stage is tantamount to anticipating Rousseau's argument that Émile should be instructed in remembering that his origins are in Nature. The ewer and copious bowl of fruit above the youngest children also talk of the state of Nature in celebratory terms.

At a more intimate level yet, Van Dyck painted *Cupid and Psyche.* It is possible that it was to be part of a cycle for the Queen's House at Greenwich, which was planned to include works by Rubens and Jordaens. As has been seen, Van Dyck's handling was here at its most Titianesque. In content, as a *poesia*, it is also very close to Titian. The story corresponds somewhat with that of Hercules. Virtue lost must be won again by Hercules through his labours; love lost must be regained by Psyche through hers. Painted in the idiom of Titian, the story is not couched in

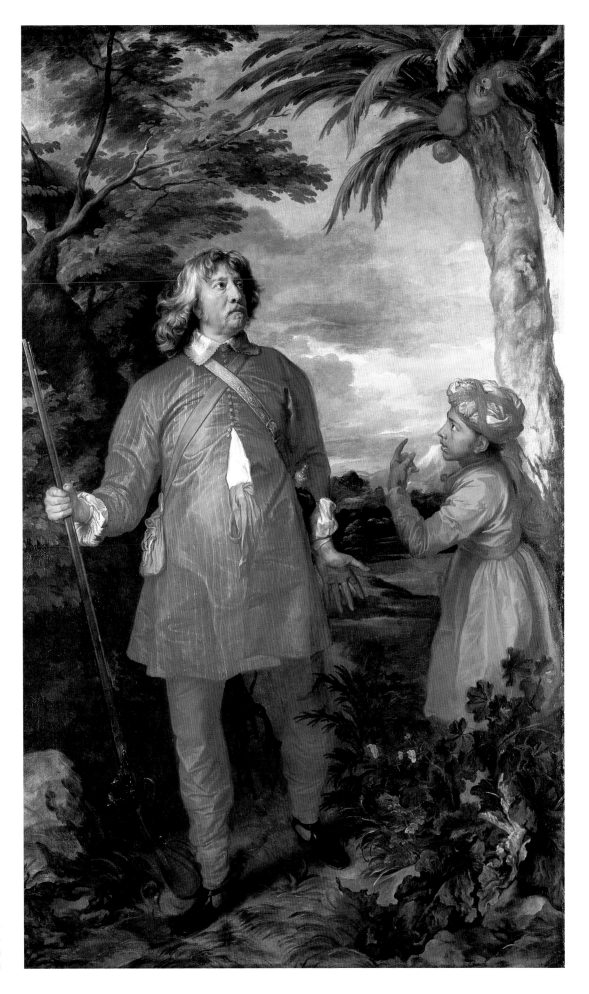

William Feilding,
1st Earl of Denbigh, 1633–34
Oil on canvas, 247 x 148 cm
National Gallery, London

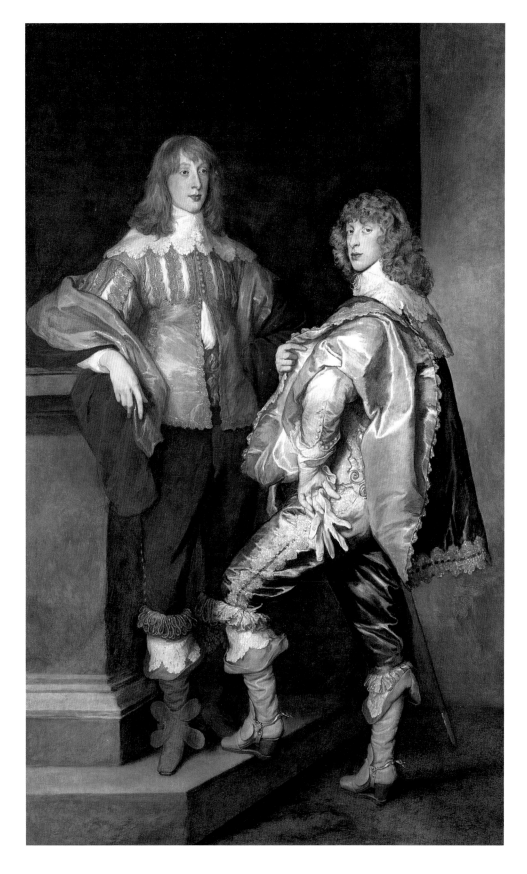

*George, Lord Digby
and William, Lord Russell,*
c. 1637, or earlier
Oil on canvas, 250 x 157 cm
Althorp Park, Earl Spencer

terms of philosophical exegesis, but of sentiment. The story of Cupid and Psyche was popular at the Caroline court. It no doubt represented, in some way accessible to poetical imagination, the marriage of Charles I and Henrietta Maria.

Aristocratic portraiture operated broadly within the same parameters as royal portraiture. Just as the monarch had reason to announce his humanity as well as

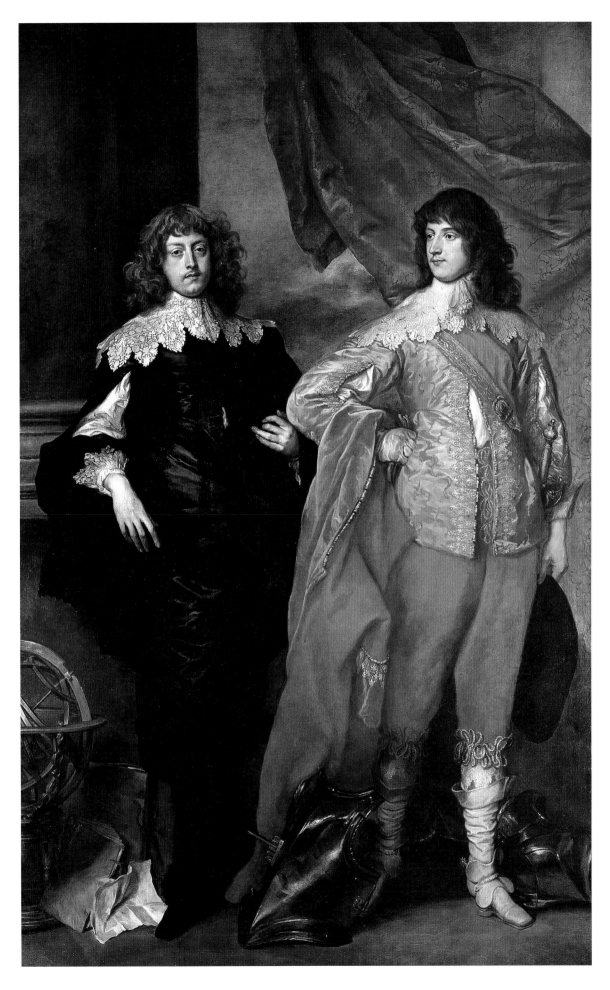

Lord John Stuart,
and his Brother
Lord Bernard Stuart,
c. 1638
Oil on canvas,
237.5 x 146.1 cm
National Gallery,
London

Detail from *Thomas Killigrew and an Unknown Man (William Crofts?)*, 1638 (see p. 98)

Detail from
*Lord John Stuart,
and his Brother
Lord Bernard Stuart,*
c. 1638 (see p. 95)

his authority, aristocracy had a role and claimed a sensibility. (From the evidence of the portraits, it sometimes seems as if some aristocrats were not able to look in both directions at the same time.) There might be a quasi-feudal duty to do again, and martial readiness remained a virtue. However, in the meantime, to be warlike and pious was not enough. Again, Renaissance humanism had produced the solution to the problem of redundancy for aristocrats in the post-feudal age. It had rediscovered and re-presented an ideal of nobility that could persist outside of the perilous conditions of feudalism. While some people lived under the yoke of necessity and others had economic and social power sufficient to enable them to exploit their situation, the noblest human being was the one who was above both need and greed. The aristocrat, so long as he was sufficiently inured, could have the privilege of conducting himself disinterestedly. A life of aesthetic self-improvement could be the way.

Thomas Killigrew and an Unknown Man (William Crofts?), 1638
Oil on canvas, 132.7 x 143.5 cm
Her Majesty Queen Elizabeth II

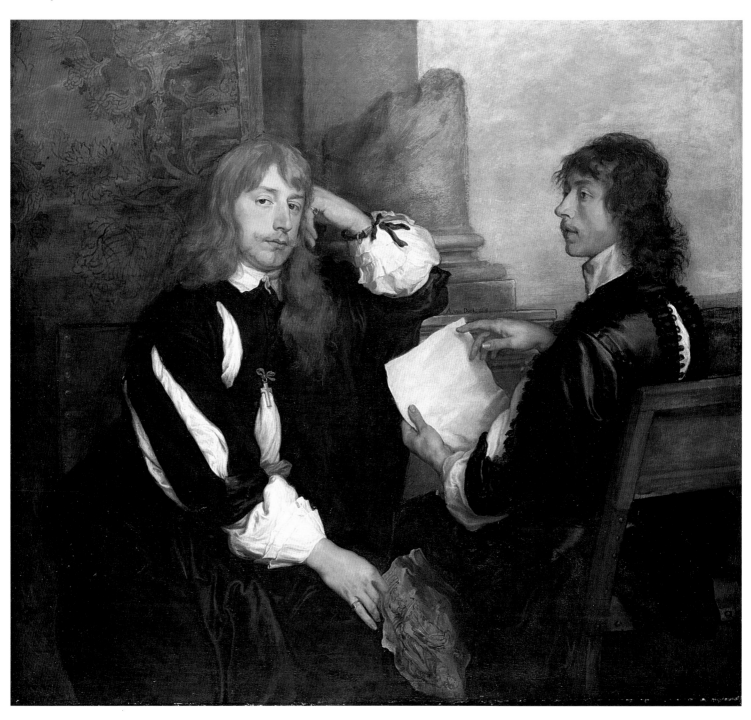

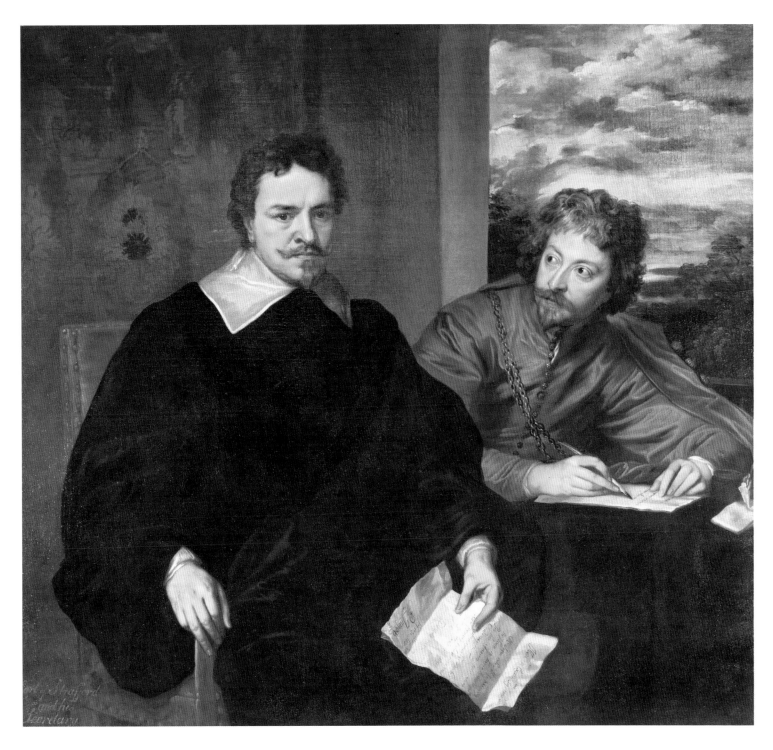

*Thomas Wentworth, Earl of Strafford
with Sir Philip Mainwaring*, 1640
Oil on canvas, 123.3 x 139.7 cm
The Weston Park Foundation

So, there emerged an aristocrat who was in two minds; concerned with duty and with the representation of his class as the model of disinterest. Inigo Jones, in 1615, expressed something of this existential dilemma:

And to saie trew thes composed ornaments the wch Proceed out of ye aboundance of dessigners and wear brought in by Michill Angell and his followers in my oppignion do not well in sollid Architecture and ye fasciati of houses, but in gardens loggis stucco or ornaments of chimnies peeces or in the inner parts of houses thos compositiones are of necessety to be yoused. For as outwardly every wyse man carrieth a gravitie in Publicke Places, whear ther is nothing els looked for, yet inwardly hath his immaginacy set on fire, and sumtimes licentiously flying out, as nature hir sealf doeth often times stravagantly, to dellight, amase us, sumtimes moufe us to laughter, sumtimes to contemplation and horror, so in architecture ye outward ornaments oft [ought] to be sollid, proporsionable according to the rulles, masculine and unaffected.[45]

The exterior man and the interior or private one were different. The aristocrat was drawn in both directions, and Van Dyck was the artist able to make sense of the ambivalence in his portraiture.

Where the sitter was clear about his role, Van Dyck would oblige. George Stuart, Phillip Wharton and John Suckling had brought their own costumes along, but they clearly did not intend to announce their public role. The same would be the case of *William Feilding, 1st Earl of Denbigh*. But the picture has a story to tell of more general interest. Feilding comes back with a traveller's account of India, her exotically clad people and the astounding colour of her avian fauna. *Algernon Percy*, on the other hand, dressed in armour, holding a marshal's baton and with an anchor as his attribute, has clearly done the portrait equivalent of signing up as a volunteer. Thomas Wentworth, Earl of Strafford, also had himself painted in armour, in the portrait at Petworth. A naval battle was shown taking place behind Percy, but his equanimity is quite undisturbed by it. A mustering of cavalry is taking place behind Wentworth, and he looks altogether more tensely involved with proceedings, partly because of the sharpness and therefore anxiety of his glance and partly because of the gesture of his free hand. If he would turn round toward the viewer, his action would be the same, though in mirror image, as Hendrick van der Bergh's.

Lord John Stuart, and his Brother Lord Bernard Stuart have nothing to say about their role in society. Indeed, they have little to communicate by way of sensibility either. However, the picture serves as a useful corrective to the temptation to find an unmediated truth in a portrait. It represents the brothers in a state of having turned away from duty; but they did not therefore have no sense of loyalty to a cause for, come the time, they both fell in the Civil War. Another double portrait, that of *George, Lord Digby and William, Lord Russell*, seems at first to refer to the individuals in relation to society rather than their private cultivation. But it is ambiguous. Indeed, it is divided by a stark fissure in form and content. The young men were students at Oxford together. The composition indicates that distinct temperaments direct them towards different careers. Extravagant in reds and energetic, Russell stands forward, a gloved hand on his hip, a sword at his side and a hat in his other hand, against a billowing drapery, with pieces of armour strewn about at his feet. By contrast, leaning on the pedestal of a marble column, and providing himself with some support physically, intellectually and morally, and dressed in black, is Digby. At his feet are the apparatus of the scholarly life; book, paper, portfolio and armillary sphere. Can such unlike characters be friends? The answer is yes, if their contrast is programmatic rather than real. In fact, they probably represent the two aspects of Minerva, the goddess of Wisdom, War and Peace. It is an emblematic rather than a living contrast.

Neither the Stuarts nor Russell and Digby interact dramatically, and to that extent, their inner lives are somewhat opaque. Sensibility, in the Caroline *milieu*, like in the other societies in which Van Dyck worked, was a function of the drama, sometimes no more than the tiniest perturbation of spirit, that gives focus to the actions and thoughts of the sitters. Hanmer's business with the glove was eloquent.

Of double portraits, that of *Thomas Wentworth, Earl of Strafford with Sir Philip Mainwaring* is very different from those already discussed. It elaborates upon Titian's portrait of *Cardinal Georges Armagnac and his Secretary Guillaume Philandrier*. The psychological contrast between Van Dyck's sitters creates a drama that is tense. The picture looks like a meditation upon the philosophical alternatives of 'present to sense' – Mainwaring's experience – and 'present to thought' – Wentworth's. Wentworth, saturnine as in his Petworth portrait, has let drop his hand which holds the letter that he has been reading, and he looks unseeingly ahead and downwards.

Venetia Stanley, Lady Digby, as Prudence, 1633–34
Oil on canvas, 101.1 x 80.2 cm
National Portrait Gallery, London

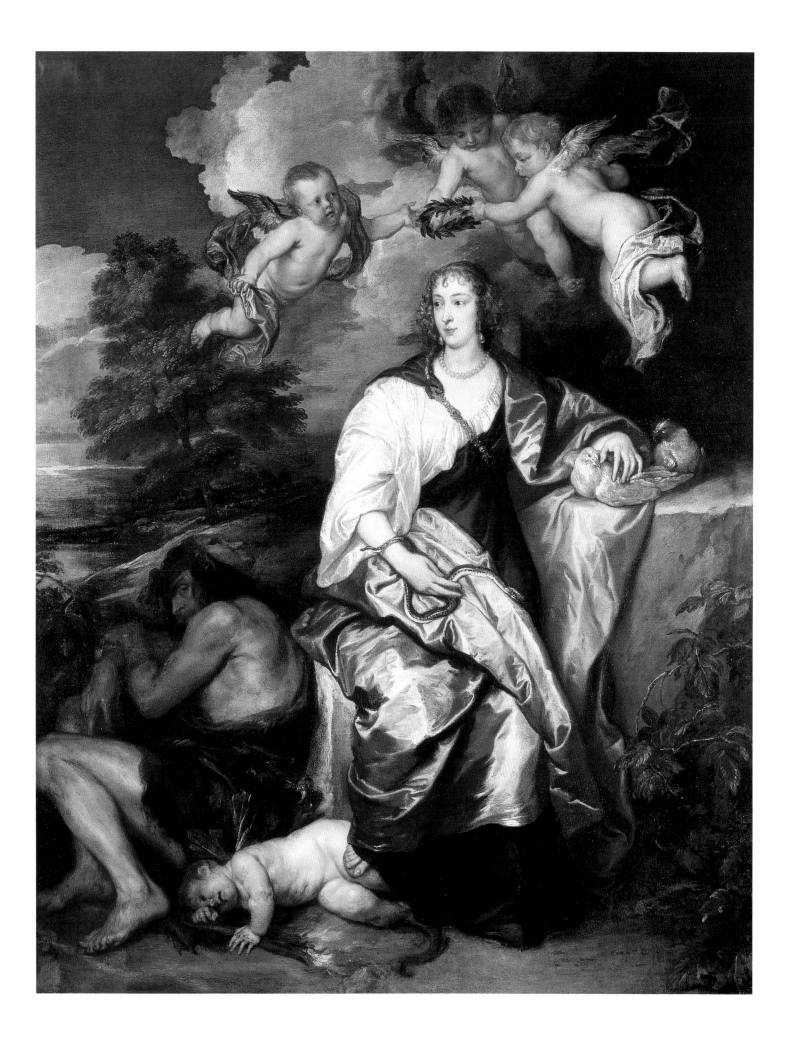

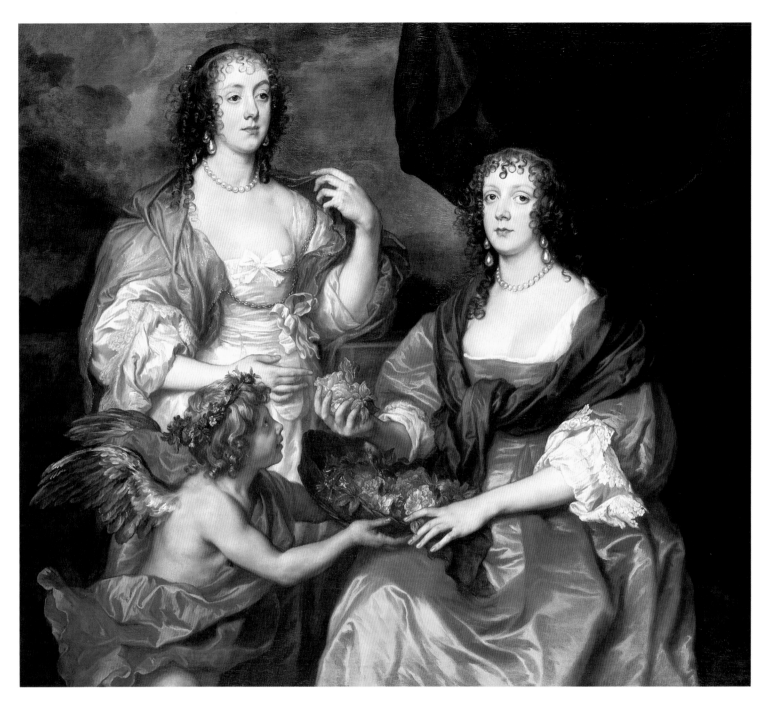

Mainwaring is seeing in a very full sense, his eyes turned strainfully towards Wentworth. He looks for the movement which will accompany the sound which will form the words that he will write down. The contrast is also between the active and the passive. Mainwaring's tousled hair, the red of his jacket and the landscape behind all speak of action and engagement in the world, compared with Wentworth's withdrawal and melancholy. In Albrecht Dürer's (1471–1528) famous engraving *Melencholia I*, a cherub perched on a millstone scribbles away furiously while the fallen angel stares into space. The set-up does not quite match.

The theme of melancholy and the individual being drawn back from it is also the narrative subject of the portrait of *Thomas Killigrew and a Unknown Man (William Crofts?)*. The sitters have required a representation of themselves in mourning for their wives – sisters who died within a short interval. Killigrew wears his wife's ring upon a ribbon round his wrist. In the lethargy of melancholia, he needs to prop up his drooping head as he lets fall the other hand which only just

Dorothy Savage, Viscountess of Andover and her Sister Elizabeth, Lady Thimbleby, c. 1637
Oil on canvas, 132.1 x 149.9 cm
National Gallery, London

Mrs Endymion Porter, c. 1640
Oil on canvas, 135.9 x 106.7 cm
The Duke of Northumberland

102

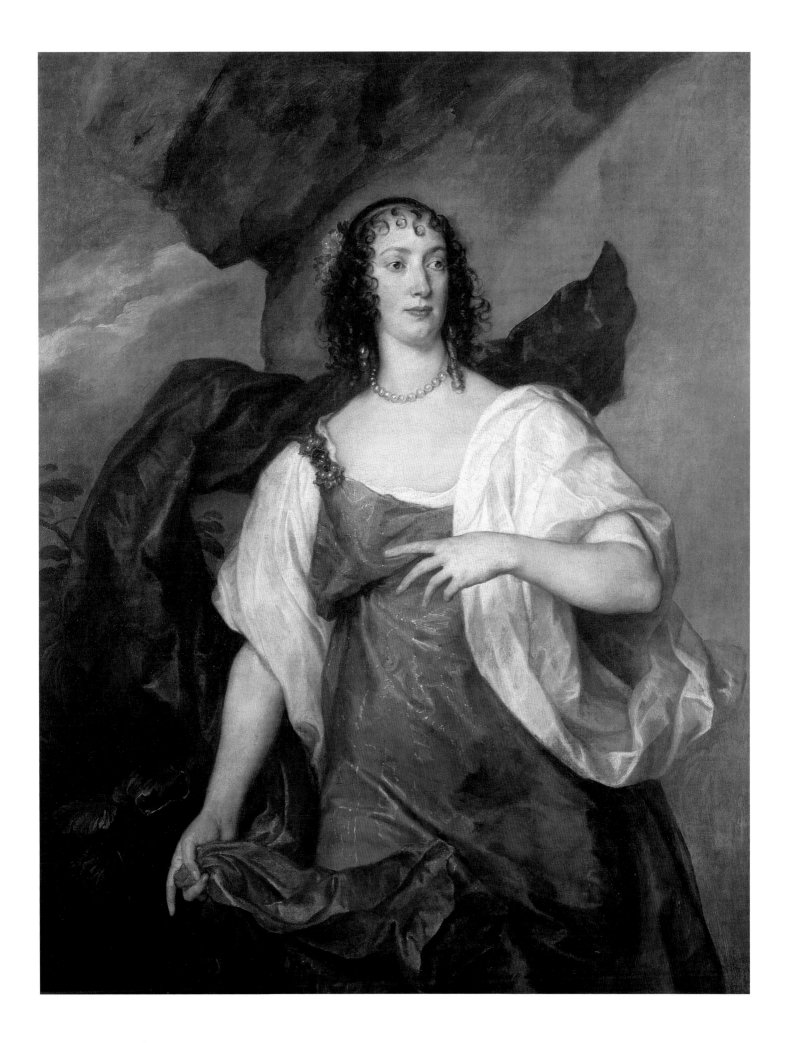

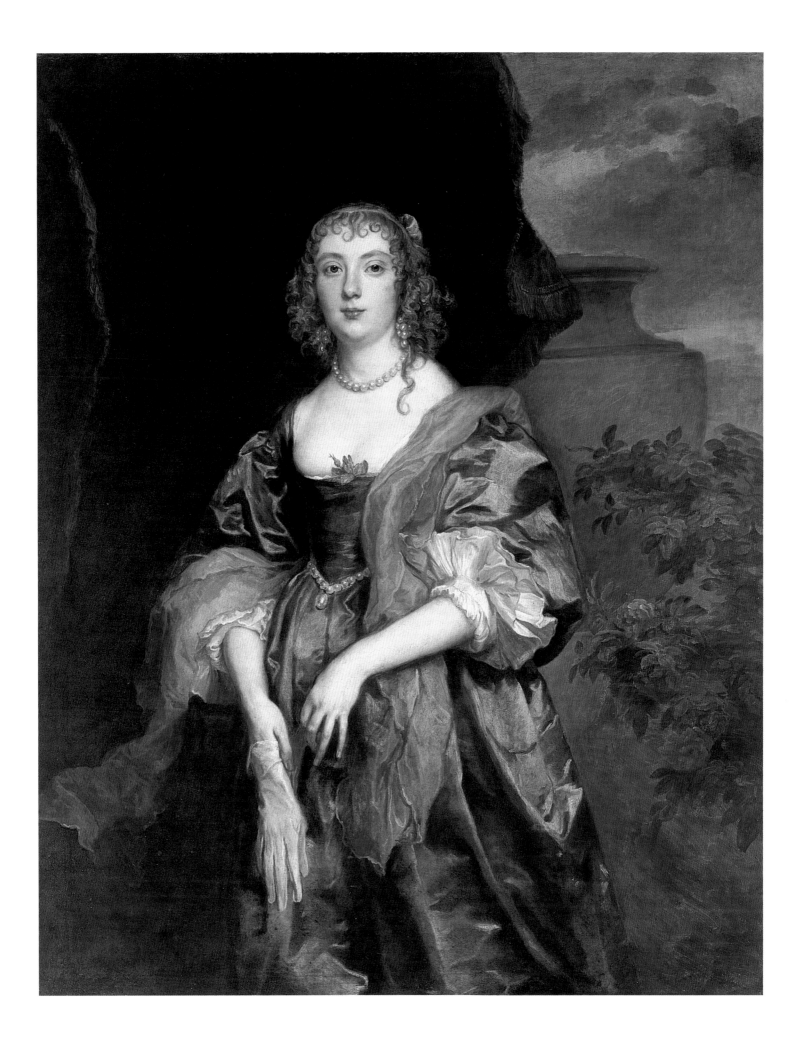

keeps hold of the paper, on which is a design for his wife's tomb. The grey sheet is juxtaposed, on the vertical axis, by the blank sheet to which Crofts points. Above it is the emblem of defeated hope, the broken column. He sits in stoic profile. As it was not quite appropriate to compare Dürer's engraving above, so it would be improper to liken the sitters here to Mozart's Dorabella and Fiordiligi. But the thought is set in train by the recognition that the action of the picture is also aural. Killigrew is silent and Crofts speaks quietly, for his act of looking is not reciprocated. In addition, there is the somewhat surprising contradiction of the prevailing mood. Killigrew looks at the viewer and to that extent is not inattentive to the world. And Crofts, whose sheet of paper is blank, is perhaps to be thought of as proposing that there is work to be done, an elegy to be written, an absent Muse to be invoked. So, the theme of melancholy is simultaneously stated and undermined.

Whatever the fine print of a reading of this picture, it is clear that the sitters played a crucial role in programming it. Something similar would have to be said of another portrait whose theme is melancholy. Closer to the melancholy of Dürer's figure than Wentworth and not dissimilar to Killigrew is *Henry Percy,* in the posthumous portrait at Petworth. A tight framework of verticals and horizontals marks out his shallow space, but Percy's body in all its parts falls into ill-fitting diagonals. He leans upon a piece of paper upon which, it has been shown, is written the proposition of Archimedes to the effect that if he had a long enough lever and somewhere to set the fulcrum, he could move the world. It can be read as an emblem of melancholy, for the greater the weight the more distant must be the fulcrum. By analogy, the greater (more universal) the idea, the more remote must be the perspective upon it and, perhaps, the weaker the light of understanding. Whatever the true interpretation of the text, it was supplied to Van Dyck rather than invented by him.

When narrative or drama infiltrates the portrait, the credit for invention should be in favour of the painter. When emblems are used to give thematic content to the portrait, then the commissioner is likely to have been the instigator. An obvious case of emblematic portraiture would be *Mary Villiers as St Agnes,* at Windsor. She has come supplied with lamb and martyr's palm, or at any rate armed with the instruction to Van Dyck to include them. *Venetia Stanley, Lady Digby, as Prudence,* is a full-blown allegorical portrait. Bellori, who discussed Van Dyck's career in England with her husband, Sir Kenelm Digby, described the original picture eloquently:

> The same Sir Digby had the idea to have his wife painted on a large canvas in the guise of Prudence sitting in white robes with a coloured cloak and a bejewelled girdle. She extends one arm towards two white doves, and a serpent is wound round the other. She has, under her feet, a cube to which are tied, in the manner of slaves, Fraud with two faces, Wrath with an expression of fury, Envy emaciated and with serpents for hair, Profane Love bound with clipped wings, broken bow, arrows scattered, his torch extinguished, with other nude figures. Above, there is a glory of angels, playing and singing, three of whom hold the palm and the garland above the head of Prudence, signifying victory and triumph over the vices, and the motto is taken from Juvenal "Except with wisdom there is no religion". [46]

On a larger scale, such a theme could well be frescoed on to a ceiling. It looks as though members of the English aristocracy might allow themselves imagery that the Monarchy denied itself.

The programme of *Dorothy Savage, Viscountess of Andover, and her sister Elizabeth, Lady Thimbleby,* congratulates the sitters in softer tones. Cupid enters bearing a basket of flowers, mostly roses, the gift obviously coming from Venus, goddess of love and springtime. The painting was probably commissioned to celebrate Dorothy's marriage. Her name-saint's attribute is also a basket of flowers. The

Lady Anne Carr,
Countess of Bedford, c. 1638
Oil on canvas, 136.2 x 109.9 cm
Petworth House, The Egremont
Collection (The National Trust)

Detail from *Lady Anne Carr, Countess of Bedford*, c. 1638 (see p. 104)

Detail from
Maria Luigia de Tassis,
c. 1629 (see p. 109)

life which Dorothy and Elizabeth have here by virtue of emblematic enrichment could not be called dramatic. But such devices serve well enough for the marking of female life-events – marriage, pregnancy, motherhood.

Olivia Porter, the wife of Endymion, however, has a livelier part to play in *Mrs Endymion Porter*, and indeed she seems to be acting out a part, for the drama looks to be one that calls upon her acting skills rather than to be a real crisis in her life. She runs in a rocky landscape and her garments are windblown. Malcolm Rogers catches the quality of social disengagement of the picture: 'It is hard to envisage the Marchesa Elena Grimaldi (National Gallery of Art, Washington) contemplating such a rash excursion among the rocks and bushes, wearing only her shift, a confection of draperies, and a simple string of pearls'.[47] In 1658, William Sanderson wrote that Van Dyck was the first painter 'that e're put ladies dress into a carelesse Romance'.[48] The implication is that something of the *poesia* invaded the lives of his English sitters and with that the interest is in sentiment rather than declamation.

'Carelesse Romance' locates the sitter outside the norms of social conduct. The intimacies of lovers happen there, and if there should be a picture, it is a private thing, impenetrable to vulgar enquiry. Olivia Porter seems to carry some such secret message. There is a certain carelessness too in *Lady Anne Carr, Countess of Bedford*. Her gauzy stole is tossed by a breeze. It is a cagey performance on her part, and suggestive at the same time. The directness of her frontal pose and gaze is slightly surprising and, when put together with that note of abandon struck by her stole, is perhaps a little less than demure. The viewpoint is slightly low, so that the underside of her chin can be seen and the viewing distance seems unusually short. Van Dyck frequently allowed a ringlet to uncurl over a lady's shoulder, but this curl unwinds further. In her decolletage is a tiny posy with a rose bud and at the level of her navel is a pearl. The fingers of her lowered left hand are unusually posed; they look as if they are playing stops on a woodwind instrument. Her right hand – also unusually – is partly inside a glove. It is assuredly not her own since it both lacks its companion and is too big. This is not a picture to be kept in a *studiolo* (it is too big for that) but while the viewer in general is welcome to look, there is someone else who sees it better than the generality ever could. In this portrait there are emblematic details; but the general viewer is aware that there is also a life of engagement that breaks through the conventionality of signs, so that Anne Carr herself breaks out of typicality.

The variousness of Van Dyck's portraiture has been remarked upon. Insofar as his sitters were defined by convention, there was no reason for him to abandon the formula. Often enough and perhaps increasingly, as would be expected, he did resort to emblems and conventions. But with more than impressive frequency he made of portraiture an art of invention. This must reflect some credit upon the sitters. The most engaging of them live a life only half of which is conducted according to social norms. Back in Flanders, immediately before his removal to England, Van Dyck painted *Maria Luigia de Tassis*. Like *Philippe le Roy*, she had aimed at symmetry when she dressed and hung a cross from her neck and pinned another jewelled one from which hung a pearl to her bodice. The strings of pearls had also added to the order of her appearance. But in her portrait, instead of the vertical axis of formal conduct, there rules a strong compositional diagonal, at either end of which is a fan. Her fan-like starched collar which had added to her symmetry contrasts with the unruly ostrich feathers of the fan that she holds. How seriously is it possible to take the modesty of a person behind such a fan? In other words, Maria Luigia stands between rule and licence. That is where everybody stands. Van Dyck says that life is the painful condition between two poles, both of which are death.

Maria Luigia de Tassis, c. 1629
Oil on canvas, 130 x 93.5 cm
Princely Collections, Vaduz Castle

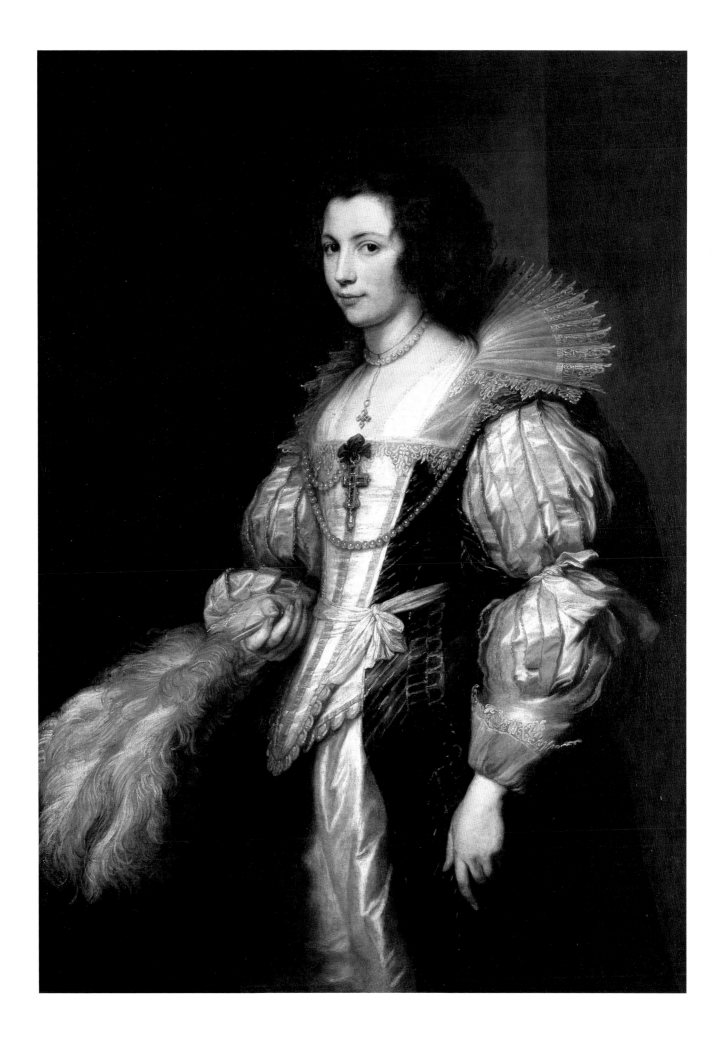

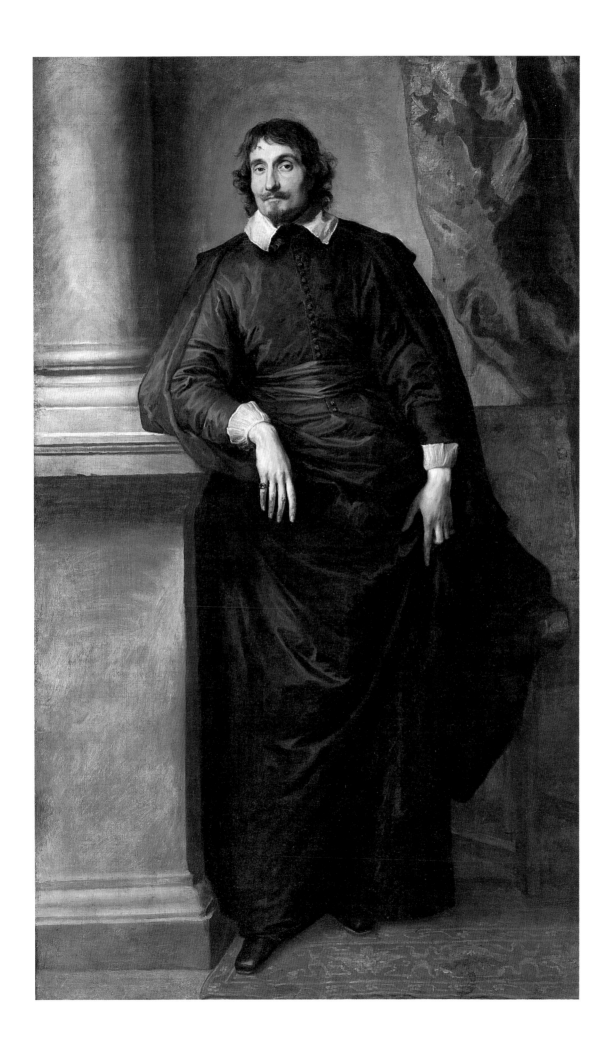

Van Dyck, 'peintre flamand'

Conclusion

Van Dyck's sitters are never so ruled by protocol that they are denied *sprezzatura*. It can be a matter of physical athleticism or the 'immaginacy' of which Inigo Jones wrote. Van Dyck delighted in setting the trap of formal or social convention for the sitter, and then showing its powerlessness. Genoa's severe matrons yet suffer the presence of unruly creatures. Men of duty think of a less-governed condition. Ladies, if scrutinised closely enough, make us lose our confidence in their modesty. In short, the observer is very often thrown off balance by Van Dyck's portraiture.

A brilliant example of Van Dyck's setting the trap, only to allow the sitter to spring it, is the portrait *The Abbé Scaglia*. The subject is hemmed in, allowed a narrow channel of freedom of movement between a column with an implacably ruled pedestal and a hanging brocade drapery. The principles of order represented by the architectural props, and of disorder, represented on the other side – earth and air – do not, however, succeed in oppressing this individual. With what reads as almost an insolent casualness, he leans his elbow on the pedestal. Perhaps he was disabled; at any rate, his other arm does not come as low as would be expected, but it hangs like a plumb line. It is a less relaxed hand, partly cast in shadow – light and shadow, like Titian's, having their own reason, indifferent in how they fall. If the picture were divided into three, vertically and horizontally, four ninths of the picture would be taken up by the near-impenetrable darkness of the bottom corner; no question of the vignette here. So, the swagger of the whole pose of Scaglia is only dimly to be made out, but it follows the extravagant curve of a Gothic carved saint.

The vertical divide of the composition in terms of order and disorder was used again, in for example *George, Lord Digby and William, Lord Russell* (see p. 94). But when it became an old idea dusted off, the column and drapery ceased to imprison, and became simply emblems. Another unbalancing device used in the Scaglia portrait was employed again in, for example, the portrait of *Thomas Hanmer* (see p. 57). The sideways tilt and turn of Scaglia's head together with the very slight backward tilt represent a turning away, like Hanmer's, from the observer, who finds himself looked at askance and a touch sceptically. The self-possession that Scaglia acquires from this tiny action gives the picture a verisimilitude that releases him and the portrait from conventionality.

Van Dyck's discovery of imbalance was vital for his art as a portraitist. By a multitude of means, he disorientates the observer. In *Endymion Porter and the Artist*, for example, he arranges for Porter not to catch the observer's eye while Van Dyck does so with a sharp glance. It is as if the picture had strabismus. *Le Roi à la Chasse* (see p. 85) is another picture that as-it-were has a squint because of the odd placing of the main figure. If conventionally a portrait is a tall rectangular field with a vertical element in the middle, this is not, strictly speaking, a portrait, or else convention has to be removed from the definition. There are cases where the very verticality of the field is refuted, as in *Algernon Percy*, presumably intended for a special location. But there are also instances of portraits whose action is in the horizontal plane, such as landscape, *Wentworth and Mainwaring* or *Killigrew and Crofts* (see pp. 98/99), for example. Imbalance or contradiction showed itself most obviously in the almost omnipresent compositional device of the diagonal. In asserting the diagonal, Van Dyck was taking part in a battle involving lots of combatants on his

Detail from *Thomas Hanmer*, 1638 (see p. 57)

Cesare Alessandro Scaglia di Verrua, Abbé of Staffarda and Mandancini, 1634–35
Oil on canvas, 204.5 x 124.5 cm
On loan to the National Gallery, London

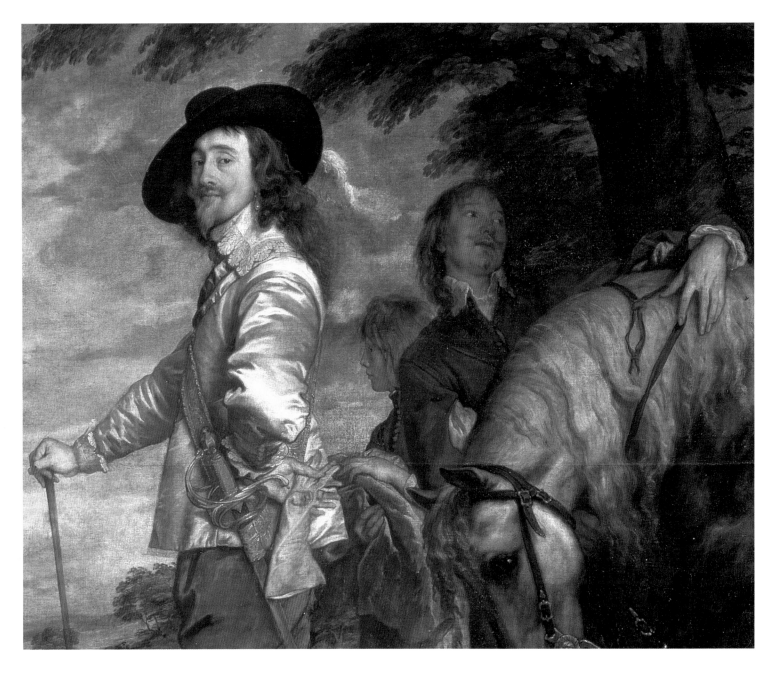

Detail from
Le Roi à la Chasse,
c. 1635 (see p. 85)

side. Like other Baroque painters, he was about the business of subverting the predictability implicit in the vertical and horizontal. From the Baroque point of view, to see a picture governed by clear verticals and horizontals was like waking up every morning and having to remark that the law of gravity was still working.

Van Dyck was also an artist of the Baroque in another subversion that he perpetrated. As the resources upon which his portraiture called have been identified, it has become clear that the integrity of the genres had no place in his art. He invoked history painting, in particular, to help him invigorate his portraits; but he also exploited still life. When he imported emblems and inanimate props, he was calling upon the viewer to seek in imagination the connection between them and the sitter, and both acquired a pulse as a result. This mixing and co-opting of the genres made perfect sense to artists such as Rubens and Bernini.

The effect of disrupting categories is to undermine rational structures. Imbalance does the same literally and metaphorically. His sitters existed between poles, or at the crossroads; they were nearly always in two minds. In those circumstances, it was the moving, shifting, disrupting, living force that celebrated life and art. It is

Endymion Porter and the Artist, c. 1635
Oil on canvas, 110 x 114 cm (oval)
Museo Nacional del Prado, Madrid

therefore the case that *Cesare Alessandro Scaglia di Verrua, Abbé of Staffarda and Mandancini*, for all the sobriety of his context, is brother in spirit to *François Langlois as a Savoyard*. Langlois is as compositionally and psychologically antagonistic to the frame as *Henry Percy* was in his melancholy abandon. But it is geniality that refuses to be caged here: his other brothers are in the work of Frans Hals and Annibale Carracci. He is tipped in every way, his head thrown a long distance off axis – nearly as far as Charles I's head in *Le Roi à la Chasse* – and his line of sight is strongly downwards and to the side, for he is nearly full-face.

Van Dyck's portraiture, with remarkable consistency, given his enormous output, retains the likeness of the sitter despite the demands of convention and improvement. The part of the portrait that consists in likeness is the outcome of that hour of real encounter between sitter and artist in the studio. Evidence of the force of Van Dyck's commitment to vision and to the individual before him is nowhere more clear than in his picture of Langlois. The observer is delighted to rediscover that Van Dyck has observed the life in its absolute particularity of time and place. What Van Dyck registered, in the particular light of that day was, again, life's essential

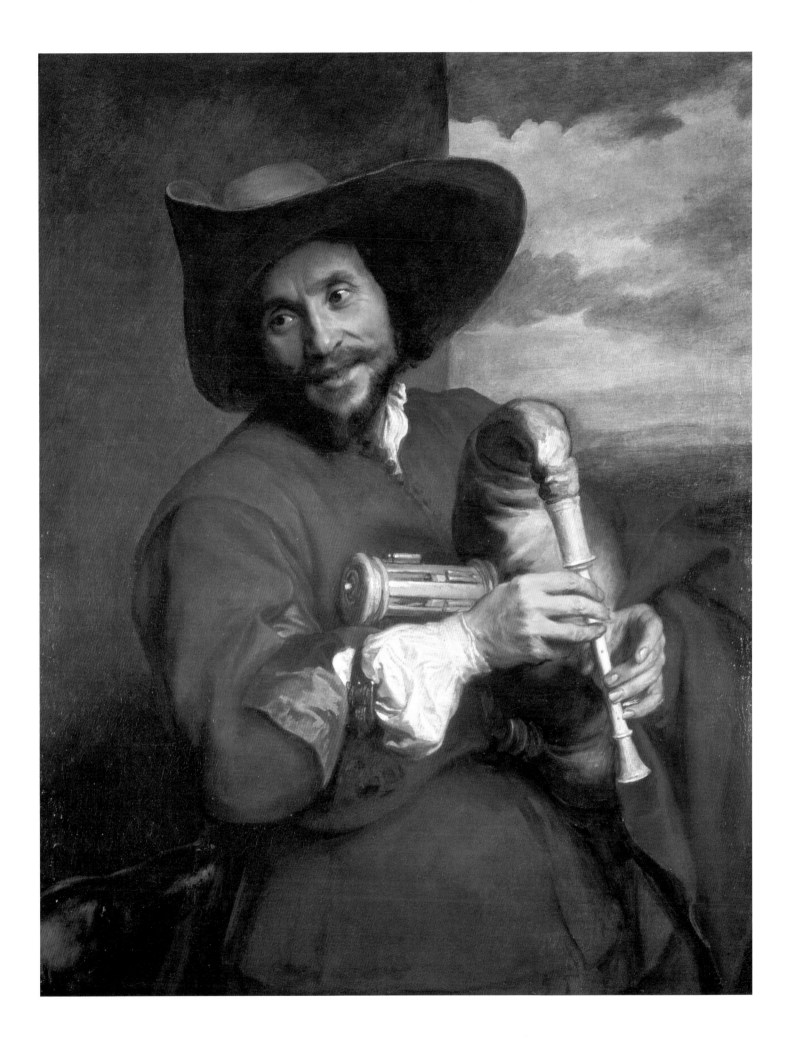

asymmetry. In real experience, eyes, for example, are not two of the same thing and therefore requiring the same treatment. So, here, the highlights and the signs of moisture in the eyes are differently distributed. And teeth, in the shadows of a mouth opened in a smile, are not white. The fact of him being slightly gap-toothed had to be improvised.

Of course, all this has nothing to do with the fancy dress. And it is fancy dress; the viewer is not to fear that this might be a real bagpiper, for he would be unlikely to have a silk lining to his sleeve. A drawing survives; however it is for the composition, not for the sake of registering the specifics of Langlois's appearance. Langlois may well have turned up for his sitting in quite different gear. Indeed, the painting has been done almost certainly in Langlois's absence. Van Dyck collected the basic physiognomical and physiological data, and worked it up later. But, in addition, and crucially for the glorious liveliness and geniality of this picture, he has noted those key incidents of light and surface that make of it an experience of Nature.

Bagpipers often turn up in pictures of the Nativity. They are the shepherds. The kings will arrive later with due pomp and gravely cognisant of the significance of things. The shepherds' understanding is of a different sort, consisting in a sensibility affirming sensation and nature. Van Dyck understood the condition of the kings. They would have to cast off dignity at last. This is the sensibility that had created a portraiture that marked the stress of living in society. In 1634 Van Dyck entered into negotiations to buy a property in the country – later, Rubens's Château de Steen.[49] It would have been a place of retreat. Its spiritual occupant at the beginning of the next century and, in an important sense, Van Dyck's successor, would be Antoine Watteau.

François Langlois as a Savoyard, 1634–37
Oil on canvas, 103.6 x 84.1 cm
National Gallery, London

Notes

1 J. Roberts, *Holbein* (Oresko Books, London, 1988), p. 5.

2 H. Walpole, *Anecdotes of Painting in England* (new edition by R. Wornum, London, 1988), vol. II, p. 94. The painter who seems actually to have acted in accordance with these instructions was the miniaturist, Samuel Cooper (1609–72).

3 C. Brown, *Van Dyck* (Phaidon, Oxford, 1982), p. 140.

4 Quoted by O. Millar, *The Tudor, Stuart and Early Georgian Pictures in the Collection of Her Majesty the Queen* (Phaidon, London, 1963), p. 96.

5 Roger de Piles, *The Art of Painting and the Lives of the Painters, ... to which is added an essay towards an English-School with the lives of above 100 painters* (London, 1706), p. 470.

6 G. P. Bellori, *Le vite de'pittori, scultori e architetti moderni*, ed. E. Borea, introduction by G. Previtali (Einaudi Editore, Turin, 1976), p. 272.

7 Bellori, *Le vite*, p. 273: 'Ma parendogli tempo di trasferirsi in Italia, partitosi dalla patria si fermò ... in Venezia, tutto rivolto al colorito di Tiziano e di Paolo Veronese, nel quale fonte si era imbevuto anche il maestro [Rubens]. Copió e disegnó le megliori storie ... e così intinse il suo pennello ne' buoni colori veneziani'.

8 De Piles, *The Art of Painting*, p. 303.

9 Brown, *Van Dyck*, p. 137.

10 Brown, *Van Dyck*, p. 131 and p. 231 note.

11 Brown, *Van Dyck*, p. 221 and p. 232 note.

12 Brown, *Van Dyck*, p. 214 and p. 232 note.

13 See C. Hope, *Titian* (Jupiter Books, London, 1980), pp. 163–64: 'Après avoir legerement ébauché un Portrait, il faisoit mettre la personne dans l'attitude qu'il avoit auparavant méditée, & avec du papier gris & des crayons blancs et noirs, il dessinoit en un quart d'heure sa taille & ses habits qu'il disposoit d'une manière grande, & d'un goût exquis'.

14 A. Grosart, *The Complete Works in Verse and Prose of Abraham Crowley* (Edinburgh University Press, 1881), vol. I, p. 138.

15 Bellori, *Le vite*, p. 272: 'La quale opera ritiene la prima maniera di Rubens'.

16 De Piles, *The Art of Painting*, p. 304.

17 Bellori, *Le vite*, p. 283: 'Se bene egli non fu sí capace d'invenzione, né ebbe pari lo spirito e la facilità nelle opere copiose e grandi. Conseguí egli il pregio maggiore ne' ritratti, ne' quali fu unico, ed alcune volte con l'istesso Tiziano maraviglioso'.

18 Bellori, *Le vite*, p. 278: 'Contrastava egli con la magnificenza di Parrasio, tenendo servi, carrozze, cavalli, suonatori, musici e buffoni ...'.

19 Bellori, *Le vite*, p. 274: 'Siché imitando egli la pompa di Zeusi, tirava a sé gli occhi di ciascuno'.

20 Bellori, *Le vite*, p. 278: '... partendo il Rubens, succedette il Van Dyck ... e crebbero ad un tempo li premi e li tesori, per istabilire l'ostentazione de' suoi costumi e la splendidezza delle sue maniere'.

21 De Piles, *The Art of Painting*, p. 303.

22 Bellori, *Le vite*, pp. 283–84: 'Nell'istorie però non si mostrò sufficiente e stabile nel disegno, né sodisfece con perfetta idea, mancando in questa e nell'altre parti che si convengono all' azzione de' componimenti'.

23 Bellori, *Le vite*, p. 274: 'Era egli certamente venuto a Roma non per occasione di studiare'.

24 Bellori, *Le vite*, p. 274: 'disprezandolo ch'egli non sapesse disegnare ed appena colorire una testa, lo ridussero a segno che disperato si partí di Roma ...'.

25 Brown, *Van Dyck*, p. 72; A. Poltzer (ed.), *J. von Sandrart's Academie der Bau- Bild- und Malerey-Künste von 1675* (Munich, G. Hirth Verlag AG, 1925), p. 174: '... weil ihn aber die Romanische Reglen und Academien der Antichen, auch Raphaels und anderer dergleichen seriose Studien nicht gefällig, bliebe er nichte lang allda, sondern kehrete wiederum nach Genua ...'.

26 Brown, *Van Dyck*, p. 86.

27 E. Waterhouse, *Painting in Britain, 1530 to 1790* (Harmondsworth, Penguin, 1953), p. 7.

28 Grosart, *The Complete Works in Verse and Prose of Abraham*, vol. l, p. 138.

29 De Piles, *The Art of Painting*, p. 305.

30 F. Verney (compiler), *The Verney Family during the Civil War* (London and New York, 1892), vol. l, pp. 257–59.

31 L .Hutchinson, *Memoirs of the Life of Colonel Hutchinson* (London, New York, Toronto, O.U.P, 1973), p. 46.

32 Brown, *Van Dyck*, p. 177 and p. 232 note: 'Les beaux portraits de Van Dyck m'avoient donné une si belle idée de toutes les dames d'angleterre, que j'étois surprise de voir la reine que je m'avois vue si belle en peinture, estre petite femme, montée sur son siège, les bras longs et secs, les épaules dissemblables et les dents comme des défenses lui sortant de la bouche pourtant, après que je l'eus considerée, je lui trouvais les yeux, le nez bien fait, le teint admirable'.

33 O. Millar, *Van Dyck in England* (London, National Portrait Gallery, 1982), p. 11.

34 D. Freedberg, 'Van Dyck and Virginio Cesarini: A Contribution to the Study of Van Dyck's Roman Sojourns' in *Van Dyck 350*, Studies in the History of Art, 46, Symposium Papers XXVI (Washington, National Gallery of Art, 1994), p. 156.

35 M. Rogers, 'Van Dyck's Portrait of *Lord George Stuart, Seigneur d'Aubigny,* and Some Related Works', in *Van Dyck 350*, p. 265.

36 Bellori, *Le vite*, p. 273: 'Espresse Antonio il cardinale a sedere con una lettera nelle mani, e quasi l'abbia letta si volge . . .'.

37 Brown, *Van Dyck*, p. 225 and p. 232 note.

38 Brown, *Van Dyck*, p. 202 and p. 232 note.

39 Grosart, *The Complete Works in Verse and Prose of Abraham*, vol. l, p. 138.

40 Brown, *Van Dyck*, p. 130.

41 Bellori, *Le vite*, p. 274: 'Erano le sue maniere signorili più tosto che di uomo privato, e risplendeva in ricco portamento di abito e divise …'.

42 J. Hook, *The Baroque Age in England* (London, Thames & Hudson, 1976), p. 35.

43 A more grandiose imagery was attempted by Gerrit van Honthorst (1590–1656) during his stay at Charles I's court in 1628. He painted Charles I and Henrietta Maria with the Liberal Arts. It is at Hampton Court. See M. Whinney and O. Millar, *English Art, 1625–1714* (Oxford, The Clarendon Press, 1957), p. 5.

44 Brown, *Van Dyck*, p. 162.

45 J. Summerson, *Architecture in Britain, 1530 to 1830* (Harmondsworth, Penguin, 1953), p. 73.

46 Bellori, *Le vite*, p. 280: 'Venne in pensiere al medesimo cavaliere Digby di far dipingere sopra una gran tela la signora sua consorte in forma della Prudenza sedente in candida veste con un velo di colore e balteo di gemme. Stende ella la mano a due candide colombe, e l'altro braccio è avolto dal serpente. Tiene sotto i piedi un cubo, al quale sono legati in forma di schiavi la Fraude con due faccie, l'Ira in aspetto furioso, l'Invidia magra e crinata di serpente, l'Amor profano bendato, tarpate l'ali, rotto l'arco, sparsi gli strali, spenta la face, con altre figure ignude al naturale. Sopra una gloria di angeli con suoni e canti, tenendo tre di loro la palma e la ghirlanda sopra la testa della Prudenza in contrasegno di vittoria e di trionfo de' vizii, e 'l motto è cavato da Giovenale "Nullum numen abest si sit prvdentia"'.

47 Rogers, 'Van Dyck's Portrait', p. 266.

48 Rogers, 'Van Dyck's Portrait', p. 263.

49 A. Wheelock Jr., S. Barnes et al, *Anthony Van Dyck*, exhibition catalogue, (Washington, National Gallery of Art, 1990), p. 21.

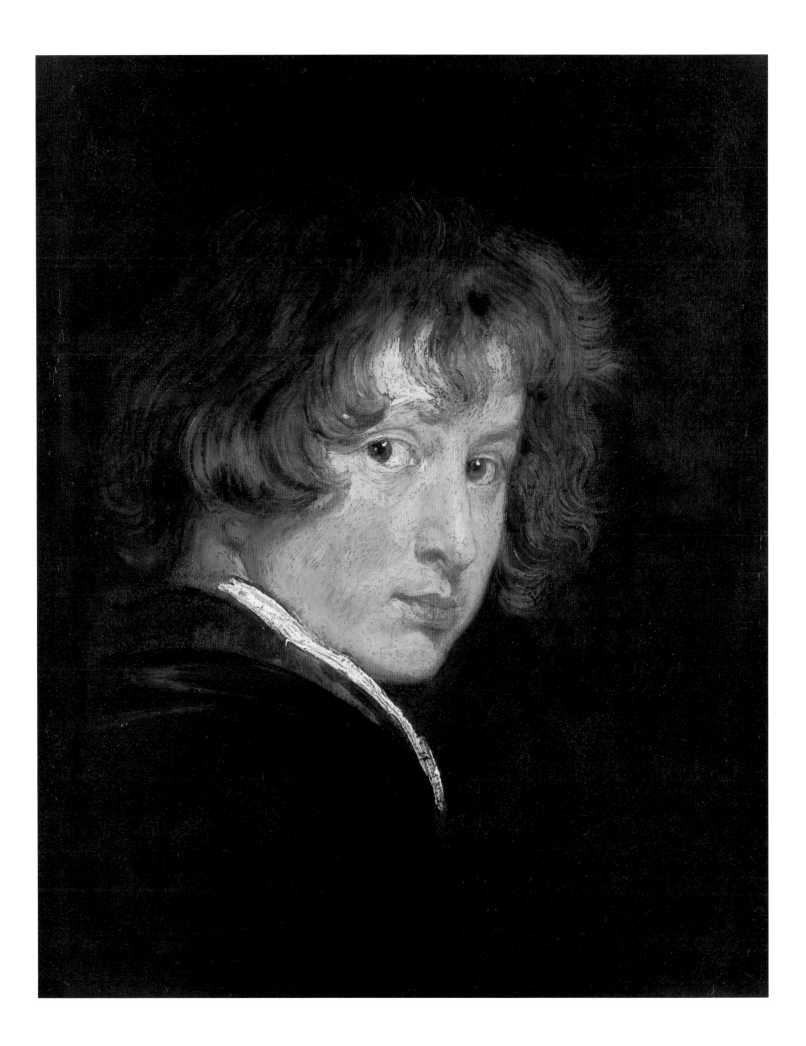

Biography and Context

By Kate Ferry-Swainson

Anthony Van Dyck lived in an explosive half-century of change, opportunity and unrest. Scientists and philosophers upset the hierarchical order by altering our perceptions of the world and our place in it, new homes and new markets were established at the edges of the known world, the authority of kings was built up and knocked down. Censorship and conspiracy were the political and social bywords.

Set against the backdrop of the Protestant Reformation and the Catholic Counter-Reformation, continental Europe was a cauldron of religious unease and persecution that erupted into the Thirty Years' War. Perhaps the most efficacious weapon of the Catholic Church at this time was the exuberance and emotional intensity of the Baroque movement, intended to bring the spectator to his knees in humble, Catholic fervour.

The leading artists of the day fell into two camps along with the rest of society: Catholics painting rich, theatrical, highly coloured works appealing to the emotions and the authority of Church and monarchy; Protestants, particularly the Dutch, developing a new style of honest, intimate snapshots of simple, hard-working folk.

In England, struggles between Parliament and the king — who believed God gave him his authority to rule — led inexorably to Civil War. Van Dyck played his part in the establishment as a vital link in the propaganda machine of the time: portraying kings, queens and princes as elegant, authoritative, beneficent authorities at peace with their subjects, in control of their world.

Self-portrait, 1613–14
Oil on panel, 25.8 x 19.5 cm,
set in larger octagonal panel,
43 x 32.5 cm
Gemäldegalerie der Akademie
der bildenden Künste, Vienna

The Early Years

Antwerp 1599–1618

22 March 1599
Anthony Van Dyck was born in Antwerp the seventh child of a devout Catholic family. His parents were Frans Van Dyck, a prosperous cloth merchant, and his second wife, Maria Cuypers, an embroiderer who 'painted with her needle', according to Bellori's *Le Vite de' Pittori, scultori et architetti moderni*, published in Rome in 1672. They lived on Grote Markt in a house called Den Berendans. His mother recognized her son's early talent, which outstripped her own skills.

25 December 1599
The family moved to Korte Nieuwstraat into a house called Het Kasteel van Rijset.

17 April 1607
Van Dyck's mother died.

October 1609
To progress his artistic skills, Van Dyck was apprenticed to Hendrik van Balen, a successful painter in Antwerp. Van Dyck became a member of the Antwerp Guild of St Luke, the painters' guild.

1613
Van Dyck painted his first self-portrait (see p. 118).

1615
Van Dyck took the unusual step of setting up his own studio in Antwerp on Large Minderbroederstraat in a house called Den Dom van Ceulen before he was named a master. He employed two assistants, Justus van Egmont and Herman Servaes.

1617
Van Dyck received the commission (and 150 guilders) to paint a *Crowning with Thorns* for the Pauluskirche in Antwerp. Rubens and Jordaens were also involved in this project.

11 February 1618
He was named a master in his own right of the Antwerp Guild at an unusually young age.

Politics

In 1609 seven Protestant provinces, which included Holland, in the north Netherlands won their independence from their Catholic, Spanish overlord. In the north, Dutch merchant towns sprang up and became rich from trade in the New World and the Far East, and their open society led to a stream of Jewish and Protestant refugees from Catholic countries. The southern part of the Netherlands, Belgium and Flanders, remained Catholic, under Spanish rule, and developed even closer ties with Spain. Antwerp flourished as the cultural and artistic centre of the region.

In 1608 the leader of the German Protestants, Frederick, Elector Palatine of Bohemia, set up the Evangelical Union, a Protestant alliance of princes and cities, to defend their faith against the Catholic Habsburgs who dominated Europe. To counter this, the Catholic League was founded in 1609. The existence of these two groups ignited the situation that led to the Thirty Years' War a decade later.

In England, Elizabeth I died on 24 March 1603; her successor, James I, had already reigned for 35 years as James VI of Scotland. A Protestant, he was tolerant of Catholics, and his association with Catholicism alarmed the predominantly Protestant population. In an age of religious unrest, on 5 November 1605 the most serious Catholic conspiracy of the time, the Gunpowder Plot, failed to blow up the English Parliament and the king. The plan was leaked, and the conspirators were arrested. Guido Fawkes was discovered with the gunpowder in a cellar beneath Parliament. He was tortured for some months and then tried, hanged, drawn and quartered.

In a triumph of his authority over the church, James I commissioned a new translation of the Bible, the Authorized King James Version, published in 1611. Two years later he tried to bring about religious peace in Europe by marrying his daughter Elizabeth to Frederick, Elector Palatine. In November 1612 Henry, Prince of Wales died aged 18 after diving into the River Thames; his younger brother Charles assumed the mantle.

Culture

A new style of painting was starting to sweep through Europe. Annibale Carracci wished to cultivate classical beauty with an added spark. In about 1605 he painted *The Dead Christ Mourned*, which used rich colours and emotional intensity to create a strong effect in the observer. Caravaggio wanted to portray truth as he saw it and manipulated contrasts of light and shade (chiaroscuro) to create maximum emotional and spiritual power. His *Doubting Thomas* (c 1600) and *The Supper at Emmaus* (1600–1) portrayed the apostles as wrinkled, swarthy labourers, and *The Death of the Virgin* (1605–6) was found indecent by the Carmelite priests who had commissioned it because it showed an old lady laid out roughly, her dirty feet sticking out from under her robes.

English literature of the period was dominated by William Shakespeare. By 1597 he had written 10 plays and thereafter wrote two plays a year. Ben Jonson, a Catholic, was a member of the same theatre group as Shakespeare – the Chamberlain's Men who moved to the Globe Theatre in 1599 and were renamed The King's Men when they received the patronage of James I in 1603. Jonson wrote *Sejanus* (1603), a play detailing conspiracy and assassination at court and for which he had to answer charges of popery and treason; his work also includes *Volpone* (1605) and *The Alchemist* (1610). In 1605 he collaborated with Inigo Jones for the first time to create the *Masque of Blackness*.

The first documented opera was *La Dafne*, written in 1600 by Jacopo Peri. It was Claudio Monteverdi, however, who developed the artform. His *Orfeo* of 1607 showed the true possibilities of opera, interspersing recitatives with arias, choruses and dances to great dramatic effect.

John Donne, the metaphysical poet, converted to Protantism and took holy orders in 1615; James I appointed him royal chaplain and approved of his anti-Catholic works during this period. Adding fuel to the religious unrest, the collected works of John Calvin were published posthumously in Geneva in 1617.

Society

In 1600 Elizabeth I granted a charter allowing 80 London merchants to set up the East India Co., with a monopoly to trade in the Far East. Two years later the Dutch East India Co. was formed, and in 1609 the Dutch were the first to ship tea from China back to the West. In 1609 they landed at Mocha, hoping to begin shipping the newly discovered coffee back to the West. They were not welcome, however, and in 1616 Pieter van der Broecke, a merchant involved in the coffee trade, stole some bushes and planted them in the Amsterdam Botanical Garden. Forty years on these bushes, *coffea arabica*, went into cultivation.

Merchants and religious dissenters from England and France started to explore and settle the eastern seaboard of the New World, and to search for a north-west passage. In 1607 the first permanent English colony was settled at Jamestown, Virginia. July 1608 saw the founding of Quebec, the first city in Canada, by Samuel de Champlain, while exploring the St Lawrence river for a north-west passage.

The Protestant Dutch led the way in scientific discovery. In 1608 Hans Lippershey, lens grinder and spectacle maker, invented the refracting telescope. The Dutch government tried to keep this invention under wraps because of its military potential, but news reached Galileo Galilei in Italy. In 1609, Galileo observed four major satellites of Jupiter and the phases of Venus. This provided enough evidence to confirm Copernicus' earlier suggestion of a heliocentric model for the universe. His discoveries had an impact on the hierarchical structure of society: upsetting the divine authority of both monarchy and Church. In 1616 Galileo was accused of heresy and pressurized by the Inquisition to give up teaching Copernican theory and to change his views. It would be many years before his discoveries were accepted.

Christ Nailed to the Cross,
1627–32
Pen and sepia, washes of sepia
and grey, 22.3 x 16.7 cm
The British Museum, London

Politics

In Catholic France, Henry IV in 1600 divorced Marguerite de Valois and married Marie de' Medici by proxy on 5 October. Her dowry included cancellation of all French debts to Florence. The following year the future King Louis XIII was born. In 1610 Henri IV was assassinated, leaving Louis aged nine. Marie de' Medici established herself as regent and ruled until 1614 when Louis reached the formal age of majority. Unwilling to accept her change of status to Queen Mother at this point, she ruled for a further three years as president of his council. In 1615, a dynastic exchange of brides was arranged: Anne of Austria, daughter of Philip III of Spain was married to Louis XIII of France; Isabella of Bourbon was wed to the future King Philip IV of Spain.

Cardinal Richelieu, originally Marie's ally in her attempt to hold France together after Henri's death, became her opponent as she placed a stranglehold on the authority of the new King Louis. In 1617, in an attempt to reimpose the king's authority, Louis and Richelieu exiled Marie to Blois and took over the reins of government.

Culture

Inigo Jones, a Catholic and Royalist, became the leading theatrical set designer in London before he started to practise as an architect. Under the patronage of Queen Anne, he created sets and costumes for masques written by Ben Jonson, in a celebrated partnership. Staged at wildly extravagant expense by the Court after banquets, masques were an important part of Court life, involving a combination of dance, song and drama. Courtiers themselves – and the monarchs – took part, and all the guests wore fancy dress, including masks. Jones invented moveable scenery and has been credited with the invention of the proscenium arch. In 1610 Jones was made Surveyor of Works to Henry Prince of Wales. Three years later he toured Italy with Thomas Howard, the 2nd Earl of Arundel, a leading art collector of the day, and came under the spell of Palladio's work. Back in England he began to design the Queen's House, Greenwich.

In the same period *Don Quixote* (Part I, 1605 and Part II, 1615) was written by Cervantes and won immediate popularity in Spain and, in translation, throughout Europe.

Society

Francis Bacon was perhaps the most influential writer of the century and, like Galileo, stressed that science must result from first-hand observation. In 1605 *The Advancement of Learning* was published, setting out his intellectual reforms and defending his pursuit of knowledge.

The German astronomer Johannes Kepler announced in *New Astronomy* of 1609 his first and second laws of planetary motion. He declared that planets follow elliptical and not circular orbits, and laid the foundations for the discoveries of Newton later in the century.

Inigo Jones, 1632–36
Black chalk on white paper, 24.5 x 20 cm
The British Museum, London

Inigo Jones, 1632–36
Black chalk, 24.4 x 19.8 cm
The Duke of Devonshire
and Chatsworth House Trust

CELEBERRIMVS VIR INIGO IONES PRÆFECTVS ARCHITECTVRÆ
MAGNÆ BRITTANIÆ REGIS ETC.
Ant.van Dyck pinxit Mart. vanden Enden excudit Cum privilegio

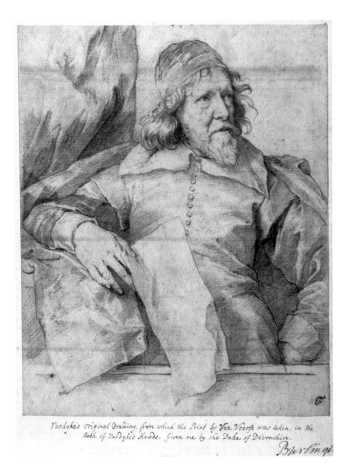

Vandyke's original Drawing, from which the Print by Van. Voerst was taken, in the
Book of Vandyke's Heads. Given me by the Duke of Devonshire.
Burlingt

Establishing a Reputation

Antwerp and London 1618–21

24 April 1618

This date provides the earliest evidence of the fact that Van Dyck was working with Peter Paul Rubens: Rubens made mention in correspondence of a pupil, commonly referred to as Van Dyck, who worked on his *Achilles and the Daughters of Lycomedes*.

May 1618

Van Dyck assisted Rubens with a commission to design tapestries depicting the story of the Roman consul Decius Mus, painting cartoons from Rubens' designs.

29 March 1620

Van Dyck was named Rubens' chief assistant in a contract between Rubens and the Jesuits in Antwerp to decorate the newly built Jesuit Church in Antwerp. Van Dyck was also mentioned as painter of an altarpiece for one of the minor altars.

17 July 1620

The influential Countess of Arundel, Aletheia, wife of Thomas Howard, the 2nd Earl of Arundel, passed through Antwerp on her way to Italy and sat to Rubens for a portrait. A member of her entourage, the Earl of Arundel's secretary, Francesco Vercellini, informed the Earl by letter that 'Van Dyck is still with Signor Rubens and his works are hardly less esteemed than those of his master. He is a young man of 21 years, his father and mother very rich, living in this town, so that it will be difficult to get him to leave these parts, especially since he sees the good fortune that attends Rubens.'

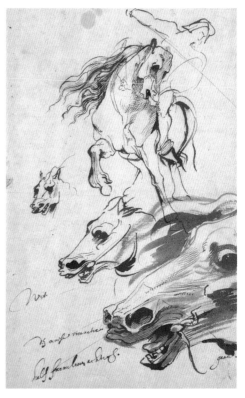

(Studies of a) Man on Horseback and 3 horses heads, c. 1620–21
Pen and brown ink, point of brush, brown wash, 26.2 x 16.3 cm
Rijksmuseum, Amsterdam, Rijksprentenkabinet

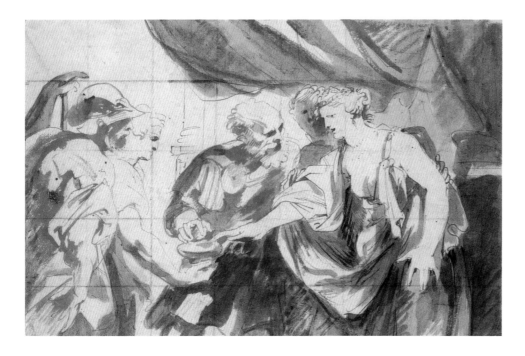

Sophonisba or Cleopatra (The Suicide of Sophonisba), c. 1618–21
Pen and brown ink, brown and grey washes, squared up in black chalk, 16.3 x 25.3 cm
Rijksmuseum, Amsterdam, Rijksprentenkabinet

Politics

In 1621 the Twelve Years' Truce between the United Provinces, the Protestant north Netherlands, and Spain came to an end. Archduke Albert, governor of the Spanish Netherlands, wanted to sue for permanent peace with the Dutch; however, the terms were unacceptable to the Dutch, and the war resumed. In 1621 Albert died, leaving his widow, the Archduchess Isabella, in charge of the government of the Spanish Netherlands until her death in 1633.

In Europe the spark kindled by the founding of the Evangelical Union and the Catholic League ignited into the Thirty Years' War in 1618. This was a series of conflicts involving Catholic Spain and the Austrian Habsburgs (the ruling family of the Holy Roman Empire) versus the Dutch, the Protestant princes of Europe, the Danes and Swedes. England was not involved. The war was fought mainly in Germany on the grounds of religious hatred, a desire to limit the power of the Holy Roman Empire and the ruling Habsburgs, and power struggles between German princes.

The war started on 23 May 1618, when Bohemian Protestants rose up against Catholic oppression, despite the fact that freedom of religion had been granted them by their Catholic king, the Holy Roman Emperor Rudolph II in 1609. They threw Rudolph's deputies out of a window, precipitating a Protestant uprising. The following year Frederick was declared King Frederick V of Bohemia, the Winter King. The English poet John Donne was sent in vain by James I to mediate between the Holy Roman Emperor and the Protestant dissenters in Bohemia. During the next year, 1620, Protestantism was suppressed in Bohemia when the Catholic League, under Count Johan Tserclaes of Tilly, defeated the Evangelical Union at White Mountain, near Prague. Frederick V and his family fled to the United Provinces.

Culture

The division of the Netherlands into Protestant North and Catholic South affected the art of the region. Churches and monarchs from the Spanish Netherlands in the south commissioned Rubens to paint vast pictures glorifying their power. By contrast, the Protestant North had very different taste. They rejected the emotional pomp of the South and preferred their art to show restraint and honesty: and the Golden Age of Dutch painting was born.

Rubens dominated the art scene in the whole region, and influenced all the creative arts there. He established his reputation in Mantua, Rome and Genoa at the turn of the century, creating ties that were to take Van Dyck to Italy two decades later. Returning to Antwerp in 1608 he took with him ideals of the Counter-Reformation: Jesuit thinking and imagery, and the taste for the Baroque. Now skilled in painting huge canvases to decorate churches and palaces, his work suited the taste of the aristocracy, and in 1609 he became Court Painter to Albert and Isabella.

He now had his pick of all the major commissions in the region and worked for the Jesuits in Antwerp, Albert and Isabella, Louis XIII and Marie de' Medici, and Philip III of Spain. He was an honoured guest of kings and princes, engaged in learned correspondence with them, and acted as diplomat, in particular trying to end the war between Spain and England that raged until 1604. After Albert's death, Rubens became adviser and diplomat for Isabella.

He created huge altarpieces in the new Jesuit Church in Antwerp: *Raising of the Cross* (1610–11) and *Descent from the Cross* (1611–14). He had more commissions than he could cope with and appointed pupils and assistants, who were charged with transferring his sketched plan to the large canvas; Rubens would make his own finishing touches to their work.

Society

In 1620 the Pilgrim Fathers set sail for Virginia in the Mayflower. A group of 100 Separatists, unhappy with the religious climate in England, they were in search of a new land where they could worship in peace. After a stormy voyage they landed in New England and established the Mayflower Compact, an agreement for the government of their colony, the Plymouth Plantation. Their first winter was hard, and half of them did not survive. They traded crops, including tobacco, with England; James I considered tobacco the scourge of society.

At this time, Jews were on the move from Spain, where they were hunted down by the Inquisition, up to the Protestant Netherlands and the New World. Those in the north Netherlands were allowed to practise freely although at first they had to disguise their synagogues. By 1620, however, Amsterdam had three separate congregations, all with buildings.

The market for black slaves in Europe and the New World was gathering pace at this time. In Africa of the 1620s Queen Nzinga of Ndongo attacked Portuguese soldiers in a rejection of Portugal's seemingly insatiable appetite for slaves. Reports of the terrible conditions under which slaves where shipped to the New World had reached her, sparking off the violence.

October 1620
Van Dyck was reported to be in London in the service of James I, on a salary of £100 per annum. Here he made contact with the Earl of Arundel and the king's favourite, the Duke of Buckingham, another leading art collector. Several paintings were commissioned by both men, both of whom granted Van Dyck access to their extensive art collections.

16 February 1621
Van Dyck received £100 from James I as a reward for some special service performed. This was possibly to make tapestry designs for the king's new factory at Mortlake.

28 February 1621
James I seemed to want to keep Van Dyck in his service, granting him a passport to travel for eight months as 'His Majesty's servant', 'having obtained His Majesty's leave'.

March 1621
Van Dyck returned to Antwerp.

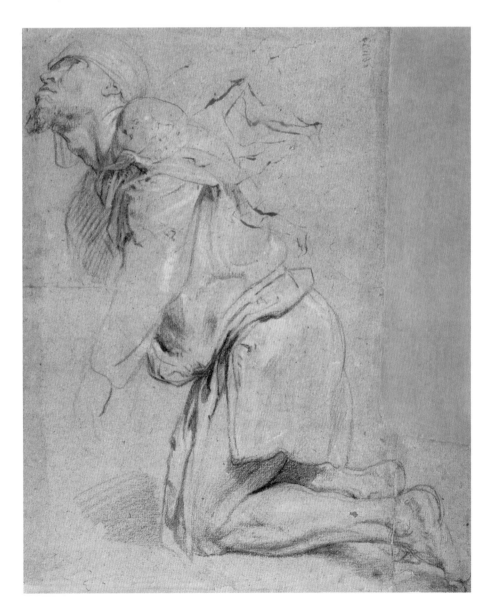

A Kneeling Man, 1618–20
Black chalk with white highlights,
34.2 x 28.5 cm
The Duke of Devonshire
and Chatsworth House Trust

Politics

In England, Sir Walter Ralegh was executed for alleged treason in 1618. In the same year James I appointed George Villiers 1st Duke of Buckingham. Having come to court in 1614, Villiers soon became a favourite of James I and was rapidly given a host of honours and titles. James I is said to have begun an affair with the Duke in 1618 and wrote to him 'God Bless you, my sweet child and wife, and grant that ye may ever be a comfort to your dear dad and husband, James R'. Over the next decade Buckingham would play a major role in English politics. The year 1619 saw the death of the queen, Anne of Denmark, and a slow decline into the 1620s with poor harvests and an adverse balance of trade.

In France, Marie de' Medici, still in exile, started to conspire against the king, her son. Seeing the threat this posed to the authority of the king, Richelieu reconciled mother and son in 1620, brought Marie back from exile and installed her in the newly built Luxembourg Palace, designed by Salomon de Brosse in 1615.

Culture

Frans Hals, in the United Provinces of the north Netherlands, started to paint his lively genre scenes with his spontaneous and spirited brushwork. He painted *The Laughing Cavalier* in 1624 and went on in 1633 to paint the portrait of Pieter van der Broecke, the Dutch merchant who brought coffee to the West. Hals' 'snapshot' of Broecke represents the antithesis of the carefully manipulated portraiture of Van Dyck.

In 1619 James I established a tapestry factory at Mortlake in west London and offered privileges to Flemish weavers prepared to move there. Tapestry was a statement of a king's authority, and James wanted to bring it further within his control and avoid the high costs of importing it from Flanders. In the 1620s and 1630s Mortlake flourished and James I and his successor Charles I added energetically to the English royal tapestry collection. Owing to the high status of tapestry, an artist was honoured to be asked to design tapestry and would often be paid personally by the monarch for his work.

Inigo Jones continued his architectural success by designing the Banqueting House in Whitehall in 1619, intended to be used for royal banquets and masques. Completed in 1622 under his supervision, this was the first classical building in England, constructed to Palladio's ideal proportions. He also designed the Prince's Lodgings, Newmarket, Suffolk between 1619 and 1622, which would provide a model for numerous domestic houses at the end of the century. Jones went on to rebuild St Paul's Cathedral before it was destroyed in the Great Fire of London; he also designed the first London square on the Duke of Bedford's estate in Covent Garden.

Society

Francis Bacon outlined his new scientific method in his *Novum organum* of 1620. Johannes Kepler became court astronomer to Rudolph II and published his third law of planetary motion in *Harmonies of the World*, 1619. In 1620 Cornelius Drebbel, a Dutchman who had settled in England in 1604, constructed the thermometer as well as a prototype submarine, which was successfully tested in the Thames.

In England fashions were changing: the stiff Spanish fashions – iniluding the tailored doublet and hose – were giving way to a more natural look, in which the ruff was replaced by the lace-edged falling collar, with white linen showing through slashes in doublet sleeves. James I and Queen Anne lavished money on their own and their children's clothes in an era in which extravagant displays of fine clothes and jewels were expected among the nobility – especially at courtly events such as masques, the theatre, cock fights, horse races and bowling alleys. By contrast, the Pilgrim Fathers wore the 'sugarloaf' hat, plain white collar and hooded cape also worn by the Protestant Dutch middle classes.

A Formal Portraiture

Italy 1621–27

3 October 1621
Van Dyck left Antwerp for Italy, arriving in Genoa towards the end of November.
He stayed with the brothers Cornelis and Lucas de Wael, painter friends from
Antwerp.

Winter 1621
Van Dyck, portraitist to the aristocracy, started work, and was appreciated in
Genoa and given many commissions. According to Bellori, he 'always found
a refuge in Genoa, as if it were his native city; he was loved and held in high
regard by everyone there'.

February 1622
Van Dyck left Genoa and travelled to Rome, where he stayed at the Papal Court
with Cardinal Bentivoglio, another contact from Flanders.

July–August 1622
He was commissioned to paint the portraits of Sir Robert and Lady Shirley, in
Rome on a diplomatic mission from Abbas, king of Persia, to Pope Gregory XV
to gain support for Abbas's campaign against the Persian's Turkish enemy.

According to Bellori, at this time 'he was still a young man, his beard scarcely
grown, but his youthfulness was accompanied by a grave modesty of mind and
nobility of aspect, for all his small stature. His manners were more those of an
aristocrat than a common man, and he was conspicuous for the richness of his
dress and the distinction of his appearance, having been accustomed to consort
with noblemen while a pupil of Rubens; and being naturally elegant and eager
to make a name for himself, he would wear fine fabrics, hats with feathers
and bands, and chains of gold across his chest, and he maintained a retinue
of servants.'

August 1622
Van Dyck left Rome after having been ostracized by the local community of
Flemish artists. He had snubbed them and subsequently been criticized by them.
He went on to join the Countess of Arundel in Venice.

November 1622
Accompanying the countess, he travelled to Mantua, Milan and Turin.

1 December 1622
Van Dyck's father died in Antwerp.

January 1623
Shortly after arriving in Turin, Van Dyck left the countess and went on to
Florence and back to Rome, arriving there in March.

Politics

In England, on behalf of James 1, the Duke of Buckingham was despatched to Spain in 1623 to engineer an alliance between the Infanta Maria of Spain and James' son Charles; he failed. The following year England went to war again with Spain to try to regain territories seized from Frederick, Elector Palatine, and in support of the Protestant cause in Europe. The English formed an alliance with the United Provinces of the north Netherlands, and the Dutch signed a non-aggression treaty with Catholic France.

On 27 March 1625 James 1 died and his son succeeded him as Charles 1. He, like his father, believed firmly that he had been appointed by God and was answerable to neither Parliament nor the people. He made visible the supreme authority of the monarchy in the outward trappings of masques and dances as well as royal patronage of the arts. He systematically acquired works for the Royal Collection and aimed to attract Europe's most notable artists to work for him.

Charles 1 married the French princess Henrietta Maria on 13 June 1625 in Canterbury Cathedral. The youngest child of Henri IV and sister to the French king, Henrietta Maria was only 15 years old. Within six weeks of the marriage they were separated. She had been raised to believe that she would reconvert England to Catholicism, and her marriage contract permitted her freedom of expression of her faith. This and her French attendants made her unpopular in England and further raised the political temperature of the country.

On 2 February 1626 Charles was crowned king. Later that year Parliament attempted to impeach the Duke of Buckingham, who retained an elevated position in this new reign, after his calamitous military expedition to Cadiz. Charles dissolved Parliament to prevent the Duke's trial. This was to be the first of many confrontations with Parliament.

Culture

In Spain Philip IV succeeded his father Philip III to the throne in 1621. A discerning patron of the arts, he appointed Velázquez Court Painter in 1623. Velázquez had been born in the same year as Van Dyck. He was impressed with the work of Caravaggio and in 1620 painted the *Waterseller of Seville*, which echoes Caravaggio's *St Thomas* in style.

In Rome, the Papacy was becoming patron of the arts in the name of the Counter-Reformation. As the Protestants of northern Europe preached against decoration in churches, the Catholic Church enlisted the artist to sweep the spectator off his feet. The world was to be reconverted to Catholicism through the power of the artist as churches became exuberant showpieces for painting and sculpture complete with candles, incense and music.

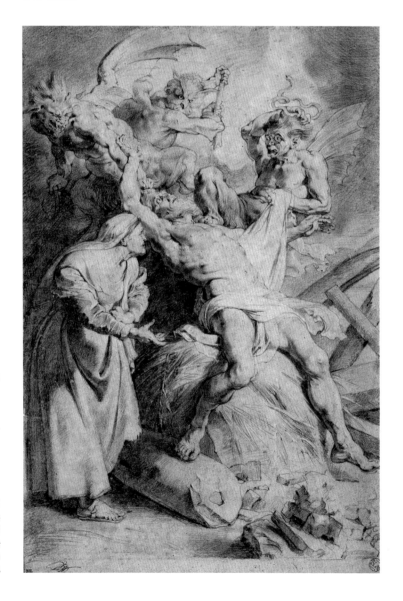

Torments of Job, c. 1620–21
Black chalk, with white chalk highlights in the body and clothes of Job and his wife, and some red chalk in the face of Job's wife, 40.3 x 27.6 cm
Musée du Louvre, Paris

Society

Antwerp had links with Genoa, based on trade. There was a ready exchange of painters from the two places, cross-fertilizing and leaving small resident communities in their place. This made Genoa a natural choice of venue when both Rubens and Van Dyck went to Italy.

In 1621 the Dutch established the West India Co. which controlled trade with the New World and governed the New Netherlands where New Amsterdam (later New York) was founded in 1626. Massachusetts was founded in 1629. In the same year English ships clashed with the French when they blockaded French ships on the St Lawrence river; this started the struggle to control the fur trade in North America.

Autumn 1623
Van Dyck returned to Genoa.

Spring 1624
At the invitation of Viceroy Emmanuele Filiberto of Savoy, Van Dyck travelled to Palermo, Sicily. When a severe outbreak of the plague erupted, Van Dyck received several commissions for paintings depicting Palermo's patron saint, Saint Rosalie, to incercede against the outbreak.

12 July 1624
Van Dyck visited portraitist Sofonisba Anguissola, the most famous woman painter of her generation, now in her nineties and almost blind. He made a drawing of her in his Italian sketchbook and recorded their conversation about portrait painting.

3 August 1624
The Viceroy died of plague.

September 1624
Van Dyck returned to Genoa 'as though in flight', according to Bellori.

July 1625
Van Dyck apparently visited Marseilles and Aix in France.

1627
Van Dyck left Italy for the Spanish Netherlands.

Landscape near Genoa, n. d.
Pen and brown ink and point of brush, with brown and grey wash, 27.3 x 37 cm
Her Majesty Queen Elizabeth II

Politics

From 1627 to 1630 Charles waged war with his brother-in-law, Louis XIII of France, in an attempt to make him honour the terms of Charles' marriage treaty.

In France, meanwhile, Cardinal Richelieu was appointed first minister of France in 1624 by Louis XIII who was completely dependent on him for his authority and political acumen. Richelieu's first task was to reduce the power of the Protestant Huguenots, and he was instrumental in their being besieged at La Rochelle at the hands of the Catholics in 1627–28. The Duke of Buckingham, in his final mission for the English Crown, failed to relieve the Huguenots. The following year he was assassinated in Portsmouth by an aggrieved naval officer.

The Thirty Years' War in Europe took a new turn as Christian IV of Denmark entered the hostilities. Albrecht Duke of Wallenstein, commander of the imperial armies, and Count Tilly conquered Denmark.

Culture

Two popes in particular were responsible for starting the style of art we now call Baroque. Pope Paul V (pontiff 1605–21) commissioned Carlo Modeno to design the Baroque facade of St Peter's. Urban VIII, pope from 1623, became the greatest patron of the arts, raising papal debts in the cause of Catholicism. A tax on bread would be needed in the 1640s to pay for Bernini's sculpture on the Piazza Navona, and the Papacy would itself become bankrupt in the 1660s.

The Baroque style was typified by curves, fluttering draperies, theatrical effects, *trompe l'œil*, golden light effects, and fluidity. The sculptor Gianlorenzo Bernini, born the year after Van Dyck, reflected the best of the Baroque: his *Apollo and Daphne* of 1622–25 was uniquely light and fluid. In 1624 he gained his first commission of many from Urban VIII to create the Baldacchino, a bronze canopy in St Peter's. This work was completed in 1633.

Owing to the efforts of the popes, during the Baroque period Rome became a great artistic centre: Roman ruins were restored to fountains and gardens, the Papal library became one of the greatest in the world, a market in contemporary art and antiquities developed, and tourists and artists alike flocked to Rome. There was a thriving community of Flemish artists there. Nicolas Poussin made Rome his home in 1624 and met with considerable success. His first major commission was for St Peter's in 1628, *The Martyrdom of St Erasmus*.

Dutch painter Rembrandt was seven years younger than Van Dyck. In Amsterdam in 1623 he was learning to paint in the Italian style, and was much influenced by Caravaggio. Rembrandt did not paint in the Catholic Baroque tradition but was nevertheless attracted by the splendour of costumes and the chance to paint the effect of light and the sparkle of gold.

In Paris of the mid-1620s the Luxembourg Palace was ready for Marie de' Medici. Its interior decoration made it the most influential building in Europe. In 1622–25 Rubens created the *Life of Marie de' Medici* cycle for the Palace — a grand series of paintings recording in allegorical form many of the events in her life.

Society

Despite the superiority of the Dutch East India Co., rivalry continued with the London East India Co, reaching a peak in 1623 at the Dutch base in the Moluccas where 10 English merchants were executed for trading there. After this the Dutch had a virtual monopoly in the Moluccas and the other Indonesian islands.

The plague was a menace in this era: there were outbreaks in London in 1603, 1625 and 1636, in Sicily in 1624, Bologna in 1630 (where one-third of the population were killed), and Venice in 1630.

In the field of literature, the *Shakespeare Folio*, compiled by The King's Men, was published in 1623, bringing together all of his plays. John Donne became dean of St Paul's in 1621 and, in his *Devotions upon Emergent Occasions* of 1624, wrote one of the most famous passages in English prose, beginning 'perchance he for whom the bell tolls' (meditation 17). On 27 March 1625 he preached his first sermon before the new English king, Charles I.

Francis Bacon published his Utopian fable, *New Atlantis*, in 1624. This describes the fictitious Salomon's House, an imaginary scientific institute, in which the goal of the scientists, technologists and engineers is 'the knowledge of causes ... and the enlarging of the bounds of human empire, to the effecting of all things possible'. In 1626 he published *Sylva sylvarum*, the first attempt ever to provide a complete programme to revitalize science. He died in London, deeply in debt, the same year.

In 1625 Dutchman Hugo Grotius published *De Jure Belli ac Pacis*, which laid the foundations for international law.

Pinnacle of Success

Antwerp and Brussels 1627–32

1627
Van Dyck arrived in Antwerp, possibly in time to see his sister Cornelia before her death on 18 September.

6 March 1628
Now with a good deal of wealth and status befitting his reputation as the pre-eminent portrait painter of the aristocracy, Van Dyck made his will in Brussels. While living here he painted almost all the princes and aristocrats who were in Flanders at that time. According to Bellori: 'Rewards and riches increased ... to fund the ostentation of his way of life.'

April 1628
Van Dyck found himself in demand as a painter of religious and mythological pictures, and began to paint many works for the Church.

May 1628
Van Dyck joined the Jesuit confraternity of bachelors.

December 1628
The Archduchess Isabella gave Van Dyck a gold chain worth 750 guilders as payment for a portrait he made of her. On 5 December 1628 Van Dyck wrote that he had been paid £72 by his agent for his work *Rinaldo and Armida*.

1629 Charles I, the new king of England, bought *Rinaldo and Armida*.

1630
Van Dyck painted a portrait of Nicholas Lanier, Master of the King's Music, who was also Charles I's agent to buy paintings in Europe.

20 March 1630
When the City of Antwerp needed a loan of 100,000 guilders, Van Dyck put up 4,800 guilders.

27 May 1630
Van Dyck was by now Court Painter to the Archduchess Isabella. He described himself as 'painter of Her Majesty', and received 250 guilders per annum. Although Isabella resided in Brussels, Van Dyck was still living in Antwerp.

4 September 1631
Marie de' Medici (the French Queen Mother) and her son Gaston d'Orleans sheltered in Antwerp after having left France for good, and both had their portraits painted by Van Dyck.

Early 1632
Charles I invited Van Dyck to the English Court.

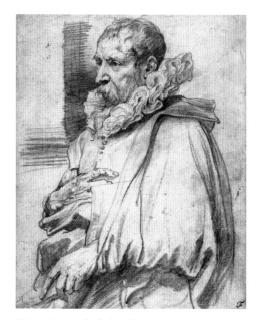

Pieter Brueghel the Younger, 1627–35
Black chalk, 24.5 x 19.8 cm. The Duke of Devonshire and Chatsworth House Trust

Politics

In England Parliament tried to curtail the powers of the monarchy with the Petition of Right of 1628. This represented a catalogue of complaints, demanded that Parliament have the right to approve taxation and insisted that the king relinquish some of his powers. Parliament bludgeoned Charles into accepting this Petition. However, the next year Charles dissolved Parliament, determined to rule by himself, as God intended him. His critics were to call this time of personal rule the Eleven Years of Tyranny.

Oliver Cromwell, born the same year as Van Dyck, had been MP for Huntingdon during the stormy parliament and became a fervent critic of the king. After the dissolution of Parliament he turned to farming until Parliament was called again 11 years later.

In 1630 England's war with Spain ended. With the Duke of Buckingham out of the way, Charles found himself reconciled with Henrietta Maria, and on 29 May their son, to be Charles II, was born, the first of nine children. This reconciliation with the Catholic queen made Charles more unpopular with Protestant Parliamentarians. The next seven years were buoyant: an end to the war with France, healthy balance of trade, rising royal income.

In France Marie de' Medici finally accepted that there was no role for her in French government with Richelieu leading the king strongly onwards, and she left France for good in 1631.

Meanwhile, the Thirty Years' War took a new turn in 1628 as Sweden joined the conflict. Wallenstein seized the Duchy of Mecklenburg and had honours heaped upon him. The following year Denmark withdrew from the war as it signed the Peace of Lübeck. In 1630 Wallenstein's ambitions led to his dismissal, and Tilly assumed command of his army. Tilly sacked Magdeburg in 1631 in a horrific massacre that branded him a brutal soldier, but his forces were routed by Sweden's Gustav II Adolph later in the year. Tilly died in 1632, leading to Wallenstein's reinstatement as commander of the imperial army in defence of the empire against the Swedes. In 1632 he was defeated by Gustav II Adolph at Lützen and again dismissed.

Culture

Rubens, Court Painter to the Governor of the Spanish Netherlands, was sent to Madrid in 1628, where he met Velázquez. In his role as international diplomat, Rubens negotiated the Anglo–Spanish treaty of 1629–30 and was knighted by Charles I. After the war, in 1630 Velazquez went to Rome on Rubens' recommendation to study the great masters.

After an outbreak of plague in Venice in 1630, the church of Santa Maria della Salute, designed by Baldassare Longhena, was dedicated to the Virgin as a thanksgiving for ending the outbreak. This is considered a supreme masterpiece of Venetian Baroque architecture.

Poussin, still in Rome, was commissioned in 1626–28 to paint *The Death of Germanicus* by Cardinal Francesco Barbarini, nephew of Urban VIII and a member of one of the most influential families of art patrons and collectors in Rome.

Rembrandt, like all self-respecting artists of the period, went to study in Italy. He was particularly engaged with the study of moods and emotions. By 1631 he was back in Amsterdam, where he set up his own studio. In 1632, with *The Anatomy Lesson of Dr Nicolaes Tulp*, he became Amsterdam's leading portraitist; he portrayed real people in their honesty and natural dignity.

In England of the 1620s and 1630s many prosperous merchants were favouring a Dutch style of architecture for their new homes. Many Protestants from the Spanish Netherlands had decided to settle in England, and were developing a new Dutch style. In 1631 The Dutch House was built for a Flemish merchant. This was one of the first buildings in which Flemish craftsmen used their own style of brick bonding and a softer brick that could be carved after having been built into a column.

The partnership of Inigo Jones and Ben Jonson on the creation and staging of courtly masques finally ended in 1631. Over the years Jonson had resented the growing success of Inigo Jones' stage sets. He published his text of a masque, *Love's Triumph through Gallipolis*, with his name on the title page above that of Jones'. Jones protested and Jonson lost his court patronage.

Society

By 1630 the Dutch East India Co. had won control of the Indonesian spice trade. Its trade monopoly extended to all countries east of the Cape of Good Hope, and it had exclusive rights to sail through the Straits of Magellan.

When the company was founded in 1602, its own cartographic department was set up with members from the Blaeu family. This family of cartographers, publishers of maps, and instrument makers from Amsterdam dominated the field. They began making globes, then maps of Holland and Spain, followed by a sea atlas in 1623. In 1629 Willem Blaeu published his first atlas.

Two other family firms of Hondius and Jansson were also highly influential in the development of Amsterdam as the cartographic centre of Europe. Hondius had published a unique cartographic tome in 1606, using plates from the first cartographer of this era, Gerardus Mercator, the first man to use the word 'atlas'; it ran to 40 editions before 1640. In 1610 a small single-volume atlas of Mercator's plates was produced for the emerging middle classes.

In the 1633 edition of the Mercator-Hondius atlas is a map of Amsterdam, showing a mass of ships crowding the docks and tied up at pontoons – clear evidence of the Dutch position as the greatest trading nation. The 1633 map of Asia identified many important trading stations used by the Dutch East India Co.: Hormuz, Goa, Malacca. The unexplored Terra Australis Pars was beginning to assume a shape recognizable as Australia.

William Harvey, Court Physician to James I and then Charles I, made perhaps the most important physiological discovery to date: how the blood circulates. He published his findings in *On the Motion of the Heart and Blood in Animals* of 1628. In the same year Johannes Kepler was appointed astrologer to the rising star of the imperial army, Wallenstein. Galileo did not fare so well: he was put on trial by Urban VIII, placed under house arrest, and forced into a public recantation of his work.

Court Painter to Charles I

London 1632–34

1 April 1632

Van Dyck was by now in London at the king's expense; he received £200 per annum from the king, and resided with one Edward Norgate, who received 15 shillings a day for the upkeep of Van Dyck and his entourage. Van Dyck subsequently moved to Blackfriars and was granted a summer residence in the Royal Palace at Eltham in Kent. It is unclear why Van Dyck left his successful career in Antwerp to go to London. Perhaps he was attracted by the reputation of Charles as a great patron of the arts, described by Rubens as 'the greatest amateur of painting among the princes of the world'; Rubens himself had previously been called to the English Court.

5 July 1632

Van Dyck was knighted, anglicizing his name to Vandyke, and was appointed 'principalle Paynter in ordinary to their Majesties'. He at once began to 'accumulate the rewards and resources he needed to maintain his ostentatious style and splendid way of life', according to Bellori. His house was frequented by the highest nobility, taking the lead from the king who used to visit him and who used to enjoy watching him paint. He kept 'servants, carriages, horses, musicians, singers and clowns, who entertained all the dignitaries, knights, and ladies who visited his house every day to have their portraits painted.'

At this time Van Dyck painted a prodigious number of works: 30 large portraits of Charles and Henrietta Maria and their family plus numerous commissions from the aristocracy.

8 August 1632

Van Dyck received £280 for 10 portraits he made for the king, including *The Greate Peece.*

1633

Van Dyck painted *Charles I on Horseback with Monsieur de St Antoine,* Charles' riding master and equerry. He also painted *Queen Henrietta Maria with the Dwarf Sir Jeffery Hudson.* On 20 April 1633 the King presented Van Dyck with a gold chain and a medal worth £110. On 7 May 1633 Van Dyck was paid £444 retrospectively for nine portraits of the monarchs. On 17 October 1633 Van Dyck's salary was said to be £200.

While in London Van Dyck's mistress was Margaret Lemon, described by the engraver Hollar as 'a dangerous woman' and 'a demon of jealousy'. During a fit of jealousy she tried to bite off Van Dyck's thumb. Her jealousy was probably justified, as he was romantically linked with a number of female sitters, and had an illegitimate daughter, Maria Teresa, whom he honoured in his will. According to Bellori, 'he was good, honest, noble, and generous; and despite his small stature he was well proportioned, graceful, and handsome, with the typical pale skin and fair hair of his native climate.'

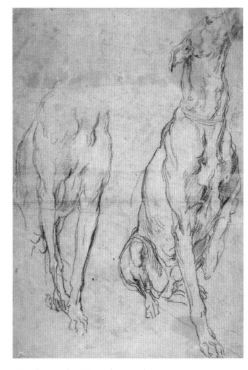

Studies of a Greyhound, c. 1633
Black chalk with white chalk highlights, on light brown paper, 47 x 32.8 cm
The British Museum, London

Politics

During this period Charles I ruled England without the backing of Parliament, asserting himself as unquestioned, supreme authority. He appointed William Laud Archbishop of Canterbury in 1633; together they worked for absolutism in Church and state. Laud was hated by the religious dissenters who continued to cause a stir in England or emigrate to the New World. Indeed in the early 1630s Puritans started arriving in New England in large numbers. In 1636 they founded Harvard University.

Culture

In Italy Pietro Berrettini da Cortona started painting the ceiling in the Barberini Palace in 1633; in true Baroque style, it presented the illusion of an open sky full of swirling figures. In England, Rubens completed the ceiling paintings for the Banqueting Hall in Whitehall in 1634.

The poet John Milton wrote a masque in 1634 to be staged at Ludlow Castle, in which the evil world of *Comus* in some way presaged his masterpiece *Paradise Lost*. John Donne died on 31 March 1631 and was buried in St Paul's Cathedral. Two years later his *Collected Poems* were published posthumously, and in 1640 some of his sermons were published.

After the building of the Luxembourg Palace books started to appear in Paris about interior decor. In 1623 Pierre le Muet published *Maniere de bien bastir pour toutes sortes de personnes*, a volume aimed at helping people build their own house. It included a series of ground plans and guidance on room proportions. The following year Louis Savot published *L'Architecture françoise des Bastimens particuliers*, offering guidance on the planning and distribution of rooms. In 1632 the *Livre d'Architecture* was published by Jean Barbet, devoted to designs for chimneypieces.

Society

Van Dyck left his mark on the society of the time in subtle ways: the Vandyke collar, with a series of large points forming a border, became fashionable, as did a Vandyke beard, which was neat and pointed. A particular hue of brown, deep and rich, became known as Vandyke brown.

The newfound happy family life of Charles I and Henrietta Maria had a great impact on fashion and interior decoration in England, where French style became popular, giving more ammunition to the Protestant Parliamentarians. By the 1630s the fashion was for lavish and loose decoration on clothes: bows, braids, buttons, straps, buckles and feathers. Men's clothes were much looser and less formal than in James' reign, with a calculated untidiness, cascades of lace, shirts spilling out, long and curly hair, and feather-trimmed hats perched nonchalantly. Ladies' fashions were greatly influenced by the French style and personal taste of Henrietta Maria. She introduced the short-waisted bodice with slashed sleeves, in plain silk fabrics. High heels became fashionable in this century too.

Massive sums of money were spent by the monarchs on their clothes in an attempt to make visible the supreme authority of the Crown in an increasingly uncertain era. A stir was created when corruption was discovered in the royal Department of the Wardrobe in 1633: items from the wardrobe were being sold abroad for personal gain. An inquiry was launched, resulting in a slashing of the Wardrobe budget.

Dwarves had been used as court jesters since medieval times; often given ridiculously extravagant names, they were the butt of courtly humour and insults. Their feelings as ordinary humans were ignored; Velázquez said that they had the same tragic dignity and humanity as Jesus Christ. In this era they may be seen in paintings, where they accompany the monarch and raise their stature.

Head and Front Quarters of a Horse, 1618–20
Black chalk with white highlights, 34.1 x 31.9 cm
The Duke of Devonshire and Chatsworth House Trust

Consolidation

Antwerp and Brussels 1634–35

28 March 1634

Van Dyck was back in Antwerp to visit his family. He bought some property near the Chateau de Steen at Elewijt, a country residence which Rubens bought in May 1635.

14 April 1634

In Brussels, Van Dyck authorized his sister Susanna, a nun, to administer his property in Antwerp.

18 October 1634

Only the second person after Rubens to be granted the privilege, Van Dyck was made honorary dean of the Antwerp Guild of St Luke.

4 November 1634

After the death of Isabella on 1 December 1633, the new regent of the Spanish Netherlands, Cardinal-Infante Ferdinand, took up his position in Brussels amid great ceremony. Van Dyck painted his portrait. By December 1634 Van Dyck was said to be living in Brussels.

5 January 1635

Van Dyck received more than 500 pattaconi for two portraits of Prince Thomas-Francis of Savoy-Carignan, temporary regent after the death of Isabella.

Study for a Madonna, 1634–35
Black chalk with white chalk highlights, on blue paper, 44.4 x 31.8 cm
Staatliche Museen Preussischer Kulturbesitz, Berlin, Kupferstichkabinett

Study of a Nude Man, c. 1630
Red chalk heightened with white, 19.2 x 14.3 cm
The British Museum, London

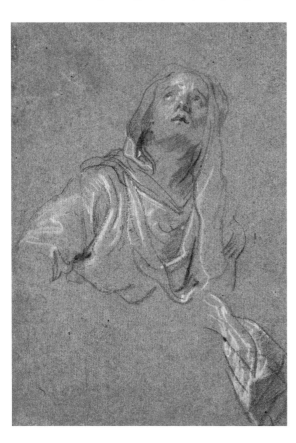

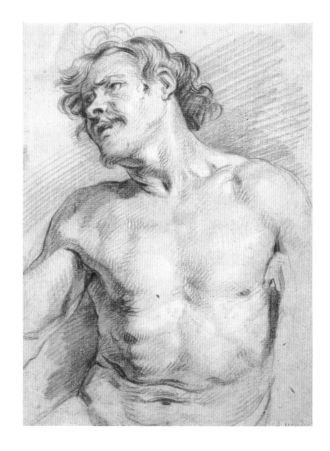

Politics

The Thirty Years' War continued to rage across Europe. In 1634 Wallenstein was accused of treason and assassinated by Irish mercenaries. In September of the same year the Swedish Protestants were defeated at Nördlingen by the imperial army under the command of Ferdinand of Hungary. The German Protestants signed a peace settlement with the Holy Roman Emperor in Prague in May 1635.

Culture

In 1634 the new Governor of the Spanish Netherlands, Cardinal-Infante Ferdinand, made his triumphal entry into Antwerp. Rubens was commissioned to design the Stage of Welcome.

In 1635 Inigo Jones' masterpiece, the Queen's House, Greenwich, was finished. His most notable achievement in the house was the creation of the Tulip Staircase: cantilevered, it had carved stone treads and a wrought iron balustrade incorporating the eponymous tulip design. Italian painter Orazio Gentilleschi was responsible for the decoration of the house. Born in Pisa, he won his reputation with the Vatican and the Medici family in Genoa. He settled in England in 1626 when called there by Charles I.

In France Richelieu founded the Académie Française in 1635 and charged it initially with the publication of an authoritative dictionary of the French language. As an ongoing concern, he gave the Académie the responsibility of maintaining the purity of literary French.

Society

By this time the Dutch were highly skilled and experienced merchants, always ready to seize a new opportunity to make money. In 1634 they started to trade in tulip bulbs. The first tulips had appeared in Europe a century earlier. Turkish in origin, they quickly became a curiosity – fanciful shapes and colours blossoming anew each year from an unlikely-looking bulb. Royalty, aristocrats and bankers welcomed tulips into their 'cabinets of curiosity', in which they displayed exotic flowers as if in an outdoor museum.

Even the Dutch painter Jan van Goyen became a tulip merchant. Trading began on dormant bulbs; demand continued to grow, and prices soared. The commercial value depended on the shape and colour of a tulip: 'Semper Augustus', which was red and white, topped the scale, followed by 'Viceroy', white and purple; beneath these were tulips that were flamed red or violet on yellow, and, of least value, single-colour tulips.

Enormous wealth could be made – at its peak, one tulip bulb could cost as much as 13,000 guilders, twice the cost of a fine city townhouse. As the craze escalated bulbs themselves were no longer traded but bills of exchange.

In January 1637 many Dutch traders could call themselves millionaires. Yet on 1 and 2 February rumours abounded to sell as soon as possible, and by the following day the market had crashed. Many investors lost everything.

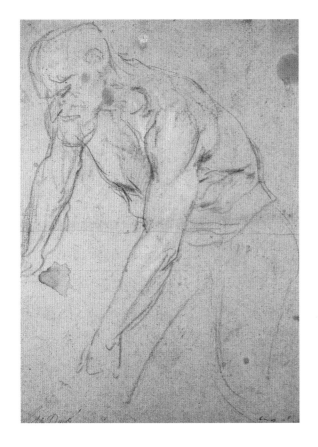

Study of Nude Male Figure, n. d.
Black chalk with touches of red and white chalks, 27 x 37 cm
Ashmolean Museum, Oxford

The Final Years

London 1635–41

Spring 1635
Van Dyck was in London again. Charles 1 had a jetty built in the River Thames at Blackfriars so that he could more easily visit Van Dyck's studio there in June and July. Van Dyck painted *Triple Portrait of Charles I* – full face, profile and half profile – as a model for Gianlorenzo Bernini who had been commissioned by the queen to make a marble bust of the king.

1637
Van Dyck painted *The Five Eldest Children of Charles I*, the latest and most ambitious of Van Dyck's portraits of the royal children. On 23 February Van Dyck was paid £1,200 by Charles 1 for a variety of pictures.

Autumn 1638
Van Dyck sent a note to the king, in which he listed 25 paintings for which he had not been paid. He also asserted that he had not received his salary for five years. The king annotated the note and reduced the price of 14 paintings.

14 December 1638
Van Dyck was paid £1,603, and on 25 February 1639 he received a further £305.

1639
Aged 40, Van Dyck married Mary Ruthven, the queen's lady-in-waiting.

1639
Plans were made for a series of canvases to decorate the Queen's Bedchamber at the Queen's House, Greenwich. Van Dyck hoped to be commissioned to do this, but Jacob Jordaens was chosen instead.

26 June 1639
The queen commissioned Bernini to sculpt a bust of herself like that which he had made of the king, and promised to send portraits of herself (in profile and full face) by Van Dyck to act as models. The portraits were never sent because of England's increasing civil unrest.

30 May 1640
Rubens died in Antwerp.

13 September 1640
Van Dyck, through the auspices of the Earl of Arundel, received a passport for himself and his wife to travel to Europe.

23 September 1640
In a correspondence between Cardinal-Infante Ferdinand and Philip IV of Spain, Van Dyck was discussed as being expected to be in Antwerp for the feast day of St Luke, the patron saint of the Guild of Painters, on 18 October.

English Countryside, 1632–40
Bodycolour on bluish-grey paper, 27 x 21.9 cm
The British Museum, London

Plant Studies, 1630–41
Pen with brown ink and
brown wash, 21.3 x 32.7 cm
The British Museum, London

English Countryside, 1632–40
Watercolour and bodycolours
on grey paper, 24.5 x 39.7 cm
The British Museum, London

Politics

In England, Charles I was at the height of his power, ruling without Parliament. In 1637 Charles' flagship *Sovereign of the Seas* was launched, funded by the hated tax, Ship Money. His religious policies also alienated the Puritans. In 1635 Archbishop Laud attempted to anglicize the Scottish Church; this led to a war in 1639. The following year the Scots rebels invaded England and occupied Newcastle upon Tyne.

Charles was obliged to call Parliament in April 1640. Dubbed the Short Parliament, it lasted three weeks. Cromwell sat on it as MP for Cambridge. Charles was unwilling to ask Parliament to fund the war with Scotland, and instead approached Spain and the Pope. In November of the same year the Long Parliament was summoned; it lasted until 1660. Here Cromwell showed himself to be a vehement supporter of Puritanism.

The year 1641 saw a major revolt of Irish Catholics in October; they claimed to have massacred one-fifth of Ulster's Protestants on Charles' authority. Charles, desperate to regain some authority, stormed Parliament with troops and attempted to arrest five MPs. The position of the Protestant Parliamentarians strengthened, Charles' weakened, and the stage was set for the Civil War.

Civil War broke out in 1642 between Royalists and Parliamentarians. After seven years of conflict, Charles was tried by the Parliamentarians at Westminster, found guilty and beheaded at Whitehall on 30 January 1649. The monarchy was then abolished and a Commonwealth was established, with Cromwell as chairman. In 1657 he was offered, and refused, the Crown.

Culture

Charles commissioned Rubens to paint the ceilings in the Banqueting House, Whitehall in 1635. Rubens made the paintings in Antwerp and had them transported to London. Charles was so pleased with them that he banned masques from taking place inside the building for three months to prevent the works being damaged by smoke.

The following year Rubens was commissioned to paint pictures for Philip IV of Spain's hunting lodge, the Torre de la Parada. He died in 1640, leaving the work unfinished. After his death, Jacob Jordaens became the leading figure painter in the Spanish Netherlands.

In 1637–41 in Italy, Borromini built the church of Santo Carlo alle Quattro Fontane, an original, splendid and theatrical building. He invented much of the architectural language of the Baroque, and his critics thought him deranged.

In comparison to the splendour of the Baroque, the Dutch Pieter Saenredam painted his cool, white church interior, Grote Kerk, Haarlem, in 1636–37. Rembrandt created his dramatically lit masterpiece *The Night Watch* in 1640–42.

Poussin, still in Rome, was commissioned by Richelieu to produce a series of *Bacchanals* in 1635, and four years later was encouraged to return to France to enter the service of Louis XIII and revitalize French painting. His *Et in Arcadia Ego* dates from 1638–40. A lover of theatricality, he used model stage sets to experiment with composition and lighting for his paintings.

Society

Galileo Galilei, still under house arrest, published his greatest work, *Two New Sciences*, in 1638. He discovered the basic principles of acceleration and falling bodies and established the discipline of rigorous testing of scientific principles. The Catholic Church was outraged. Galileo died in 1642, the year Newton was born.

René Descartes, a loyal Jesuit, published his famous work, *Discourse on Method*, in 1637, in which he explained the physiology learned from Harvey as simple matter in motion: I think therefore I am. He stated that the idea of God is so complex that man could not have invented him, and is regarded as the founder of modern philosophy. This work was written in French rather than Latin as Descartes intended it to appeal to the public at large. In 1641 he published *Meditations on First Philosophy* in which he set out his revolutionary views about the universe; as did Galileo, he upset the traditional hierarchical view of the cosmos.

10 November 1640
In a second correspondence, Cardinal-Infante Ferdinand reported that Van Dyck did not want to finish the paintings Rubens was making for the Torre de la Parada (Philip IV's hunting lodge) when he died.

December 1640
Van Dyck was in Paris, unsuccessfully proposing himself for the task of decorating the Grande Galerie in the Louvre; Poussin was commissioned instead.

12 May 1641
Princess Mary and Prince Willem II of Orange were married in London. Van Dyck painted their wedding portrait.

13 August 1641
The countess of Roxburghe reported in a letter that Van Dyck had been ill for a long time but, recently recovered, would be travelling to Holland in about 10 days' time.

16 November 1641
Van Dyck was commissioned by Cardinal Richelieu to paint his portrait in Paris, but while in Paris became so ill that he could not paint and asked for a passport back to England.

1 December 1641
Van Dyck's daughter Justiniana was born.

4 December 1641
Van Dyck made a new will.

9 December 1641
On the same day as his daughter was baptized, Van Dyck died at Blackfriars, aged 42. Never enjoying rude health, Van Dyck's constitution suffered under his constant heavy workload. Two days later he was buried in St Paul's Cathedral. His remains were destroyed in the Great Fire of London of 1666.

View in a Park
with Fountain and Trees, n. d.
Pen and brown ink, 15.4 x 22 cm
Ashmolean Museum, Oxford

Two Entwined Trees, 1632–41
Pen with brown ink, with
watercolour wash, 27.8 x 36 cm
Princely Collections, Vaduz Castle

Politics

In Europe, the German Protestant princes signed a peace agreement with the Holy Roman Emperor in May 1635. France entered the arena in May 1635 on the Protestant side, to assist Sweden and curb the power of the Holy Roman Empire. In this month it also declared war on Spain. The Thirty Years' War continued until 1648 when the Treaty of Westphalia was signed.

The future King Louis XIV of France was born in 1638; king in 1643; dubbed the Sun King, he was omnipotent, beneficent, and believed his powers came from God. In 1642 Marie de' Medici died in Cologne.

Culture

The classical French tragedian, Pierre Corneille, was also serving to strengthen the artistic position of France. His most famous plays date from this period: *Le Cid* (1636–37), *Horace* (1640), *Cinna* (1640–41), *Polyeucte* (1641–42). Corneille and Poussin are often mentioned in the same breath: working within a classical framework, they concentrated on themes of public good taking precedence over private emotions.

In 1637 the first public opera house was opened in Venice. This advanced the development of opera as an artform and led to the cult of the soloist.

Society

Another revolutionary French thinker, Pierre de Fermat, wrote in about 1637 his enigmatic marginal note: 'To resolve a cube into the sum of two cubes, a fourth power into two fourth powers, or in general any power higher than the second into two of the same kind, is impossible; of which fact I have found a remarkable proof. The margin is too small to contain it.' Fermat's last theorem took mathematicians over three hundred years to solve.

Hilly Landscape with Trees, 1635–41. Pen with brown ink and brush with grey, blue and green watercolour, 22.8 x 33 cm
The Duke of Devonshire and Chatsworth House Trust

Selected Bibliography

Adriani, G., *Anton van Dyck. Italienisches Skizzenbuch*, Vienna, 1940.

Barnes, S. J., *Van Dyck in Italy*, 2 vols, Ph. D. diss, New York, 1986.

Barnes, S. J., Boccardo P. (ed.) et al., *Van Dyck a Genova, Grande pittura e collezionismo*, Genoa, 1997 (exhibition catalogue, Palazzo Ducale).

Barnes, S. J., and A. K. Wheelock, Jr., (eds.), *Van Dyck 350*, (Studies in the History of Art, 46) Washington, 1994.

Bellori, G. P., *Le vite de' pittori, scultori e architetti moderni*, Rome, 1672, another edition ed. E. Borea, with a foreword by G. Previtali, Turin, 1976.

Biadene, S. (ed.) et al., *Titian*, Munich, 1990 (exhibition catalogue, Palazzo Ducale, Venice; with extensive bibliography).

Brown, C., *Van Dyck*, Oxford, 1982.

Brown, C., 'Allegory and Symbol in the Work of Anthony van Dyck', in H. Vekemann, and J. Müller Hofstede (eds.), *Wort und Bild in der niederländischen Kunst und Literatur des 16. und 17. Jahrhunderts*, Erftstadt, 1984, pp.123–35.

Brown, C., *Van Dyck. Drawings*, London, 1991.

Brown, C., and Vlieghe H., *Van Dyck. 1599–1641*, Munich, 1999 (exhibition catalogue, Koninklijk Museum voor Schone Kunsten, Antwerp, and Royal Academy of Arts, London; with extensive bibliography).

Cust, L., *Anthony Van Dyck. An Historical Study of His Life and Works*, London, 1900.

Demus, K. et al. (eds.), *Peter Paul Rubens, 1577–1640*, Vienna 1977 (exhibition catalogue, Kunsthistorisches Museum)

Filipczak, Z. Z., *Picturing Art in Antwerp*, Princeton, 1987.

Freedberg, D., 'Van Dyck and Virginio Cesarini, A Contribution to the Study of Van Dyck's Roman Sojourns', in S. J. Barnes and A. K. Wheelock, Jr. (eds.), *Van Dyck 350*, (Studies in the History of Art, 46) Washington, 1994.

Gaunt, W., *Court Paintings in England from Tudor to Victorian Times*, London, 1980.

Glück, G., *Van Dyck, des Meisters Gemälde*, (Klassiker der Kunst, XIII), Stuttgart and Berlin, 1931.

Glück, G., *Rubens, van Dyck und ihr Kreis*, Vienna, 1933.

Gritsai, N., *Anthony van Dyck*, Bournemouth and St Petersburg, 1996.

Held, J. S., 'Van Dyck's Relationship to Rubens', in S. J. Barnes, and A. K. Wheelock, Jr. (eds.), *Van Dyck 350*, (Studies in the History of Art, 46) Washington, 1994, pp. 63–76.

Hook, J., *The Baroque Age in England*, London, 1976.

Hope, C., *Titian*, London, 1980.

Houbraken, A., *De groote schouburgh der Nederlantsche konstschilders en schilderessen*, 3 vols, Amsterdam, 1718–1721.

Jaffé, M., *Van Dyck's Antwerp Sketchbook*, 2 vols., London, 1966.

Larsen, E., *L'Opera completa di Van Dyck, 1626–1641*, 2 vols., Milan, 1980.

Larsen, E., *The Paintings of Anthony van Dyck*, Freren, 1988.

Mai, E., and H. Vlieghe (eds.) et al., *Von Brueghel bis Rubens. Das goldene Jahrhundert der flämischen Malerei*, Vienna, 1992 (exhibition catalogue, Kunsthistorisches Museum).

Martin, J. R., 'The Young Van Dyck and Rubens', in *Essays on Van Dyck*, Ottawa 1983, pp. 37–44; reprinted in *Revue d'Art Canadienne/Canadian Art Review (RACAR)*, X, 1983, pp. 37–43.

Martin, J. R. and Feigenbaum, G., *Van Dyck as a Religious Artist*, Princeton, 1978.

Mauquoy-Hendrickx, *L'Iconographie d'Antoine van Dyck*, 2 vols., Brussels, 1956 (2nd edn. Brussels, 1991).

Mayer, A. L., *Anthonis van Dyck*, Munich, 1923.

McNairn, A., *The Young Van Dyck/Le jeune Van Dyck*, Ottawa, 1980 (exhibition catalogue, National Gallery of Canada).

Millar, O., *The Tudor, Stuart and Early Georgian Pictures in the Collection of Her Majesty the Queen*, London, 1963.

Millar, O., *The Age of Charles I Painting in England. 1620–1649*, London, 1972 (exhibition catalogue, Tate Gallery).

Millar, O., *Van Dyck in England*, London, 1982 (exhibition catalogue, National Portrait Gallery).

Moir, A., *Anthony van Dyck*, New York, 1994.

Müller Hofstede, J., 'Neue Beiträge zum Oeuvre Anton van Dycks', in *Wallraf-Richartz-Jahrbuch*, XLVIII–XLIX, 1987–1988, pp. 123–186.

Müller-Rostock, J., 'Ein Verzeichnis von Bildern aus dem Besitze des Van Dyck', in *Zeitschrift für Bildende Kunst*, XXXIII, 1922, pp. 22–24.

Pauw, C. de, et al., *Van Dyck's Antwerp*, Antwerp, 1991.

Piles, Roger de, *The Art of Painting and the Lives of the Painters (…) to which is added an essay towards an English-School with the lives of above 100 painters*, London, 1706.

Roberts, J., *Holbein*, London, 1988.

Rogers, M., 'Van Dyck's Portrait of Lord George Stuart, Seigneur d'Aubigny, and some related works', in *Van Dyck 350*, (Studies in the History of Art, 46), Washington, 1994.

Rosenbaum, H., *Der junge van Dyck (1615–21)*, Ph. D. diss., Ludwig-Maximilians Universität, Munich, 1924.

Schinzel, H., *Raumprobleme des Ganzfigurenporträts in England von 1600 bis 1640*, Frankfurt, 1980.

Strong, Sir. R., *Charles I on Horseback*, London, 1972.

Vey, H., 'Anton van Dycks Ölskizzen', *Bulletin Koninklijke Musea voor Schone Kunsten*, V, 1956, pp. 167–208.

Vey, H., *Van Dyck Studien*, diss., Cologne, 1958.

Vey, H., *Die Zeichnungen Anton van Dycks*, 2 vols., Brussels, 1962.

Walpole, H., *Anecdotes of Painting in England with some account of the principal artists*, ed. J. Dalloway, revised by R. Wornum, 3 vols., London, 1988.

Waterhouse, E., *Painting in Britain 1530 to 1790*, Harmondsworth, 1953.

Wethey, H. E., *The Paintings of Titian*, 3 vols., London, 1969–75.

Wheelock, A., Jr., and S. Barnes, *Anthony Van Dyck*, Washington, 1990 (exhibition catalogue, National Gallery of Art).

Whinney, M., and O. Millar, *English Art 1625–1714*, Oxford, 1957.

White, C., *Anthony Van Dyck, Thomas Howard, The Earl of Arundel*, Getty Museum Studies on Art, Malibu 1995.

Photographic Credits